OtherWorlds

How to Imagine, Paint and Create
Epic Scenes of **Fantasy**

Tom Kidd

IMPACT

CINCINNATI, OHIO
www.impact-books.com

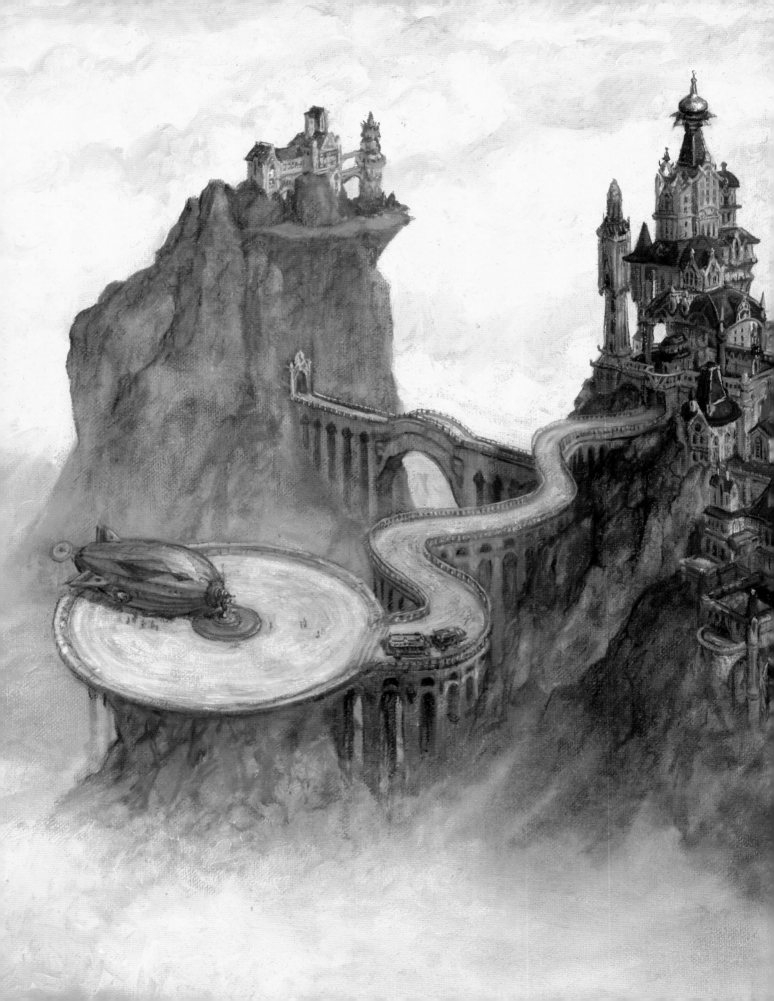

OtherWorlds. *Copyright ©2010* by Tom Kidd.
Manufactured in China. All rights reserved. No part
of this book may be reproduced in any form or by any
electronic or mechanical means including information
storage and retrieval systems without permission in
writing from the publisher, except by a reviewer who
may quote brief passages in a review. Published by
IMPACT Books, an imprint of F+W Media, Inc.,
4700 East Galbraith Road, Cincinnati, Ohio, 45236.
(800) 289-0963. First Edition.

Other fine IMPACT Books are available
from your local bookstore, art supply
store or online supplier. Visit our web-
site at www.fwmedia.com.

14 13 12 11 10 5 4 3 2 1

Distributed in Canada by
FRASER DIRECT
100 Armstrong Avenue
Georgetown, ON, Canada L7G 5S4
Tel: (905) 877-4411

Distributed in the U.K. and Europe by
F+W INTERNATIONAL
Brunel House, Newton Abbot,
Devon, TQ12 4PU, England
Tel: (+44) 1626 323200, Fax: (+44) 1626 323319
Email: postmaster@davidandcharles.co.uk

Distributed in Australia by
CAPRICORN LINK
P.O. Box 704, S. Windsor NSW, 2756 Australia
Tel: (02) 4577-3555

Library of Congress Cataloging in Publication Data
Kidd, Tom.
 Otherworlds : how to imagine, paint, and create epic
scenes of fantasy / Tom Kidd. -- 1st ed.
 p. cm.
 Includes index.
 ISBN 978-1-60061-866-6 (alk. paper)
 1. Fantasy in art. 2. Painting--Technique. I. Title.
II. Title: How to imagine, paint, and create epic scenes
of fantasy.
 ND1460.F35K52 2010
 751.45'47--dc22
 20100178603

edited by **Sarah Laichas**
designed by **Jennifer Hoffman**
production coordinated by **Mark Griffin**

About the Author

Tom Kidd has been a top award-winning fantasy art illustra-
tor for over twenty-five years. His work has been featured in
many volumes of the *Spectrum: The Best in Contemporary
Fantasy Art* series, and he is the author of *Kiddography: The
Art and Life of Tom Kidd* (Anova Books/Paper Tiger 2005). He
has won multiple awards for his science fiction and fantasy art,
which has encompassed book covers and interiors, magazines,
films and figurines. He has exhibited at many museums and
provided conceptual and design work for companies as diverse
as Disney and American Express. The breathtaking vistas of
the art of Tom Kidd, alias Gnemo, alias Newell Convers, can
be mistaken for no other. Visit his website at **http://spellcaster.
com/tomkidd** and blog **http://kiddography.blogspot.com**.

METRIC CONVERSION CHART		
To convert	*to*	*multiply by*
Inches	Centimeters	2.54
Centimeters	Inches	0.4
Feet	Centimeters	30.5
Centimeters	Feet	0.03
Yards	Meters	0.9
Meters	Yards	1.1

*This book is dedicated to my wife Andrea Montague
who shares in all my ups and downs even when I flew in a blimp.*

Acknowledgements

I'd like to thank my editor, Sarah Laichas, for patiently shepherding me through the making of this book and my designer, Jennifer Hoffman, for making the pages beautiful.

All of the following people graciously took the time to teach me something that made it into this book: Julia Jackson, Abe Echevarria, Cortney Skinner, Elizabeth Massie, A.C. Farley, John Pierard, Sergio Martinez, David Mattingly, Barclay Shaw, Paul Chadwick, Eric Peterson, Rick Berry, Michael Whelan, Mark Ryberg and the Artlisters.

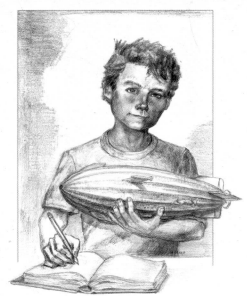

Contents

FOREWORD | BY MICHAEL WHELAN

Tom asked me to write an intro for this book. I haven't seen the book yet, but I think it's bound to be good. In fact, I'm sure of it. You see, that was our deal; I write an intro, Tom gives me a copy of his new book. Then, hopefully, mysteries are answered: I learn something of how he does what he does, acquire some of his glorious color sense, absorb his feel for three-dimensional structure, learn where his fantastic ideas grow from and how he nurtures them into full-flowered paintings of wonder and beauty. I imagine that's why you are holding this book, too.

We are going to have to rely on Tom's own words and examples for this info. I went over his biographical background, asked him some annoyingly personal questions, and all I can gather is that he is Tom Kidd the celebrated fantasy and science-fiction artist, more in spite of his history, than because of it.

His life wasn't so special, as he often points out.

Like many of us, he was born.

He grew up some. He got very sick. (St. Louis encephalitis, or SLEV as it is called by the CDC, is an uncommon but occasionally fatal nervous system viral infection, nearly impossible to treat.)

He recovered … but slowly and haltingly.

Nevertheless, he continued to grow.

He read. He was curious. He learned. He drew.

Then—

He got the idea he could make a career out of illustrating.

His family and friends assumed the poor guy was feeling the effects of a latent SLEV hallucination, but it was not so.

He worked at it. He ignored doubters. He refused to take no for an answer.

Entering the 1974 Florida State Fair art competition, he won a scholarship to Syracuse University.

At Syracuse and afterwards, he diligently worked on developing a portfolio, and worked very hard to get that portfolio seen by the right people in the publishing business.

So, because he would not accept otherwise, he got his first assignment. He got another assignment. Is still getting assignments.

Along the way he has won many awards, and worked on a wide variety of projects, including movies (Disney's *Treasure Planet*), theme park conceptualization, a series of works in an alternate persona [the Gnemo collection], and so on. At the same time he has developed a following and a reputation for excellence that makes him a much sought-after and perennially popular artist.

So despite my joking and his comments to the contrary, Tom's was an unusual and onerous upbringing to be sure. But even a glance at his history makes it plain that it is his artist's mindset [powered by determination and intelligence] that has turned his experiences into art, not the other way around. His experiences didn't make him an artist, but overcoming them may have endowed him with the patience, tenacity and wisdom that informs one's work and ensures a successful career. We readers may not have shared his experiences, but we are lucky to be able to benefit from them, because Tom is sharing what he has learned in these pages.

It has often been noted that adversity spawns creativity, but it is not so often recognized that adversity can encourage a sharper desire to separate the wheat from the chaff and go to the heart of a thing, avoiding the superfluous and redundant. Though he obviously has a restless and broadly inquisitive mind, when it comes to his work it is my guess that Tom realizes life is too short to waste on nonessentials. This distillation of knowledge also informs these pages. Treasure it; the knowledge gleaned thereby did not come easy or overnight!

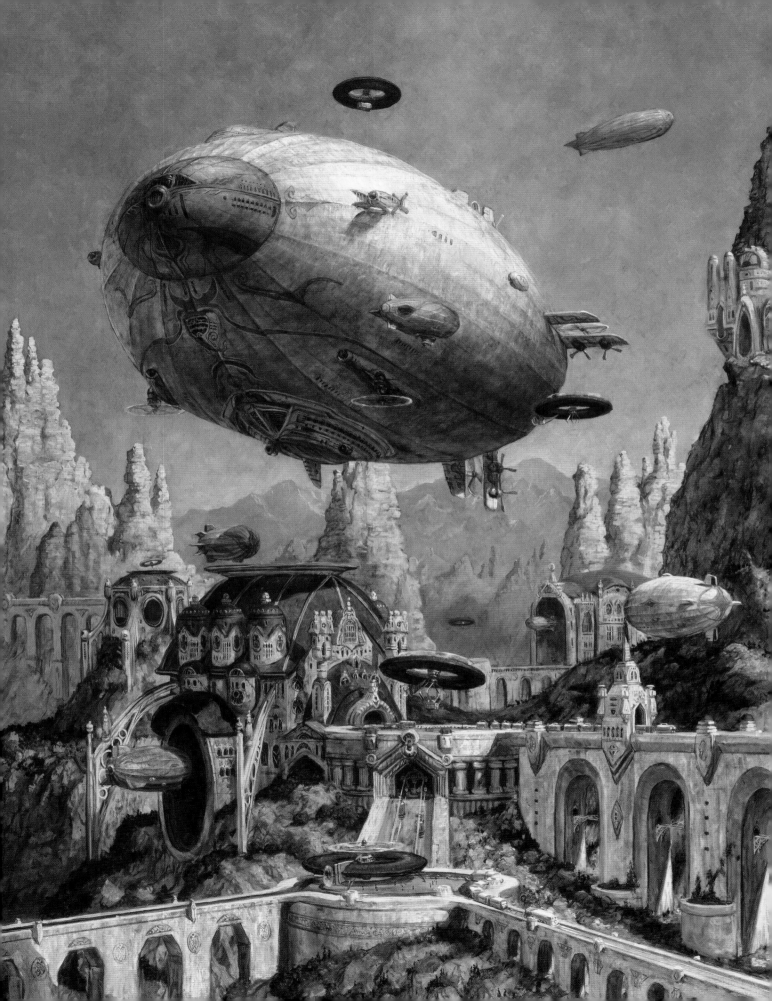

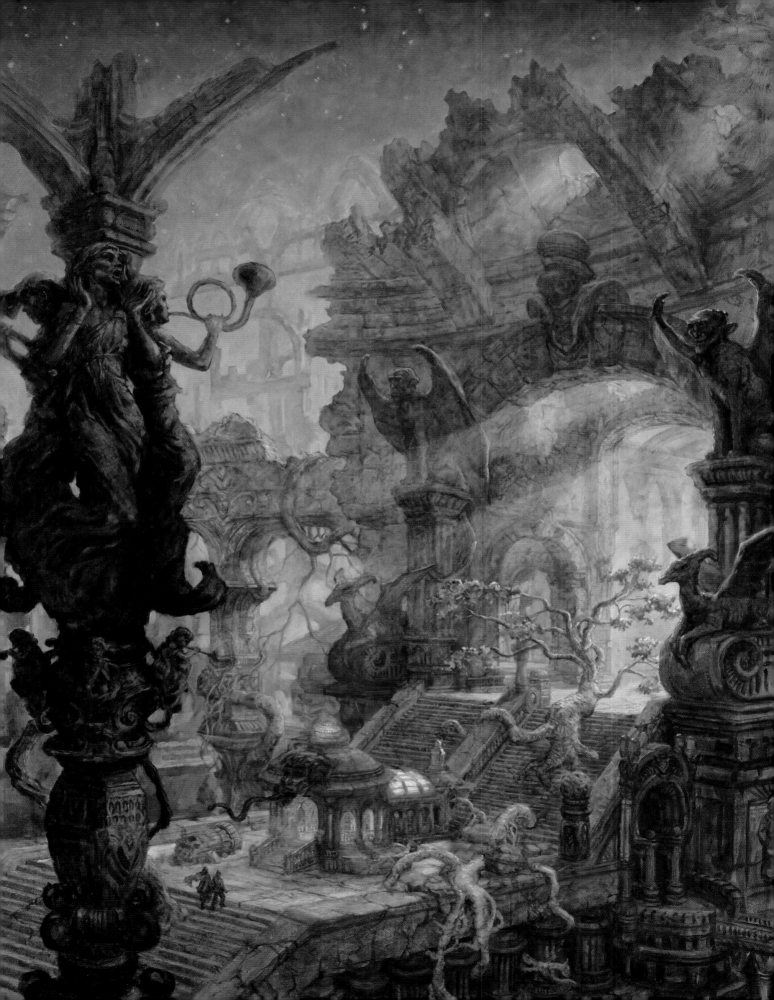

INTRODUCTION

Consider yourself a Spartan warrior, a gladiator or an Amazon skilled in all the weapons and methods of art. Whatever confronts you is only an opportunity to display your superb abilities. You're fearless. You're eager to the challenge. You possess a fit and lean artistic body ready to spring into artistic action. All this ability didn't sprout overnight. It came from intense and prolonged training. Now you walk through all the dangerous situations in your career with the confidence that your nimble hands and quick mind will produce only the best results. You will see the strength of your imagination fill your canvases with epic art. This I predict as your future if you're willing to put in the long hours that will make you a master. I also predict that you'll look back on your masterful body of work and feel pride in the art you've made. This is not to say you'll be famous or make a great deal of money. I leave that up to the gods of chance and wish you the greatest of luck.

When you're making something fantastic or impossible, it's important to know how to make it feel perfectly natural. My intention with this book is to not only show you how to do this but train your brain to imagine new places and even new worlds, that when painted, a person can enter into as if they only need to take a step forward. I'll give you methods for stimulating your imagination; I'll show you approaches that will bring forth your ideas more quickly; I'll show you how to give your work depth; I'll show you how to communicate a sense of place and I'll give you examples of how to evoke a full range of emotions. When it's all brought together, you should be able to make the viewer smile, laugh and cry; to feel love, experience fear, sense joy and, most of all, feel a thrill of adventure.

There's a certain excitement in exploring the unknown. The larger purpose of the imaginative landscape is to take the viewer on an exotic journey. We all want to escape the mundane and see

unique new places. That's what vacations are for. This book will show you how to make extraordinary places wholly from your imagination. All you'll need is paper and pencil to start, but when you're ready for a great adventure you'll need paint. If you can be so bold as to use oil paint, you will find it to be the most friendly and facile of mediums. You may find computer programs like Adobe® Photoshop® or Corel® Painter™ to be just as friendly and certainly less messy, but oil paint remains the medium of the true adventurer.

During the day we spend much of our time in directed thought. This is to our advantage at work, planning out our activities and in school. However, to become a successful and respected fantasy artist you'll have to unleash the power of your free-ranging brain. That's the part of your brain that's active when you dream. The ability you have to imagine in your sleep can be harnessed when you're awake. As strange as it seems, the best way to do

As you create your vast new world with its giant cities, expansive landscapes and exotic peoples, also take the time to create the small things such as this little dragon airshipman pin or medal of valor.

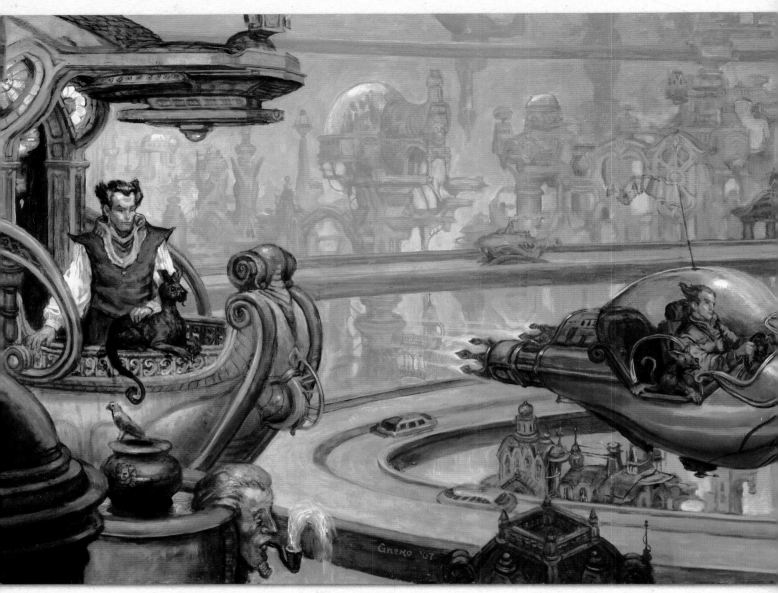

that is by careful observation of nature and understanding the visual world by actively studying it through art. The more you do this, the better you become. The better you can see, the better you can imagine, the better you can make things up and paint them. Careful study of the world around you will cause your brain to grow—literally. When I say *see*, I'm not talking only about the surface of things but also why they take on the forms they do. One impediment to seeing well is that, for the sake of efficiency, our brains convert what we see into symbols. You'll need to see things as they are. For some people this comes more naturally but it can certainly be learned. The way to see well is simple. If you can learn to draw objects, animals and people and make them look the way they look, you're beginning to see well. Do this as much as you can.

Learning by imitating other artists is a fine way to learn, but it can become a crutch. If you only read the step-by-steps in this book, you won't learn how to create unique works of art. You'll only learn how to copy what I do. That

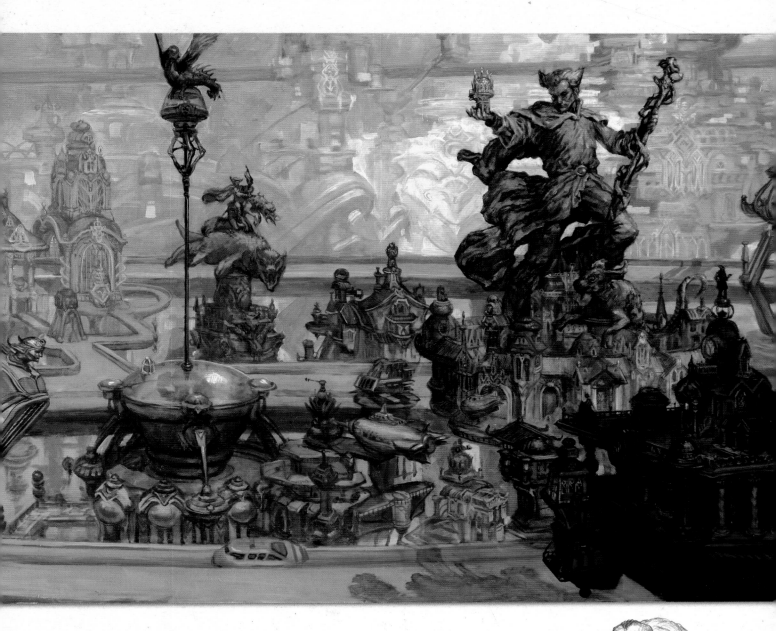

won't be enough. What I know is barely enough for me and there's no way one book can tell you all I know because a lot of what I know I don't know I know. Study the work of all artists and be a careful observer of nature.

Now that you've read my basic thinking on how to create, we can go onto the main thrust of the book—painting fantasy landscapes, environments, its flora and fauna and its denizens.

Restricting your thinking can result in angst and pain delivered by a pain demon.

1

The Basics of Getting Started

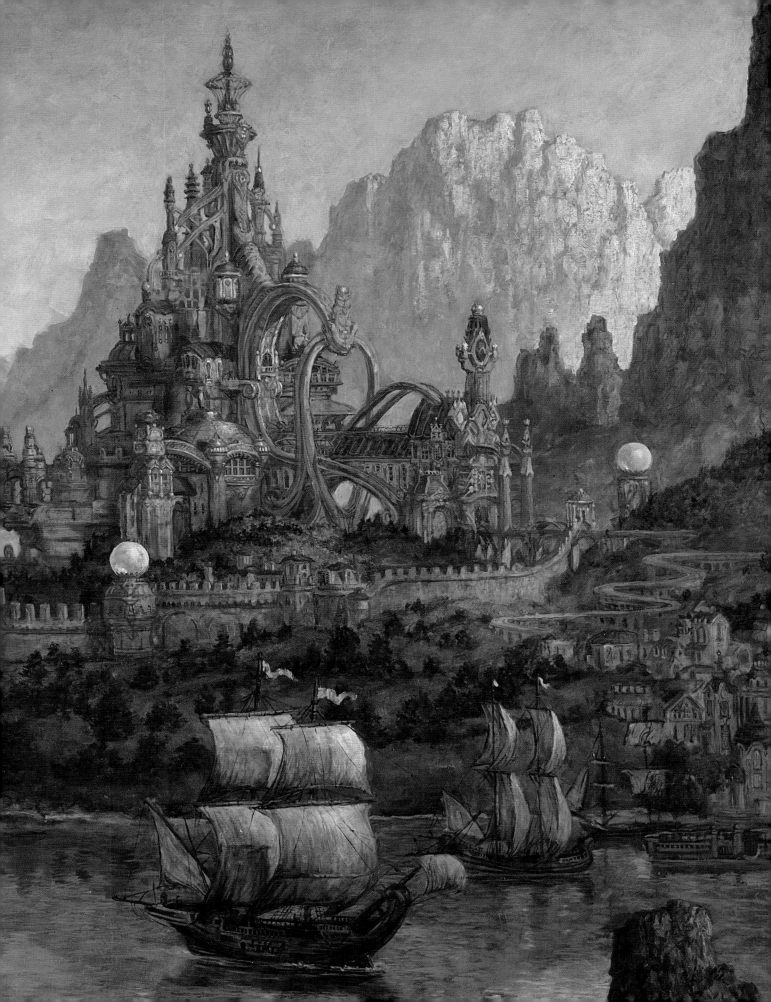

SETTING UP A STUDIO SPACE

"The house is a machine for living in."

— Le Corbusier, architect and urban planner

Like your house, your studio is very much a machine for making your art. Mine is chock-full of stuff that I use every day as well as things I use from time to time. The tools I use every day are close to me, and the things I use less frequently are at varying distances away. I prefer to paint standing up so I can easily reach everything around me. Painting while standing also allows me to regularly view my painting up close as well as to back up easily to see the full picture.

Reference Library

Over the years I've collected thousands of books on a variety of subjects and cut out thousands of pictures from magazines. Though every artist's reference collection is different, you should have regional and historical pictures as well as every kind of natural phenomenon depicted. When you travel, even on walks or bicycle rides around town, take pictures and then place them in logical files on your computer. The purpose of your reference library is to check facts as well as to review from time to time to refresh your visual brain. Avoid using reference files every time you make a painting. This will limit the use of your imagination.

Use these photographs of my studio to get you thinking about the layout of your own studio space. Not pictured is my camera, tripod, drawing table, paper cutter, television for playing recorded movies and DVDs of related subject matter and numerous file cabinets of different sizes holding drawings and reference. All these are used at one time or another when I work.

A View of My Studio (opposite page)

A MOVABLE PALETTE.

B BRUSH HOLDER: A 2' × 4' (61CM × 122CM) BOARD WITH 1-INCH (3CM) HOLES BORED IN AT AN ANGLE SO BRUSHES ARE LESS LIKELY TO TOUCH. FOR DETAIL WORK, EACH BRUSH IS ASSIGNED A COLOR RANGE AND IS ONLY CLEANED AT THE END OF THE DAY.

C HOT FILE FOR PRINTED REFERENCE, NOTES AND MANUSCRIPTS.

D AN EASEL FOR PAINTING ON AND ONE TO HOLD ONE OF MY COMPUTER DISPLAYS. THE LARGER EASEL HAS A CRANK TO LIFT AND LOWER THE PAINTING.

E SWIVEL TO CHANGE THE ANGLE OF THE PALETTE.

F SMALL CLIPBOARD NAILED TO PAINT TABORET TO HOLD A PAPER TOWEL FOR CLEANING OR REMOVING PAINT FROM A BRUSH. THIS WAY I DON'T HAVE TO HOLD A RAG AS I PAINT.

G PENCIL SHARPENER ON ITS OWN SHELF.

H DRAWERS FILLED WITH OIL PAINT ARRANGED BY COOL TO WARM WITH BLACKS AND WHITES ON THE BOTTOM.

I ART AND REFERENCE BOOKS IN BOOKCASES AND ON SHELVES.

J BRUSHES NOT IN USE BUT AT THE READY.

K A BOARD WITH HOLES DRILLED TO HOLD FILM CANISTERS OF MEDIUMS.

L PAPER TOWELS FOR WIPING, CLEANING AND SPREADING MEDIUM.

M A DRAWER OF PAINTS.

N SCANNER FOR FLAT ART AND TRANSPARENCIES.

O MAHL STICK MADE FROM A BROOM HANDLE. THE RUBBER TIP IS PLACED ON THE DRY AREA OF A PAINTING WHILE I REST MY RIGHT HAND ON IT TO HELP KEEP MY PAINTING HAND STEADY.

P ONE OF MANY RULERS. THIS ONE'S MAGNETIC. IT'S HOLDING TO A FILE CABINET.

Q BULLETIN BOARD FOR HOLDING CURRENT INFORMATION AND NOTES.

R THE PAPER TRAY FOR A PHOTOCOPIER USED TO COPY DRAWINGS QUICKLY.

S COMPUTER MONITOR FOR REFERENCE. I RUN SLIDESHOWS OF SIMILAR SUBJECT MATTER AS I PAINT, OR PLAY MUSIC OR PODCASTS.

T NETWORKED PRINTER HOOKED TO ALL OF MY COMPUTERS.

U WACOM TABLET USED AS A MOUSE OR TO WORK DIGITALLY AS YOU WOULD WITH A BRUSH.

V T-SQUARE AND TRIANGLE USED FOR CHECKING HORIZONTALS AND VERTICALS.

W CLIPS FOR HOLDING REFERENCE OR LONG NOTES.

X LAMPS FOR EXTRA LIGHT OR FOR PHOTOGRAPHING ART OR REFERENCE.

Y BLUE STICKY NOTES I USE TO MAKE NOTES ON FOR THINGS THAT OCCUR TO ME WHEN I PAINT.

Z A STICKY NOTE USED TO TEST BRUSHSTROKES. ONCE FULL, IT'S THROWN AWAY.

Although surrounded by machines you must keep your humanity. Don't let yourself become robotic in your painting. Though that robo-easel is pretty cool. I've got to get one.

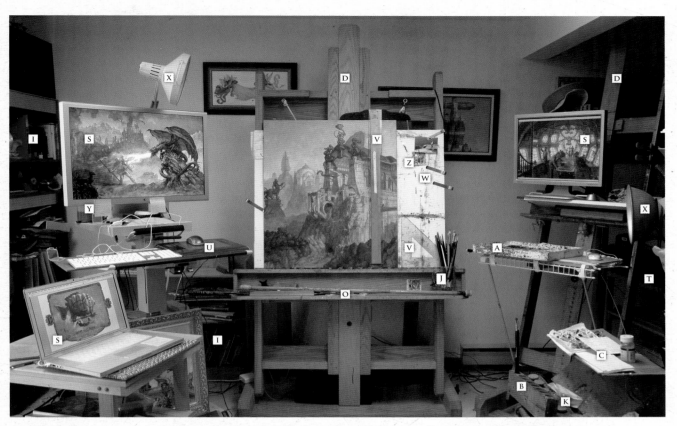

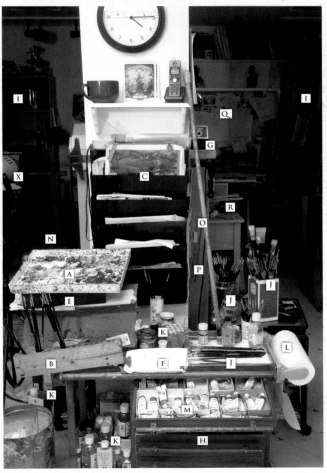

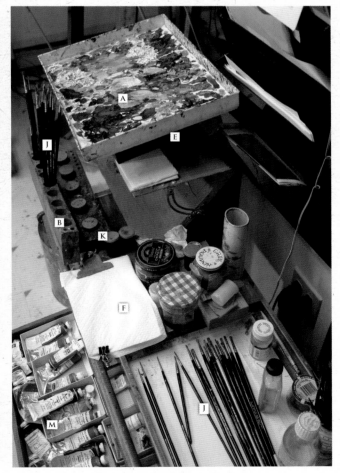

THE SIMPLE PENCIL

A pencil is a basic tool that is easy to understand. The harder you press it to the page, the darker a mark it makes. There are a large variety of graphite pencils you can buy. Your basic wooden pencil comes in a range of hard leads, that make light marks on the paper, to soft leads, that will make darker marks on the paper. These pencils are usually marked H for light, the higher number being the lightest and B for dark, the highest number being the darkest. A typical pencil, the yellow kind seen in school are 2B pencils. These are excellent pencils to draw your basic ideas. When you get to the finer points of drawing, you'll want to buy art pencils. They're a little bit more expensive but they are less likely to have bits of grit to them. If you use a pencil with an eraser on the back of it, don't use that to erase with. It's more likely to smudge than to erase anything. Mechanical pencils are often an excellent choice. The graphite is higher quality and you won't need to sharpen them. Use the ones with thicker leads for your idea sketches. As you become more familiar with drawing, you'll develop a drawing shorthand, a simple way to get an idea down.

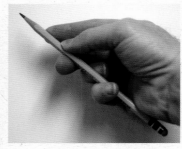

HOW TO HOLD YOUR PENCIL

The two hands are holding the pencil the same way but at different angles. Holding the pencil loosely in your hand allows you to create wide, flat strokes as well as finer lines. You can even vary your line from thin to thick much like you can with a paintbrush. You lose a little bit of control here, but you make that up in creativity. Let the pencil wander the page and show you the way.

Try spinning the pencil back and forth between your fingers while you make a line. This will add interest to any natural form and keep you from becoming too regular with your line.

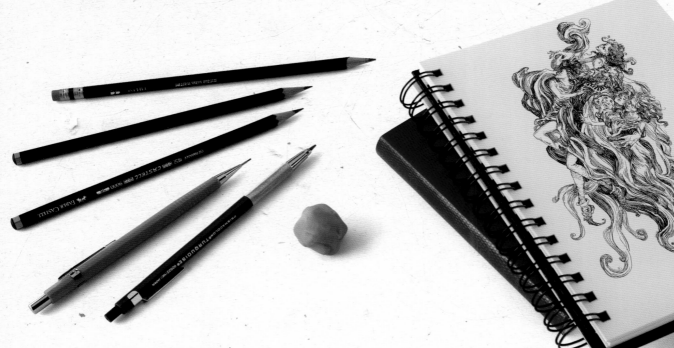

2B OR NOT 2B ... OR MAYBE 2H?

Keep a variety of pencils on hand for sketching and planning your paintings. Here are a variety of wooden pencils ranging from 2H to 8B, an assortment of mechanical pencils with different advancing mechanisms and a kneaded eraser. Use a kneaded eraser instead of the one on your pencil to cut down on smudging.

SKETCHBOOKS

Make a habit of carrying a sketchbook and pencil to capture your ideas. I used to carry a sketchbook, but after misplacing so many, now I prefer to carry around loose paper in a container and use a simple clipboard as a flat surface to draw on. By drawing on separate pages, I can categorize my drawings and keep them in files. It's a practical approach but not as romantic as a sketchbook. The important thing is to be prepared.

SKETCHING YOUR IDEAS

Even when there's nothing in your head you can put your pencil to the page and generate pictures. Make a squiggle and another and another. Is it starting to look like something? Whatever it is, draw it. Draw something from life on a small portion of paper and then expand or modify it with your imagination. Don't limit yourself. Do your best to draw a wide variety of subject matter. All of your ideas can easily turn into science fiction or fantasy because the two genres contain elements of every other genre. Westerns, romances, detective stories, thrillers, historicals, humor, animal stories, mysteries, action and adventure, biographies and mythologies will all become your subjects when you put your pencil to fantasy. It's best to learn them all.

SCRIBBLE TIPS FROM THE GIANT PENCIL GNOME

The giant Pencil Gnome is here to remind you to always start roughly and let your pencil wander freely and lightly across the page. You can find new ideas in all of your scribbles. Use a large pencil with a dull point. The more control you have in the beginning, the less likely you'll discover something new. Pencil lines can be erased so don't worry about mistakes. If you draw hard on the page, you can always redraw. Or trace your rough drawing using vellum.

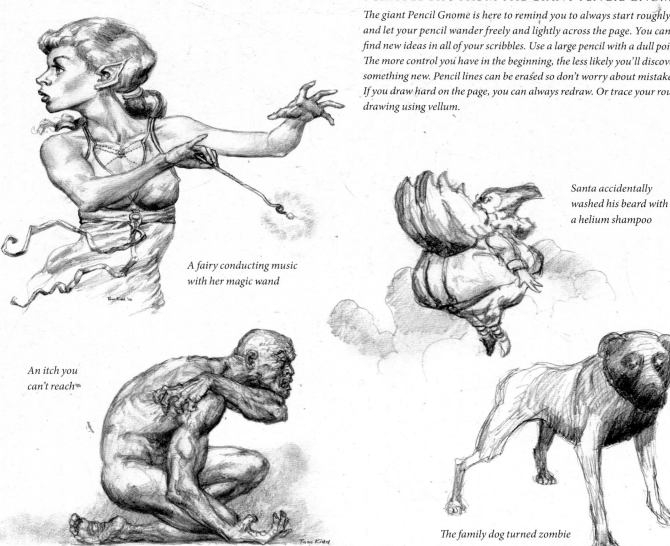

A fairy conducting music with her magic wand

Santa accidentally washed his beard with a helium shampoo

An itch you can't reach

The family dog turned zombie

PENCIL AND SKETCHING TECHNIQUES

When you first start drawing, it's a time of discovery. This is where the ideas come from. Hold your pencil loosely when you're sketching out ideas. If you're too formal, too perfect with your lines, you'll stifle your ideas. During the idea stage you shouldn't be working on expensive paper so if the drawing is a failure you can simply set it aside and start another. Even if you like your drawing but it's not quite right, try a quick gestural sketch—fast drawings done to capture the feeling of movement—to compare it to. Often this will be superior to the initial attempt. If you can draw something once, you can draw it again.

Some artists put their sketches on a lightbox to redraw them perfectly. This is a nice approach but can cause you to miss out on new discoveries. Unless you are completely satisfied with your drawing and just want an antiseptic version of it, devoid of character, you should redraw not trace.

DRAWING ORGANICALLY

A nice way to develop an idea is to draw a small unimportant area first rather than the main elements. It's best to begin somewhere on the side of the paper or surface. Your initial subject should be some small detail from the story.
Take it and expand outward adding other elements on it as if it's a living, growing thing. This approach tends to create a composition naturally as well as one that's a bit different than you might usually invent.

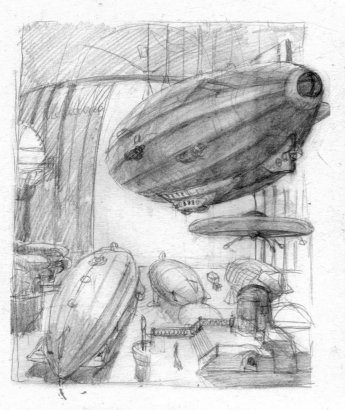

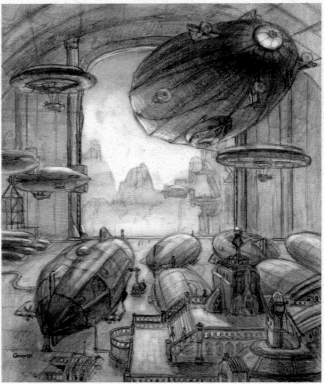

AN IDEA SKETCH: BEFORE AND AFTER

My first sketch of this airship hangar is a fairly developed idea, but the angles were off. I improved the sketch's tonal range in Photoshop. Editing software helped me adjust the values and work out the complicated bounced light in this idea sketch.

DRAW AND REDRAW YOUR IDEAS

A good habit to get into is drawing and then redrawing your ideas. You may end up painting your first idea, but you'll learn the finer points of what makes a good composition through a redraw. Try to redraw from memory. You will often remove problems without knowing that you're doing it. By starting over completely, you revisit the idea and mentally see it in all its dimensions rather than only trying to correct the flat drawing.

Keep in mind that the purpose of this type of drawing is to generate and put down ideas rather than to make a clean, finished product. You can always refer back to your original sketch for a comparison when you're finished.

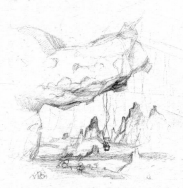

A quick idea sketch of a small group of people being lowered into a deep cave.

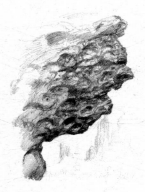

The fleshed-out sketch adds power.

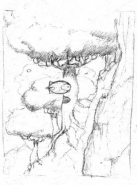

A quick idea sketch done in the moment.

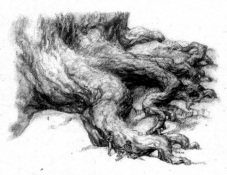

The fleshed-out sketch of the roots of a giant tree.

ORIGINAL THUMBNAIL

ELEMENT ADDED TO DRAWING

DIGITALLY EDITED SKETCH

PHOTOSHOP TECHNIQUES FOR IDEA SKETCHING

Although redrawing your thumbnails is the best way to go, you can always use a computer for a few quick but substantial changes. You can insert separate drawings like the airship or simply crop your picture for a different center of interest. Here I made significant changes—I brought in an airship sketch, moved the airplane to the right and turned it upward, and brightened the sunburst (the light that comes out from behind the cloud).

TOOLS FOR OIL PAINTING

I've never met a painting medium I didn't like, but my favorite medium is oil paint. If you want to start painting in oil, I recommend first visiting a museum to see oil paintings in person. You'll observe a world of difference compared to what you might see online or in a book.

Oil paint has many qualities. It can run like water, be as smooth as butter, gooey and viscous as glue, or it can be solidly dry. You can use all of these properties to your advantage or even combine them.

Painting Surface

Your main surface choices for painting in oil are canvas or a gessoed hardboard. I recommend you buy canvas on rolls so you can choose from a variety of weaves. You can buy hardboard (usually called Masonite) at a lumberyard and have it cut there, or you can cut it yourself to whatever size you want. To prepare the hardboard, sand it and apply at least a couple of coats of gesso (sanding after each). I prefer to glue my canvas to sanded hardboard rather than to stretch it on stretchers. The process is call marouflage, an approach that's been in use for 3000 years. Gesso helps the paint bond to the surface.

Paint Colors

Sets of oil colors are sold for beginners, but if you're buying paint individually, here's what I recommend. Keep in mind that no paint is perfectly opaque or perfectly transparent.

- Opaques: Titanium White, Cadmium Yellow, Cadmium Red, Turquoise, Cobalt Blue, Cobalt Green, Permanent Green, Mars Red (a brown more than a red) and Mars Black. Depending on the manufacturer, some forms of Burnt Sienna are opaque and some are more transparent.

- Transparents: Transparent White (it's really semi-opaque), Indian Yellow, Alizarin Crimson, Permanent Rose, Phthalo Blue, Ultramarine Blue, Manganese Blue, Phthalo Green, Payne's Gray, Burnt Umber and Ivory Black. Any transparent color can be made more opaque by mixing it with Titanium White.

Many transparent colors appear very dark out of the tube and are usually used thinly as glazes or with white mixed into them. By mixing Titanium White with Transparent White in different proportions you can control the translucency of the glaze.

All colors vary in their properties. You can test a color on any white surface by putting down a small amount and smearing from thicker to thin. This should give you some idea of its translucency.

If you need a fast drying time with oils, using alkyds will speed up the drying time. Also, mixing in a faster drying medium such as Liquin will speed up the drying time. The slowest drying colors are Titanium White, Permanent Rose, Ultramarine Blue, Ivory Black and all the Cadmiums. If you buy those in alkyd form, you can use them thickly and they'll dry quickly but with a slightly different surface texture than regular oil paint. You can mix them with other paints with no problems. This is a nice way to get a drying time you desire. An important quality with oil paint is painting wet-into-wet paint. You really don't want a drying time that's too fast. I like it when what I paint is dry the next day.

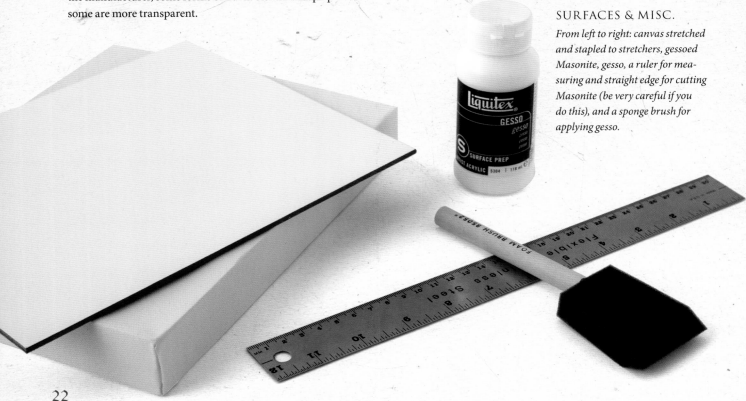

SURFACES & MISC.

From left to right: canvas stretched and stapled to stretchers, gessoed Masonite, gesso, a ruler for measuring and straight edge for cutting Masonite (be very careful if you do this), and a sponge brush for applying gesso.

Mediums

Mediums are used in oil paintings to change the consistency of paint. Linseed oil is used to thin paint and turpentine to clean your brushes. Linseed will also slow drying time, and comes with various dryers such as Fast Drying Oil or Pale Drying Oil. Mixing in Liquin will dry your paint quickly. It can be mixed with linseed oil to slow down the drying time. The larger purpose of a medium is to change the quality of the paint so it either applies a little easier, becomes watery, keeps a particular sheen, thickens the paint or even makes it a bit tacky. Using a wax medium with oil paint will give it a very interesting quality. It's best used along with another binding medium though. Think of it this way, a medium can be used to give you a bit more control of the paint or to lose some of the control to the special qualities of the medium itself. Often I'll put down a medium directly and leave it alone for a while until it becomes a tad tacky before I paint into it. This works well when you're painting rough surfaces such as rocks or tree trunks. Turpentine can be used as a medium to thin oil paint down to the consistency of watercolors. Working this way will actually give your oils a watercolor look. Keep in mind you can use all these mediums and approaches together in one painting.

Brushes

You'll need a variety of brushes for painting with oil: big to small, flat to round and stiff to soft. My favorite brush is a bright. It's flat, soft and keeps a sharp edge. For bristle brushes you should have a range going from no. 4s to no. 20s, for brights a nice range is no. 4s to no. 8s and a no. 1 is likely all you'll need for a sable round. It's best to have a few of each of the sizes of the sables and brights. They can wear out quickly based on the quality of the brushes.

Palette

You will need a palette to mix your paint on. You can mix oil paints and blend on any nonabsorbent surface. Wax-coated paper palettes can be bought in any art store. Some artists use varnished wood palettes, and some use a glass surface but those need to be cleaned at the end of each day. You can also buy butcher paper to mix paint on. For watercolors and acrylics you can buy plastic palettes to mix on. I use aluminum foil wrapped around and taped to a board for watercolors. It can be wiped clean with a paper towel and reused again and again.

OIL PAINTS
& MEDIUMS

The two mediums at right change the viscosity and drying time of oil paint. They are also useful for mixing transparent or translucent glazes. Turpentine is even thinner and can be used to clean brushes or to thin paint to a watery consistency. You can mix mediums with paint or thinly paint them directly on a surface prior to applying paint.

BRUSHES & PAPER PALETTE

Brushes apply paint differently depending on the brush size, shape, stiffness or type of surface. For instance, a bristle brush applies paint smoothly to canvas but tends to go down rough on a smooth surface like gessoed Masonite, depending on the concentration of the paint.

TOOLS FOR WATERCOLOR

Watercolor is a quick and fun medium. It works well over a pencil drawing because the drawing can be seen through it, unlike an opaque medium that covers the drawing underneath. When you're working with a pencil you're subtracting light, meaning the more lead you apply, the less light bounces off the paper. The same goes for transparent watercolor.

Watercolor can be done most places. It's easy to carry around and doesn't require the preparation an oil painting does. You won't need any unpleasant smelling solvents with watercolors. Although it's considered a transparent medium, and therein lays its greater qualities, you can work opaquely with it as well.

Painting Surface

The best surface to work on is watercolor paper. It's designed to handle being wet. Good watercolor paper doesn't necessarily have to be stretched. I don't stretch mine. It will even out underneath something flat and heavy on its own. Also, it'll take better punishment like wiping the surface.

Brushes

Any brush that holds water well is a good watercolor brush. Sables are a good choice for this. To lay in broad colors, buy two or three big flat watercolor brushes going up in size to a no. 8. Watercolor brushes can be expensive, but they get considerably less wear than oil brushes and should last quite a long time. I use a no. 1 round for most things.

Watercolor Paints

Watercolors won't all be perfectly transparent. Certain colors will be more transparent than others, and you can always add white to a color to make it more opaque. This list of watercolors is copied from my oil list (these are the more transparent ones): Indian Yellow, Alizarin Crimson, Permanent Rose, Phthalo Blue, Ultramarine Blue, Manganese Blue, Phthalo Green, Payne's Gray, Burnt Umber, Burnt Sienna and Ivory Black. Here are the slightly less transparent colors: Cadmium Yellow, Cadmium Red, Turquoise, Cobalt Blue and Cobalt Green. Titanium White is the most opaque color but not as opaque as the oil version. You can't use it to cover up a mistake to then work over. Wiping away is the best way to change something in a watercolor. You'll need good paper to do that.

Other Supplies

Gum Arabic is the only medium I use with watercolor. I mix a drop in a jar of water before I begin painting to act as a binder and to slightly change the sheen of the watercolors. The only thing you need for mixing watercolors is a nonabsorbent surface that's smooth and can be cleaned.

WATERCOLOR TOOLS
Choose a tough watercolor paper that can handle rubbing without pilling. You can buy tubes of watercolor paint that squeeze out like oil paint (below) or purchase it in solid form. Choose both flat and round brushes in increasing sizes. At right, Gum Arabic to use as a medium and a sturdy water jar.

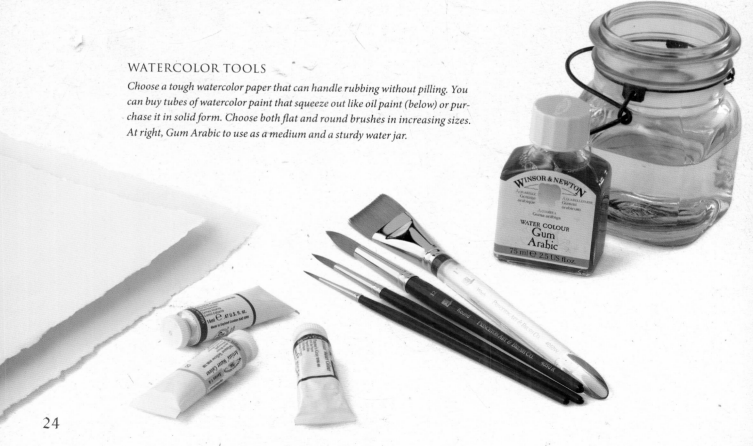

CREATE VIGNETTES IN WATERCOLOR

A vignette is to a short story as an edge-to-edge painting is to a full-length novel. Watercolors are perfect for vignettes. These small artworks or illustrations have no borders and fade out toward the edges. Start a vignette on a white surface and leave the outer area of the page untouched.

WATERCOLOR OVER PENCIL

I redrew this sketch idea in a lighter touch and then added watercolor on top. Painting with watercolor works well over a light pencil sketch. You can always build up your darks with paint. To achieve the oxidized copper effect typical of bronze statues, hold the art at an angle and let the watercolor run down the page. It's like a time-lapse photography of the bronze over the span of a few years.

REFLECT NATURE WITH WATERCOLOR

Try an experiment: Mix up some watercolor paint with a lot of water and drip it on some paper. Let it slide down the paper, then fold the page to press the clean side against the wet side. You can repeat this experiment with ink or gooey oil paint. What you'll end up with is a random pattern that's somewhat pleasing. That's nature. Using the properties of a liquid or viscous fluid to illustrate its properties is a way to reflect nature. Watercolor pretty much creates little reflections of nature because the medium is part of nature. It's water. This is why so many artists adore watercolor despite it being a difficult medium to master.

The world you're painting should come alive in your mind.

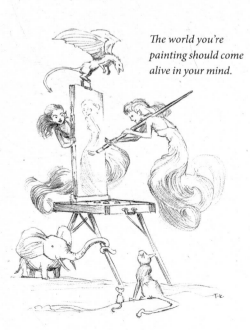

25

Pen and Ink

Ink lines are much harsher than pencil lines. Inking can certainly be a spontaneous thing that's done directly with no drawing, but planning has its merits. These examples and close-ups represent a few ways to ink. They are both methods and visual metaphors in that the lines represent something they are not. Taken literally, lines are lines and nothing else. With black lines you're forced to interpret nature because nature isn't made up of lines. The visual world is made of a wide tonal range of lights and darks. Our eyes even interpret the spectrum of light as color to help us distinguish objects. It may seem impossible to make an appealing picture from only black lines, but fortunately your artist's mind is facile and your artist's hand is dexterous enough to accomplish this (with practice, of course).

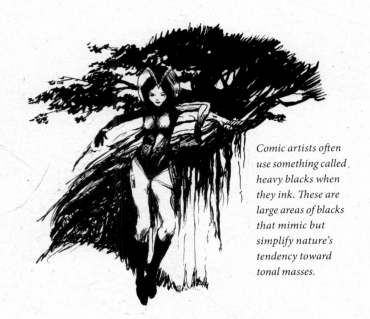

Comic artists often use something called heavy blacks when they ink. These are large areas of blacks that mimic but simplify nature's tendency toward tonal masses.

Heavy blacks with a lot of details

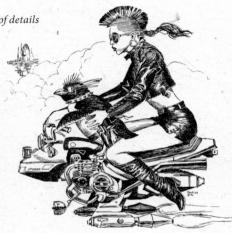

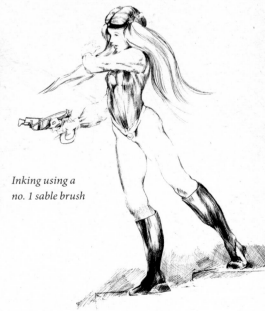

Using thick and thin lines gives the impression of tonal variation.

Black lines as scribbles. Your line quality affects the mood of your inking as the color does with oil paint.

Inking using a no. 1 sable brush

Tickling the Dragon's Tail

Back a hundred or so years ago, pen and ink was the most common form of illustration seen in books or magazines. It was easy to reproduce and to print with little diminished quality from the original. Amazing works of art were created using a crow quill pen and a jar of black ink. Pen and ink is steeped in the metaphor and simile of line. You'd do well to study this art. In addition to that, it's humbling to see what a practiced hand and mind can do with the simplest tools. So please seek out the masters and study them.

Materials

SURFACE

Smooth, hot-pressed bristol board or any surface that won't bleed through

PENS

Selection of Pigma Micron pens: sizes 005 (0.2mm) to 8 (0.5mm)

Pigma Brush pen

1 Plan Out your Ink Drawing

Your ink lines can represent many things. They can be the outlines of your subjects, or they can represent tone and texture as well. These aspects can fight with each other so it's best to plan out your pen-and-inks. These two drawings are different versions of the same story: an artist, a particularly oblivious one, has mistaken the end of a dragon's tail as his pen quill. Draw your fantasy subjects based on what you can picture in your head. On the right, the neck and face of the dragon help tell the story of his interrupted sleep so the second drawing explores a slightly different demeanor.

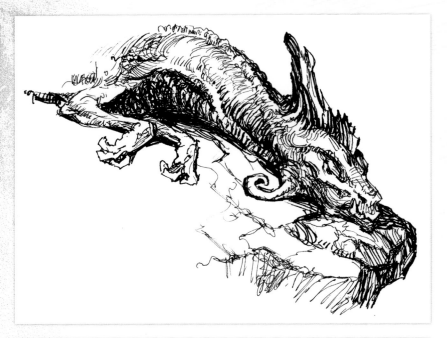

2 Testing your Ink Lines

If you're doing a complicated ink piece, do a couple of quick studies to test your lines. The way your pencil drawing looks is not a good way of telling how the inking will turn out. Test your inking by placing a blank sheet of paper over your drawing on a lightbox. Or practice your ink lines on a photocopy of your drawing. This is the time to be loose and experiment. It's often hard to know when to stop when you're inking so this test inking is a nice way to find what your stopping point should be. Both of these were done using permanent marker pens. They come in a variety of thicknesses. There are two advantages of using them over an ink-loaded quill pen. You can use them anywhere without the worry of spillage, and you can work in a more upright stance.

INK LINES CREATE FORMS, TONAL VALUES AND TONAL MASS.

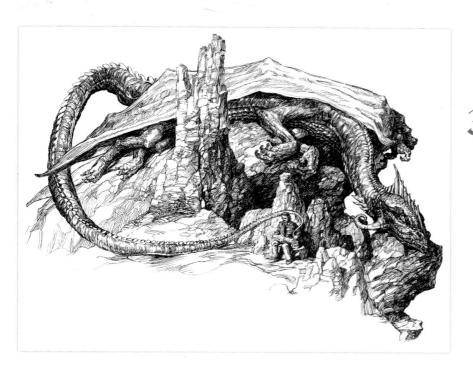

3 *Finishing the Ink Drawing*
Between the pencil and the finished ink, many things change. Changing the tail helped the flow and lifting it made it seem as if the dragon was having an involuntary reaction to getting his tail dunked in ink. Since few people use an inkwell anymore, using the rules of political cartooning, I wrote ink on it to make it obvious. Speaking of political cartoons, you'll see some of the finest examples of inking in newspapers. They continue to carry on the great tradition of inking that you see little of in more current books and magazines.

COMPARING PENCIL TO PEN

Although you lose the subtle qualities in the pencil drawing, you pick up a bit of the ability of the ink lines to show volumetric form. The inking of the dragon's scales and the turns within the rock follow their forms. Note the light and dark masses in the ink drawing. Our brains expect to see them because we see them in nature.

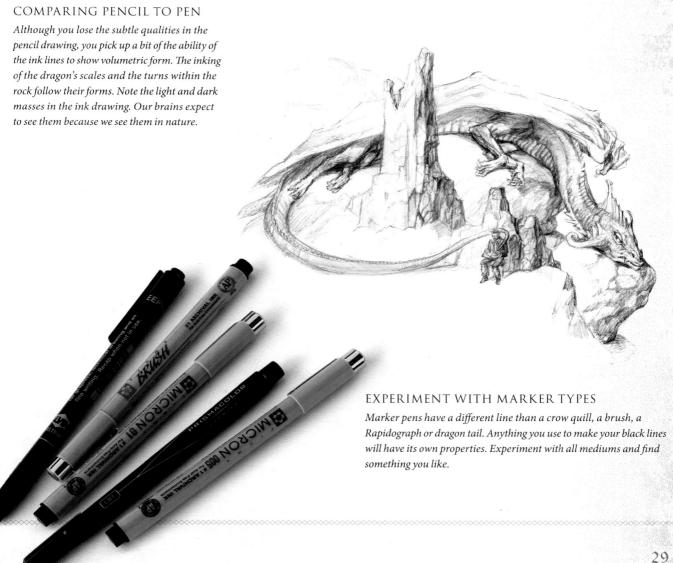

EXPERIMENT WITH MARKER TYPES

Marker pens have a different line than a crow quill, a brush, a Rapidograph or dragon tail. Anything you use to make your black lines will have its own properties. Experiment with all mediums and find something you like.

BECOME A STUDENT OF NATURE

A landscape artist needs to be in touch with the rhythm of nature. Having a sense of what's right and what feels wrong will go a long way in making great paintings. Look around. Everything is made up of somewhat large areas of lights, large areas of midtones and large areas of darks. As I look out my window, I see a group of trees that make up the dark mass, grass that makes a midtone and the sky that's a big, light area. Each area has its own texture or pattern to it. For example, the pattern for deciduous trees is different than the pattern for coniferous trees. Identify simple, less-complicated areas in nature, then focus on their complexities. The grass outside my window is simple, but with texture. Likewise the sky is simple, but has clouds (but sadly no airship, though I can add one using my imagination).

So when studying nature look for tonal masses—areas of light against large areas of dark—as well as repeating textures; large, simple areas and small areas of greater complexity. If you keep all of this in mind when you paint or draw, you'll get more pleasant results.

STUDY THE SIMPLE THINGS IN NATURE (ABOVE)

As this young student is doing, always listen to the professional wisdom of nature. Understanding the world around you will yield great rewards when later painting from the imagination.

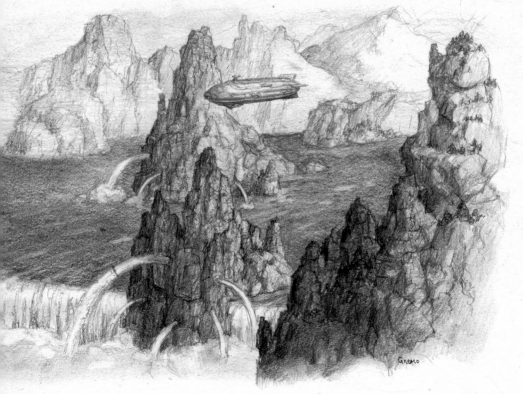

UNDERSTANDING THE BASICS OF WATER (LEFT)

Water is an important subject in nature. Understanding it will help you extrapolate things that don't exist. This porous rock forms natural fountains that spray out from hollows underneath.

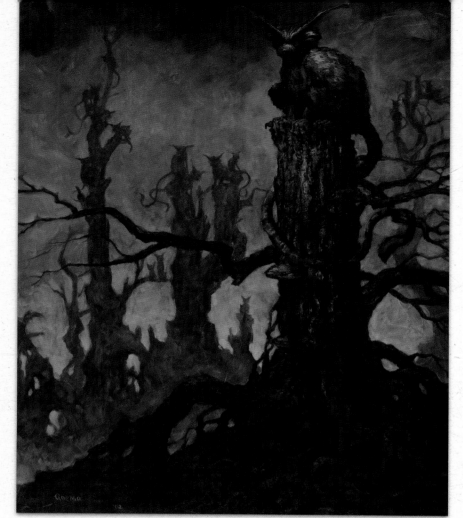

STUDY THE EARTH'S HISTORY

A basic understanding of how evolution works will help you come up with some interesting creatures. This one has evolved to use radar to see and communicate because it has lived in near darkness and fog most of its life.

STUDY NATURE BY PAINTING OUTSIDE

As often as you can, paint from nature. When out walking or driving, scout out future locations to paint and always bring your paints and drawing supplies when on vacation. The best thing about outdoor painting is that it brings you directly in contact with nature. You can walk up on your subject to study it. If you're not working from photography, you'll be seeing the full dimensionality of your subject. It's also a good time to study how the light changes as the day goes on.

Painting Outdoors

Plein air painting is a popular activity for artists, but for a fantasy artist this activity is a way to study nature, to observe keenly how it all works. Try both full landscapes and studies of the things around you. All the time you're painting you'll want to be thinking about the structure of things and how you can reinterpret that structure into fantastic scenery.

Tools for Outdoor Painting

A few nice things you'll want to bring when painting outdoors are a lightweight chair, an umbrella if direct light hits the painting, suntan lotion, a big hat and insect repellent. A French easel is important if you're outdoors painting regularly. All of these items can be found online and bought through companies that specialize in this equipment.

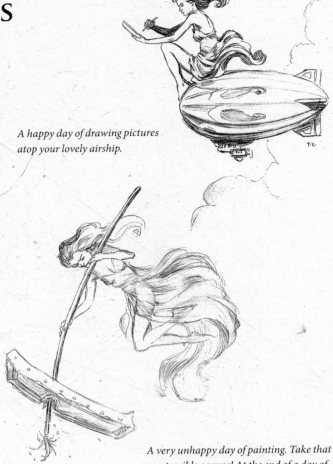

A happy day of drawing pictures atop your lovely airship.

A very unhappy day of painting. Take that you terrible canvas! At the end of a day of painting you may be delighted with your results or ready to impale your painting with your brush. But before you do that, try to remember the paint will dry and tomorrow is filled with potential.

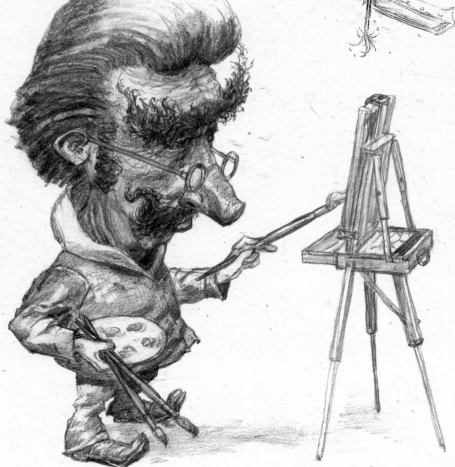

FRENCH EASEL

Outdoor painting will require a portable easel like the one this massively eyebrowed gentleman is using. It folds up into a briefcase for easy transport. Just make sure you stabilize it on the ground if you are painting in windy conditions.

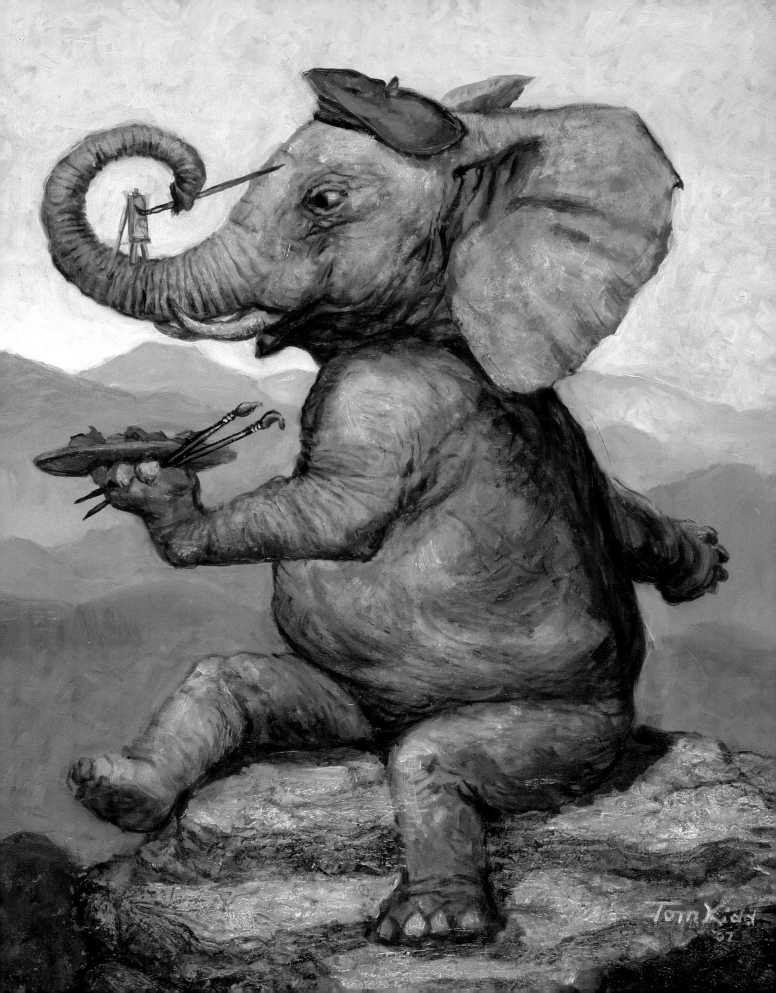

THE BASICS OF LIGHT

What could be simpler than saying "The angle of reflection equals the angle of incidence" in explaining how light works? Although true, we can't leave it with Newtonian physics alone because all that bouncing light makes imagining how a scene will look a challenging and rewarding task. It takes a massive amount of computer power to create a fully lit scene in a movie, but your brain can make quick work of it.

When dealing with a single light source like the sun or a moon, an object is made up of a lit side, a side in shadow, the light that bounces from a nearby object and whatever ambient light (light bouncing in from everywhere) makes its way into the shadow side. The lit side of an object reflects more light back into the eye. The smooth areas of an object will reflect back specular highlights, for example, the bright specs on an illuminated cue ball.

How the Eye Perceives Light

Your instincts will play a big role in how you perceive light, but it's good to understand some basic principles. The human eye is a tiny hole that allows in a minuscule amount of the light. There's tremendously more light bouncing around, missing you or reaching your body and bouncing off of it than you're seeing through the pupils in your eyes. The eye only sees what happens to reflect into your pupil. If all the light in a dimly lit room went into your eye, you'd be blinded.

Your iris expands and contracts to adjust the amount of light your eye takes in. Because your eyes adjust, a dimly lit scene won't necessarily require darker pigments when you paint it. Dim light can be accurately depicted with a shift in color rather than overall value.

Painting Different Surfaces

All surfaces are mirrors. How they reflect light depends on how smooth they are, or more accurately, how the molecules are aligned so they work in unison to reflect light in the same direction. A matte surface is a bunch of microscopic broken mirrors reflecting light in a wide number of directions. This means that the matte surface reflects light back to the eye in a diffused manner. For an artist it simply means that there won't be highlights.

Surfaces can be a mixture of both of these forms. The upper layer can be clear and glossy with a matte surface beneath. Anything wet, oily or varnished can fall into this category. A specular highlight is a mirror reflection off a surface. You're literally seeing a reflection of the light source. A matte surface won't have specular highlights. Most tree trunks, rocks, cotton garments and soil fall into this category and do not have these highlights unless wet. You can see specular highlights in many types of leaves, in some fruits and certainly in water. When you imagine an object or creature, be aware of what creates its light and dark areas.

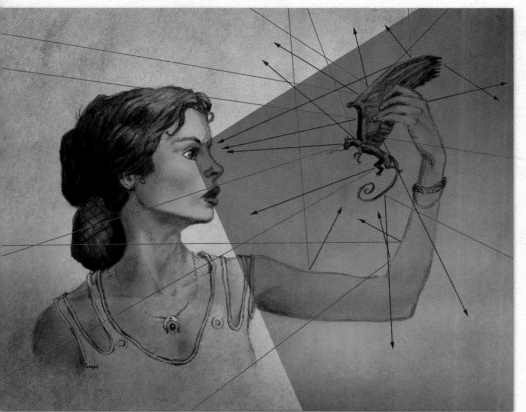

LIGHT BOUNCES IN ALL DIRECTIONS

The blue lines represent incoming diffused light, the green lines represent that light reflected and the red cone is the field of vision. Most light is reflected away from the eye. Despite the flatness of this graphic, light always comes in and bounces back in all three dimensions.

Texture and Volume

You want to give a sense of volume, but you don't want to push it to the point it looks fake. Sometimes all you need is light and shadow or little hints that a surface is turning from you. Imagine the repeated textures of a rock or tree trunk as a checkerboard. If you were to wrap this checkerboard around a tree or rock, the perfect squares will thin or become more rectangular when the edge of the tree or rock turns from you. If the light source is somewhere behind you, the edge turning from you usually reflects a little less light back. It depends on the surface.

Types of Surfaces

Before you begin a scene that you've imagined, it's a good idea to know the types of surfaces you'll be placing in the composition. These could be matte, smooth, matte with smooth a layer over it like water, or a flat smooth surface that has edges sticking up. An example of the latter could be a rock after it rains. The water holds to the surface giving a darker color (because more light is reflected away from the eye), and it may now have highlights.

Ambient Light: It's Everywhere

Direct light, bounced light and ambient light make up what we see. It's a good idea to separate them to help in imagining a potential fantasy scene. Direct light coming from a sun or a moon will be opposite the shadowed area and the cast shadow of an object. Bounced light comes in a little less directly than direct light. Its value is diminished because it gets spread out and some of the light is absorbed. For example, light bounced off a cream-colored wall will reflect back a deeper warm (somewhat orange) light. The shadow side of an object near it will pick up this warm light.

The important part in understanding ambient light is its color. If you're outside in the morning or evening, you'll notice that shadows tend to be bluer than areas in direct light. As the light from the sun enters our atmosphere, the blue spectrum is diffused and ends up filling shadows. This is the case on sunny days but not so on overcast days or foggy days when even the direct light is somewhat diffused. Consider ambient light when you paint. Shadows should typically shift towards the overall color of the sky. I've seen shadows turn a dull pink on foggy days as the sun sets. It's quite eerie.

Rim Light and Bounced Light

There's much more light in the world than we see. One such special light example is rim light. The edge of an object lit somewhat from behind will burn out to a silvery white. This is because as the light hits obliquely, more of it is reflected into your eye than you see when it hits the side facing you. When light hits the front of an object, the light is more greatly scattered so that less of it reaches your eye. Even if you set up two lights, one behind an object and one in front and make sure the one behind is less intense, it will still create the burnout effect making it seem that the light from behind is the more powerful one. All of this is important to take into account when making up the light in your imaginative paintings.

Unless an object is a perfect mirror or perfectly white it is absorbing some light. You can think of all objects as light vacuums. Each is holding some light and not releasing it. Trees cast diffused shadows even on overcast days and the leaves of a forest grab up so much light it can make it dark on a sunny day at noon. This rule applies to all objects. The larger the ins and outs of a surface area the more light it absorbs.

REFLECTED LIGHT
ADDS COLOR TO SHADOWS

The mirror surface of water can add warm color into shadows where you usually don't find it. Note how a moist surface can become a semi-mirror surface. This is what's shifting the otherwise dry bricks that are cast in blue to a violet color along the edge of the water.

EXAMPLE OF BACKLIGHTING

Though a camera has a difficult time photographing a subject lit from behind, an artist can capture this quality of light easily. When light hits a matte surfaced object obliquely (on edge), more light will make it to the eye causing the burnout effect you can also see in photographs. For instance, if you throw a small stone straight down into the water, it sinks. If you throw it at the water obliquely, it can bounce or skip off the surface. Notice how the smooth surfaces of the robot insect are reflecting the blue sky, the yellow sun and the green grass. The backlit leaves are a bright green because of the light passing through them.

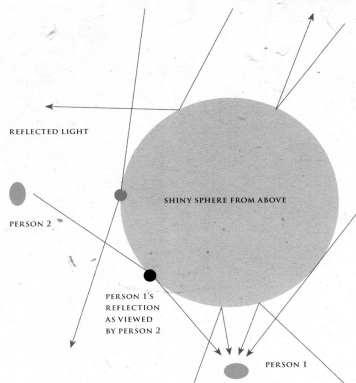

REFLECTED LIGHT

REFLECTED LIGHT

SHINY SPHERE FROM ABOVE

PERSON 2

PERSON 1'S
REFLECTION
AS VIEWED
BY PERSON 2

PERSON 1

UNDERSTANDING REFLECTIVE LIGHT

This graphic illustrates how you'd see an object's image on a reflective surface. The lines with arrows represent the angle of incident (how light reflects off a surface) and the subsequent angle of reflection. The green ovals represent person 1 and person 2. The orange dot is where person 1 sees her own reflection. The green dot represents where person 2 sees the reflection of person 1 on the sphere.

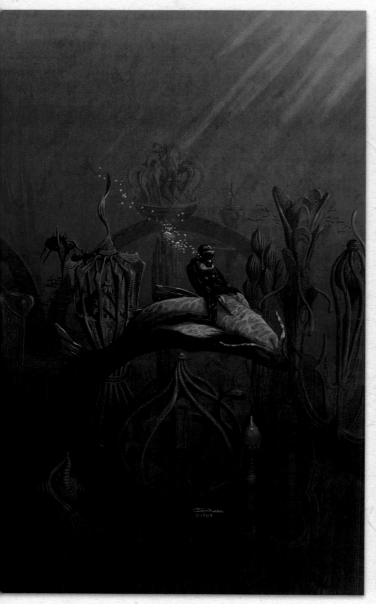

EXAMPLE OF REFRACTED LIGHT

In this piece titled Dialog with Darkness, *refracted light streaks through the water. Refracted light creates the uneven color along the fish creature.*

INCANDESCENT OBJECTS HEAT UP AND GIVE OFF LIGHT

Here, light comes from two sources: a mirror surface reflects light, and incandescent objects (ones that give off their own light). In this case, the flowing lava is reflected. Once an object heats up enough, it gives off light. Lava, like fire, follows the rule of white in the center, to yellow, to orange and then to red as the melted rock cools along its edges.

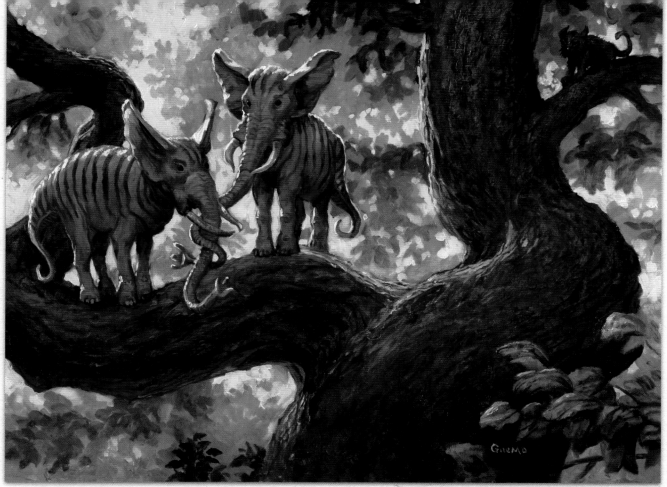

THE PRINCIPLES OF LIGHT
APPLY IN ALL REALMS

The marsulephants creatures (arboreal pachy-
derms) above do not exist, at least not on our
world. However, they do obey the same laws
of light as objects do on earth. This picture uses
ambient light, mirror reflecting objects (leaves),
the matte surface of the tree and rim created
by light from behind.

ATMOSPHERIC PERSPECTIVE

Atmospheric perspective is how the eye sees
an object based on impurities in the atmo-
sphere. This photo illustrates the extreme
atmospheric perspective caused by morning
fog. The trees in the background have less
contrast and recede because of the diffused
water particles in the air.

ROCKS AND BOUNCED LIGHT

Here light from below bounces up and warms the side of the rock surface that's
in shadow and facing you. Compare it to the rocks in the foreground that are lit
by direct light from the sun. The shadow cast by the rock on the ground in front
is cool because of the light-blue ambient light coming from the sky. Bounced light
is always a subtractive phenomenon so its brightness will be less than direct light.

THE PRACTICAL MAGIC OF COLOR

Color helps the eye distinguish between objects. By knowing that color is a tool for seeing better, you can apply it in a practical way to a painting. Color is also a way to highlight a subject or direct the viewer's eye to something important, after lights and darks. Plants attract the attention of bees by giving their flowers bright colors. The examples here illustrate what color can bring to a pencil drawing.

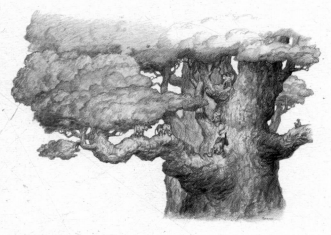

Use Color to Convey Mood & Time of Day

Blues tend to be relaxing, grays depressing, reds denote heat or violence and bright colors either happy or disturbing. It all depends on how the color is arranged. The colors you see early or late in the day have warmly lit areas and long blue shadows. Under dark clouds the world takes on muted colors and soft shadows. Dominant cool colors mean that the sun has set and night is on its way. In terms of mood, color is a bit interpretive.

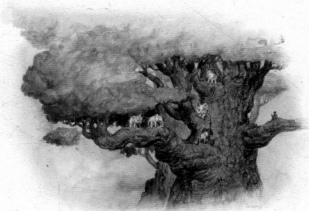

Paintings as Poetry

I believe it's appropriate to think of your paintings as poems. Color will help you create worlds of light, form, depth and movement. With color you can convey any sense of touch, weight, smell, temperature or pain. In these days of full computer animation with words, sound and action, a single painting, a simple arrangement of light and color feels like poetry. It is poetry in the sense that it can still communicate a great deal within its humble constitution.

DEFINE SUBJECTS WITH COLOR

In this pencil sketch of arboreal pachyderms in their habitat, the elements in the picture are not easy to perceive. Once color is added, the white pachyderms and little fellow sketching on the branch pop out of the scene.

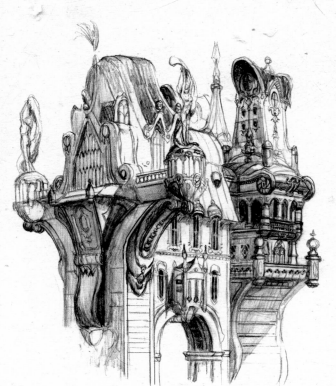

COLOR HELPS DISTINGUISH FORM

Watercolors are perfect for vignettes like Peale's Palace, art that has no borders and fades at its edges. That's why this medium was chosen for this painting over oils. Coloring the ornate Peale's Palace is almost like guilding the lily, but color helps relax the eye as it helps define objects. Warms and cools strengthen its form by defining light and shadow. This palace is filled with the oddest collection of oddities.

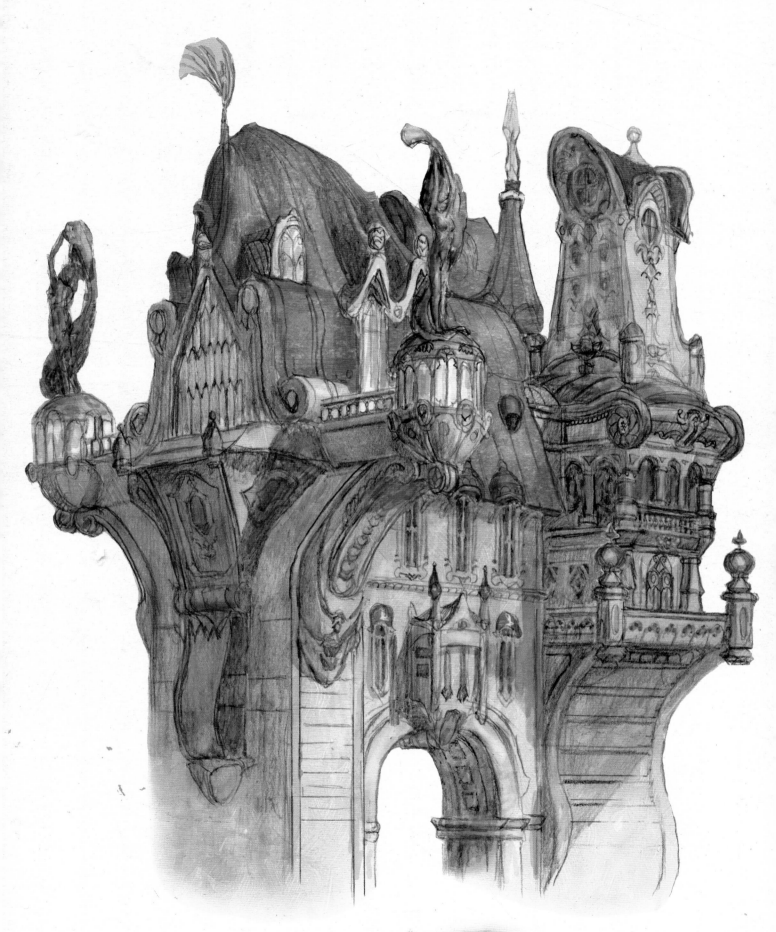

Digital Coloring

Like watercolor, you can also color a drawing quickly by working on a computer. Digital coloring is more forgiving than a medium like watercolor and enables you to do as many versions as you wish. Programmers have created many effects, textures and brushes to help you mimic the natural and unique character of paint. If it's something you want to try, go online and check out some of the free tutorials to help you figure out where to begin. There have been scores of books devoted to Photoshop and other digital coloring software for people of all skill levels. It's best to try your hand at various mediums to see what works for you.

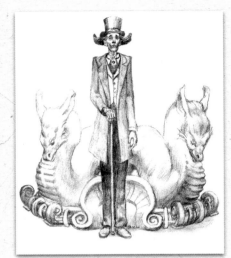

SCAN YOUR ORIGINAL SKETCH

Here's my original sketch of Jeeves. He's an amalgam of memories I have of many different people. Photo references of people are also helpful in creating fantasy characters.

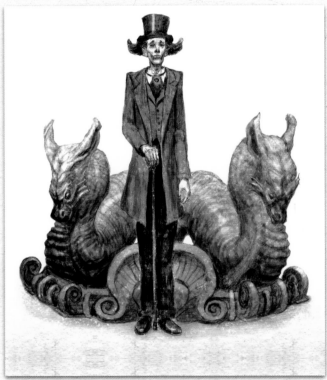

INSERTING FAUX TEXTURE

Scan texturally interesting parts of your paintings into Photoshop and add a layer of color to your image. This is similar to a watercolor, but it's perfectly transparent unlike watercolors. This is because your computer screen is incandescent light. Colors don't rely on a natural substance that are chosen by their permanency (not fading) and how close they are to pure colors. Because of the perfect colors you're using on a computer, they will give the effect of absolute transparency not found in true watercolors.

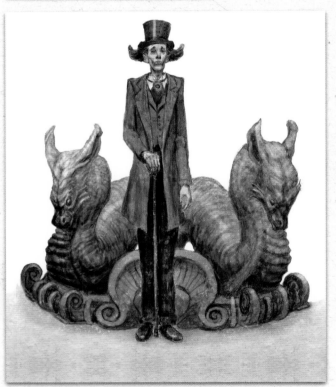

PAINTING WITH MULTIPLY LAYERS

On a drawing tablet such as a Wacom, set your tools to work in a pressure sensitive mode. Take a large scan of a section of a painting you've done and import it into Photoshop, drag it onto a previously scanned drawing and make it a multiply layer. From there you can set the paintbrush, rubber stamp or pencil to "Multiply" as well. Color this way or shift colors by selecting an area and adjusting Color Balance or Hue and Saturation. To adjust your values and tones, use dodge, burn or the eraser.

SHOOTING REFERENCE PHOTOS

If you're going to be a fantasy artist, you'll need to learn to make things up—even the human figure. That may make little sense, but you really can't understand the figure without visualizing it in your head. Many of the people you see in the paintings in this book come only from my mind. However, I do shoot reference for many things as well. If you're going take a photographic reference for a figure, do as detailed a drawing of the figure before you take your picture. It's always good to check and see if you got things right by referring to nature. Working back and forth from memory (your initial drawing) will improve your understanding of the figure. Here are a few tips for shooting reference:

- Use a digital camera so you can take many shots at numerous exposures and angles.
- Take close-ups of hands and faces separately from the full pose. The hands and heads are so full of expression that it'll take some time to pose them correctly, and the body is likely to move out of position as you do this.
- Don't use the flash to get a natural looking light.
- Shoot outdoors for outdoor reference even if you later take some more controlled shots inside. I have light stands that I use to set up for inside shots.

Working With Models

The pose is more important than how the model looks. If you understand the human form, it's easier to change a person's features and proportions while painting. Some people have a better sense of what position they're in and can look at a sketch and follow it exactly. Some people are terrible at this. Often you'll need to directly position your models or create a situation so they'll respond accordingly. A model may have to hold a pose for a few minutes that, in real life, would last a second. They will feel unnatural doing this. You may have to find supports for them to keep from falling over or take sectional shots of the body. Working with models can be hard work and often frustrating. The better you know the human figure, the better you'll be able to think it all through before you take your pictures.

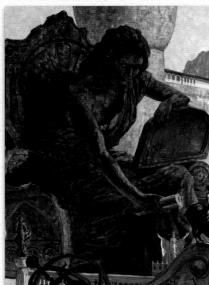

SHOOTING HUMANS FOR REFERENCE

These reference shots were taken for the sculpture in the painting Piranesi on page 186–187. When depicting fabric, I tend to use reference more. I shot a separate shot of tight folds in a skirt, different from the full figure photograph. An artist can easily meld together elements like this when she paints.

PART TWO

2

Techniques, Theory & Subject Matter

WARM AND COOL COLORS

The world is made of warms and cools—some extreme, some subtle. Color depends on its surroundings, so a cool color in one painting may look warm in another. If you're outdoors, direct light is usually warm, and ambient light tends toward cool. We have a psychological predisposition to sense yellow, red and orange as warm and blue, purple and violet as cool. Greens, violets and browns are able to be both warm and cool.

Little sparkling bits of color in a painting can serve a decorative purpose, but a careful use of warm and cool masses is an important compositional device. Sometimes they can be part of compositional masses, or they can work independently to make for a pleasant composition or control what the viewer sees first, second, third or last.

COLOR TEMPERATURE

Here is an extreme range of warms and cools. If you master how they fit together, you'll be able to create a natural environment that elicits the emotional response that fits the narrative of your painting. Note how green and purple can be both warm and cool. This depends on the colors near them.

CLOUDS SHOW THE COLOR OF THE LIGHT

White clouds are the perfect reflectors of the warmth of direct light and the cools you typically see in shadows.

COOL

COOL & WARM

WARM

WARMER

WARMEST

COOL & WARM

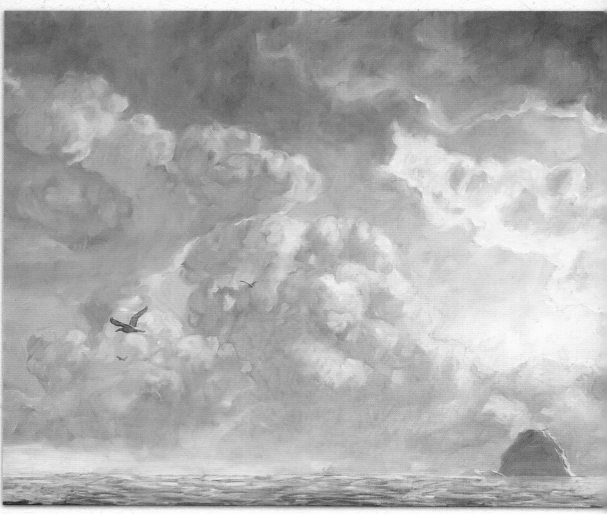

MORNING WARMTH

Here, green is used as both a warm and a cool color. As the top of the sky, a cooler green, merges with the bottom coming closer to the rising sun, it becomes much warmer. Because the ambient light (i.e., diffused light) is a mixture of all the colors in the sky (blue-green, green and orange), it fills shadows with a somewhat warm (orangeish) green. This makes for warmer shadows that you'd get if the sky were mostly blue.

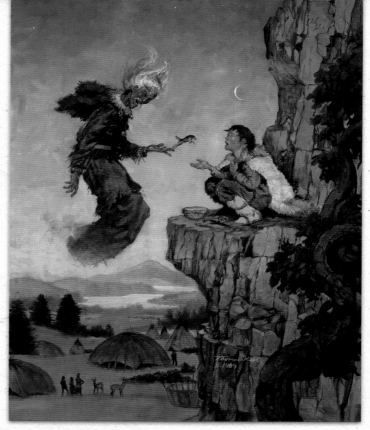

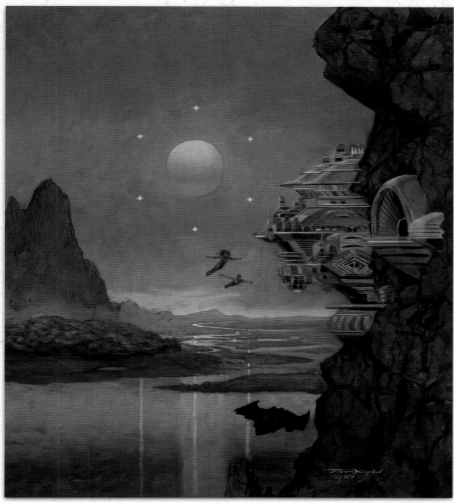

ALIEN WORLD, EARTHLY LIGHTING RULES

The dominant colors in this painting are cool and subdued. That makes the yellow of the sun even stronger.

EXAMPLES OF COLOR TEMPERATURE

EXAMPLE 1: RED
IS EYE-CATCHING

Although there are two giant figures in this painting, the red man is the most powerful in terms of color temperature.

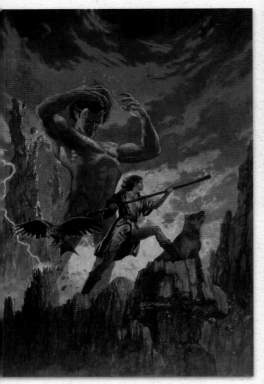

EXAMPLE 2: THERE ARE
NO ABSOLUTE COLORS

Our eyes perceive individual colors based on light intensity and adjacent colors, so a color in a painting can easily seem like a different color depending on its neighboring colors. Here, the deep maroon recedes while the light green of the demon pops forward. However, the same basic green against the yellow in the warrior lady's costume seems cool with deep yellow surrounding it.

EXAMPLE 3: RELATIVITY OF COLOR

The strange colors reflect the alien qualities of this world. Compare the green of the big-eyed creatures to the green in example 5 on the opposite page. Here it is used in the foreground as a warmer mass; it's the opposite in 5.

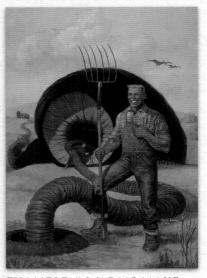

EXAMPLE 4: WARMS MAKE
GRAYS AND BLACK TONES
COOLER

Here, the black tone acts as a cool color in the form of a giant oil-drilling worm. It sits back in the background to help the farmer stand out.

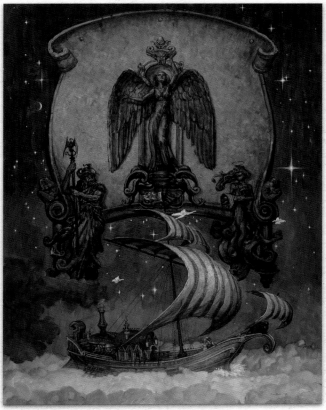

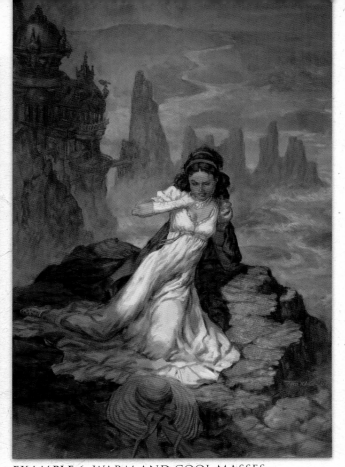

EXAMPLE 5: PUT A SPOTLIGHT ON YOUR SUBJECT

In a theater the spotlight follows around the lead actor or actors to draw attention to them. You can do the same thing with your paintings. Here I've made the ship stand out by putting it in warm light as if a shaft of light has reflected onto it. This happens in nature when light peeks through on a gap in clouds on a cloudy day.

EXAMPLE 6: WARM AND COOL MASSES

The three main colors here are yellow, red and green. They form two distinct masses—the girl and rock, and the background—to keep this busy painting fairly simple.

EXAMPLE 7: WARM AND COOL GREENS

The greens found in nature can be both warm and cool. Notice how nicely the dark trees frame the light green ones.

EXAMPLE 8: NATURE'S COLORS IN THE SKY

Look to the sky to see light being split into warms and cools.

49

LAYERS AND AERIAL PERSPECTIVE

My hair puffs up big on humid days. When your hair is straight one day and frizzes up the next, you need no hygrometer to know the moisture content of the air.

You can see humidity in the form of atmospheric perspective, which is how depth is perceived in nature as enhanced by impurities in the atmosphere. Objects appear lighter in value, detail and contrast as they recede as a result of the air between the viewer and subject. Dust is a component of this phenomenon but water is its main cause. Water in the air reflects back the ambient light.

On earth, because of the blue sky, shadows will move toward a blue color in most cases. But depending on the ambient light of a scene, sometimes highlights and middle tones go darker. This is most evident with clouds whose whites shift toward a warmer color in the distance. I've seen shadows shift toward a number of colors. It depends largely on what the ambient color is. Although most days will be similar in their aerial qualities to the next days, others will be distinctly different. We humans tend to fall into a pattern and don't notice differences in color, but as an artist you'll want to keep an eye out for the unusual, if not unique, days.

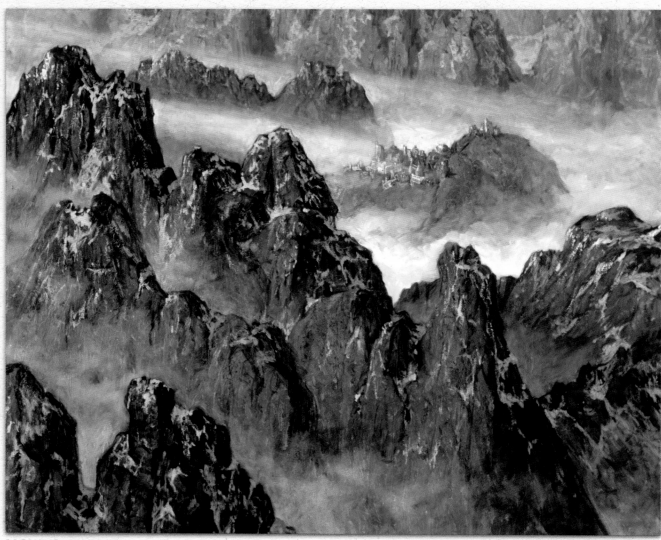

LIGHT CAN OBSCURE TO CREATE MYSTERY

Mists and mountains go together creating wonderful ethereal quality. The more light there is on water molecules in the air, the more opaque they become. Notice how the direct light of the early morning sun is warmer and obscures more of what's behind it.

Distant clouds tend to shift toward red. You'll readily see this on airplane flights. The red shift is caused by the blue in the light being filtered out into the atmosphere and not because of atmospheric particles. This is caused by the Rayleigh scatter, which is how the atmosphere scatters cooler light (blues) and allows warmer light (reds and yellows) to shoot more directly through. It's also what turns a sunset orange and tends to make the sky blue.

Adding mist or smoke in the air is a nice way to create layers to separate the subjects and establish a sense of depth in your fantasy paintings. Atmospheric perspective used with certain colors can help to establish a mood as well.

OVERLAP STRONG SUBJECTS WITH AERIAL PERSPECTIVE

Aerial perspective is a nice way to overlap strong subjects and still keep them distinct. Here the blimp is hidden behind a veil of mist so it drops into the background helping to pop forward the Valkyrie maiden.

ATMOSPHERIC PERSPECTIVE VIEWED FROM A HEIGHT

In this muted scene, the fire on the ship stands out from the ancient city on a misty day. The early morning mist softens and pushes back the city beneath. The orange of the ship's cannon fire makes it through the mist because the colors are less diffused. The orange color also draws the attention of the viewer.

LIGHT OBSCURES OBJECTS IN ATMOSPHERIC PERSPECTIVE (OPPOSITE PAGE)

The more light you have, the more the natural mist in the air will obscure something. It's the clouds' shadows that make things more visible by blocking light. Without them more of the background would be washed out. Also, note how the distant clouds shift to red. This is caused by the blue in the light being filtered out into the atmosphere by the Rayleigh scatter.

ATMOSPHERIC PERSPECTIVE IN PEN AND INK

Effectively separate the foreground from background in a pen and ink drawing by creating solid darks in the foreground and keeping your shadows light in the background.

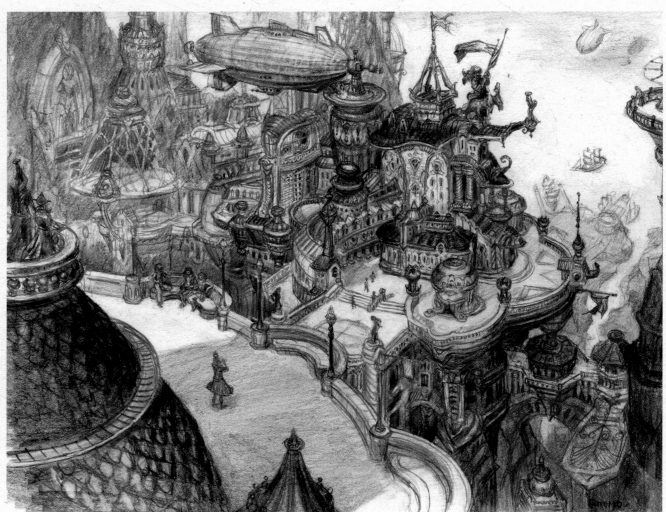

USING ATMOSPHERIC PERSPECTIVE TO SIMPLIFY A SCENE

Atmospheric perspective will help complicated subjects read as levels and help simplify your composition.

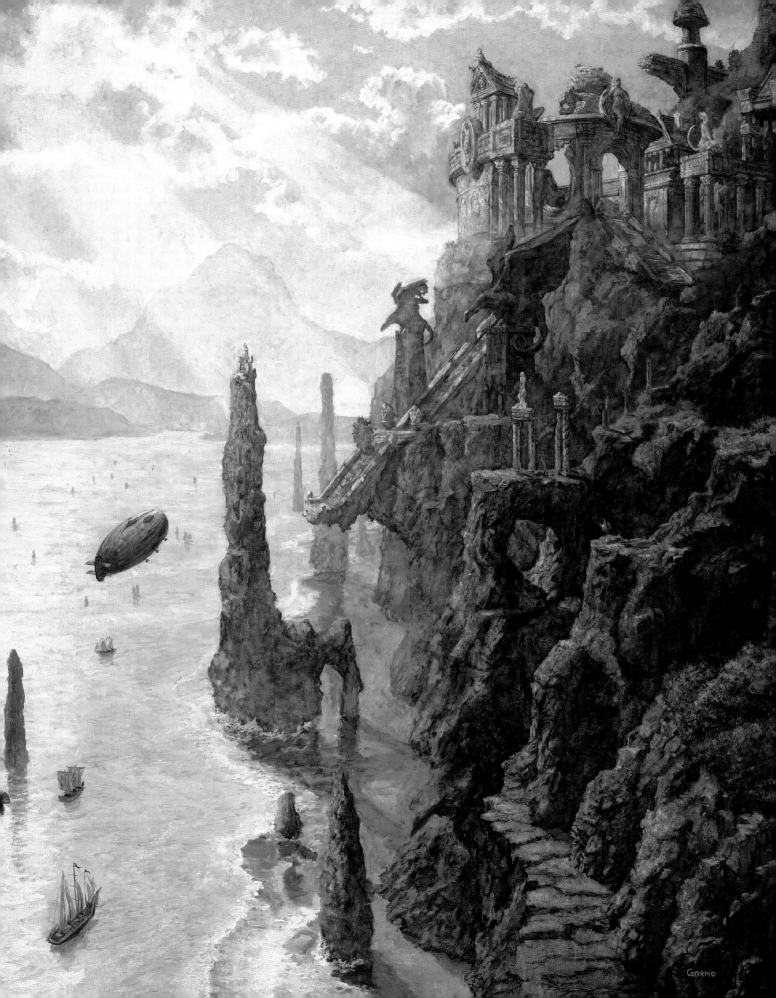

Dragon Pass

Materials

SURFACE

Fabriano Artistico
watercolor paper

WATERCOLORS

Burnt Umber
Indian Yellow
Manganese Blue
Manganese Blue Hue
Payne's Gray
Permanent Rose
Phthalo Blue
Phthalo Green
Raw Umber
Titanium White (Opaque)

BRUSHES

1½–3-inch (38–76mm) sable flats
no. 1 sable round

TOOLS

HB pencil
Sketch paper
Kneaded eraser
Rag

Though the majority of the art in this book is oil, watercolor is also a lovely medium to work with to achieve pleasant melodies of color. When working in watercolor, you want to plan ahead and work from light to dark to create texture and a sense of atmospheric perspective.

1 *Finding the Right Scene with Idea Sketches*
Use an HB pencil to sketch your ideas. If your sketch lines get too dark, press into the darker areas with a kneaded eraser to lift up some of the pencil.

There are many different ways an idea can be drawn. Here you can change how close you are to the dragon, what level you're viewing it from, its pose, the time of day or adjust your relative position on the planet's axis. Each drawing will have its own feeling. It's all a matter of what you want to emphasize more than it is a matter of aesthetics.

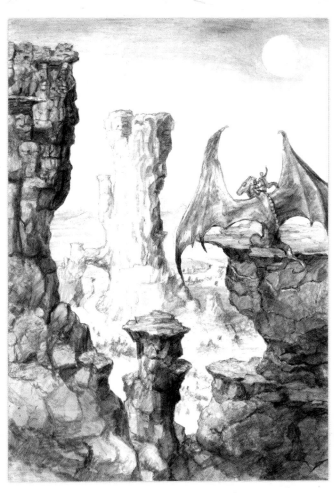

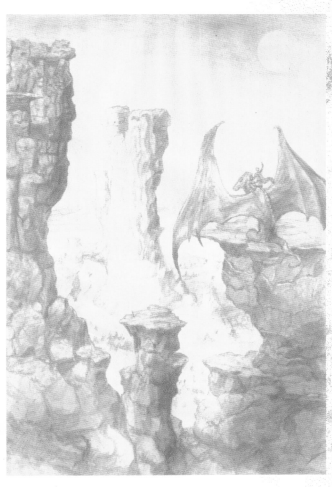

2 Sketch your Final Drawing Lightly

Unlike oil painting, watercolor is done over a detailed pencil drawing. Because watercolor is a transparent medium, the drawing will easily show through, serving both as a guide for painting and as a means to show texture. Make sure your final idea sketch is light enough to paint over.

3 Lay in a Yellow Wash

Using Indian Yellow place a yellow wash over the entire surface using a 3-inch (76mm) wide sable flat. The paper may have some wrinkle to it, but it will flatten with time. This yellow wash is intended to give the painting a subtle yellow shift with the other paint that you layer on top.

LET NATURE GUIDE YOU

The thing that's great about watercolor is that, on its own, it makes intricate forms. It'd be crazy to fight this tendency because it gives your painting character as well as mimics the forms you find in nature. You can certainly make watercolor do exactly what you want and create perfect gradations, but you'll find that your painting will be more interesting if you follow where the paint leads you.

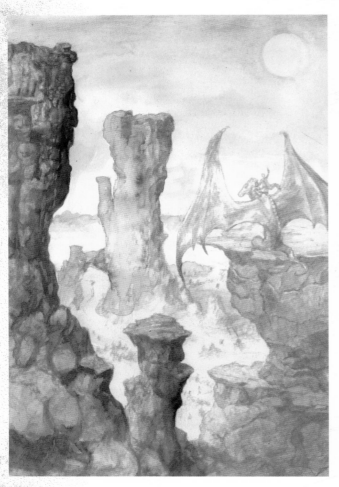

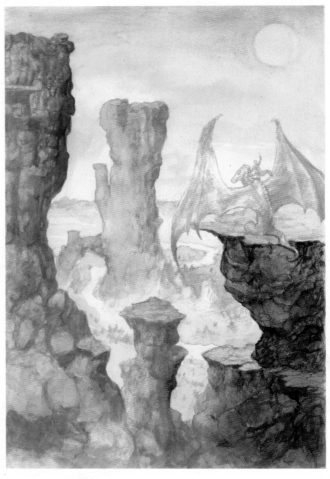

4 *Lay in the Sky & Rocks*

Lay a thin layer of watered-down Phthalo Blue into the sky area with a wide soft brush moving back and forth left to right. Let the paint flow a bit unevenly as if it's a bit hazy in the sky. The Phthalo Blue will shift toward green because it'll mix with the yellow ground.

Brush in a layer of water to the rock forms. While moist, apply a layer of Burnt Umber to achieve soft edges to the rocks. By painting wet-into-wet, the paint will naturally flow to the edges of the water and form a sharp-looking edge when the water evaporates. This happens because of the water's high surface tension. If you want to create a sharp edge with watercolor, let the water bead up some so the color flows to the bead's edge leaving an edge to it. If you want to make an area softer, lightly rub it with a moist brush, rag or finger.

5 *Soften Edges With a Rag*

While the surface is wet, mix Manganese Blue into the umbers of the distant pinnacle and rocks to variegate the colors and create some atmospheric perspective. Mix Indian Yellow, Phthalo Green and Permanent Rose to make a warm green and place dabs here and there with your sable round to create bits of moss and vegetation that cling to the rocks. The blue picks up some of the yellow from the initial wash and shifts toward green to help enhance the atmospheric perspective.

When you move a watercolor brush across watercolor paper, the paint readily leaves the brush to the absorbent paper. You can't scrape away the paint or use it thickly as you can with oil paint. However, you can blend or wipe away some of the watercolor after it dries. This can be done to correct mistakes but primarily it's done to give the paint even more character. The easiest way to do this is to wipe it with a moist rag. Allow the paint to create all kinds of interesting effects and later keep the ones you want and wipe down the ones you think are too ostentatious.

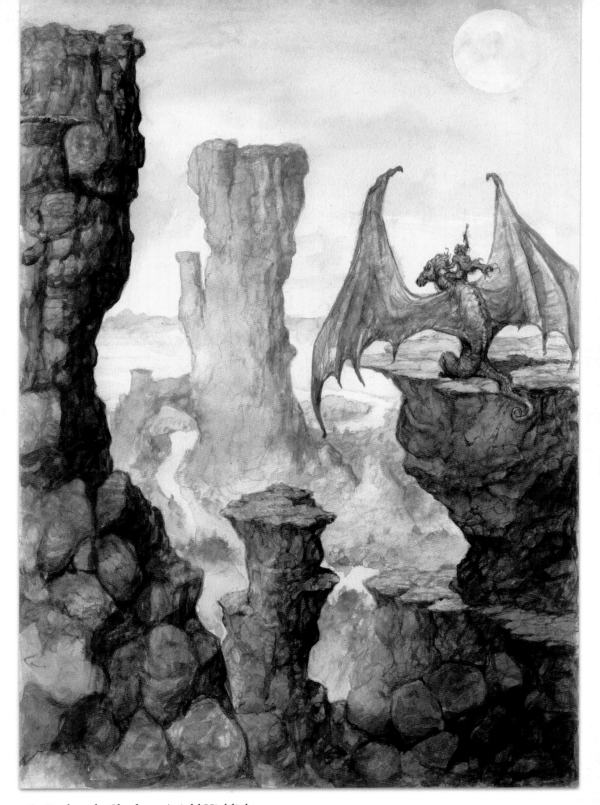

6 Darken the Shadows & Add Highlights

Use a sable on its edge and crisscross strokes to create more layers of watercolor. Create a mixture of Payne's Gray and Raw Umber for the shadow in the foreground. Use Manganese Blue Hue for the shadows in the distance. Add the final highlights opaquely with Titanium White. Although it may feel like cheating, there's no rule that says you cannot work opaquely with watercolor. It's best to save such opaque details for the end to take advantage of the wonderful properties of this medium.

Distant Tanks

Materials

SURFACE
Gessoed Masonite board

OIL COLORS
Burnt Sienna
Burnt Umber
Cadmium Orange
Cadmium Yellow
Cerúlean Blue
Flake White
Italian Burnt Sienna
Manganese Violet
Orange Ochre
Payne's Gray
Phthalo Blue
Raw Umber
Stil De Grain
Titatium White (alkyd)
Ultramarine Blue
Veronese Green

BRUSHES
no. 8 bristle
nos. 6–8 sable brights

TOOLS
HB pencil
Sketch paper
Liquid medium or linseed oil
Adobe Photoshop
Rag

Everything is relative, perhaps in life, but certainly in a painting. Colors seem different to us depending on the colors that are next to them or perceptually change based on the dominant colors in a painting. In short, every element in a painting depends on all the other elements to work. Unless you're painting abstractly, your painting is some sort of narrative. It may not be an intricately plotted novel, but it certainly has the potential to spark the viewer's imagination. As an illustrator you'll want to communicate your ideas well. Knowing how to use contrasting elements, such as atmospheric perspective, will be an important tool in accomplishing this. The task here is to paint a giant authoritarian tank. This massive weapon is a robotic peacekeeper whose presence is meant to intimidate, but its bite is just as terrible as its bark.

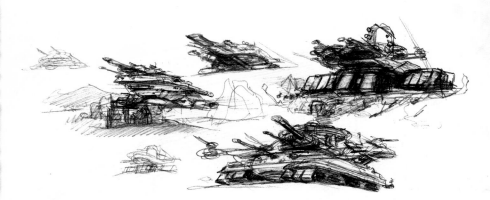

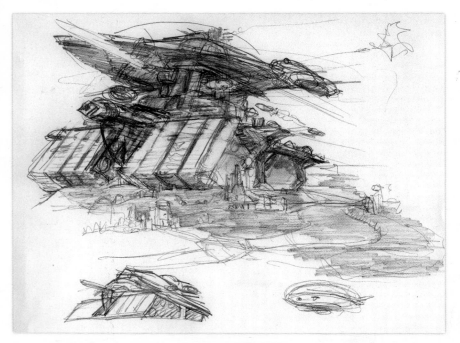

1 Thumbnail Sketches
Sketch a few quick thumbnails to understand the details of the tank—at this stage, the messier the better. Finding your way largely means finding the direction you *don't* want to go in.

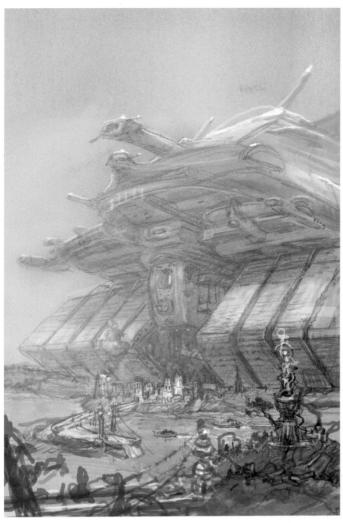

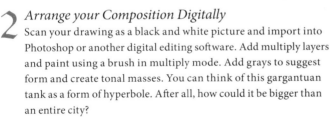

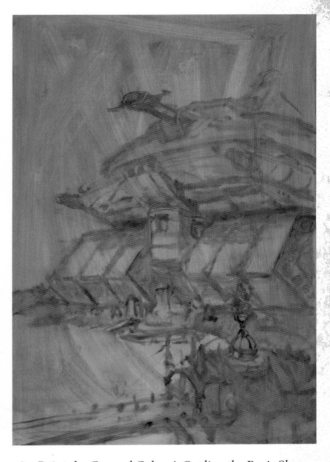

2 *Arrange your Composition Digitally*
Scan your drawing as a black and white picture and import into Photoshop or another digital editing software. Add multiply layers and paint using a brush in multiply mode. Add grays to suggest form and create tonal masses. You can think of this gargantuan tank as a form of hyperbole. After all, how could it be bigger than an entire city?

3 *Paint the Ground Color & Outline the Basic Shapes*
Coat the entire surface with a watered-down mixture of acrylic Burnt Sienna and Burnt Umber. Let it dry thoroughly, at least an hour, then cover the ground color in drying linseed oil, Liquin or a combination of painting mediums. Wipe the clear medium with a rag until a very light layer remains. Experiment on drying times and come up with a mixture that suits your painting style and speed. Wipe away the medium until you have an even, thin layer and then begin outlining the tank's shapes with a no. 8 bristle and Burnt Umber and Manganese Violet. Use a no. 8 sable bright for finer details. Control your shading by using more or less paint on your brush and painting gently into the medium.

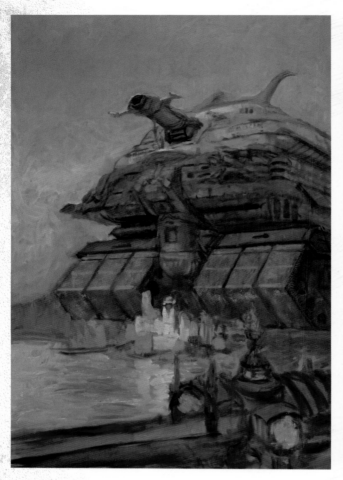

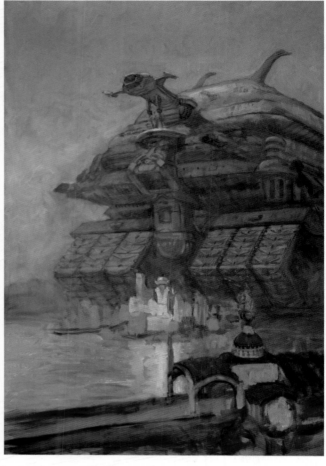

4 *Block in the Midtones*

Although this is a scene in the far future, this tank is already ancient. It's not a newly minted shiny ingénue. It is distinctly battle fatigued. Repeat the process of putting down your medium over the full surface. Paint in the basic shapes with Phthalo Blue, Italian Burnt Sienna mixed with some Ultramarine Blue, and Payne's Gray. To create your basic shapes you need to put in shadows. Paint in darker values with Phthalo Blue, Italian Burnt Sienna (mixed with some Ultramarine Blue) and Payne's Gray.

Use your brushes to add or take away paint in interesting ways. Give the tank a beaten look by mottling the surface with your brush creating a patchy effect.

5 *Continue Painting the Tank & City*

Add a translucent blue mixture of Cerulean Blue and Flake White to the tank. Although lit by the same light as the city, the tank shifts more toward the ambient color (i.e., the dominant color of the overall sky from horizon to horizon) because it is further in the background. In this case it's blue. That shift in color makes the city stand out even more.

Lay in the city using Titanium White, Orange Ochre and Stil de Grain, and plan to use brighter colors later. Use nos. 6, 7 and 8 soft, sable brights and paint thinly on a smooth, moist surface. Introduce Veronese Green and Titanium White to the bridge to warm it against the blue of the water. Since the bridge is in ruins, paint it to allow some of the underpainting to show through. This will give it the feeling of an aged surface.

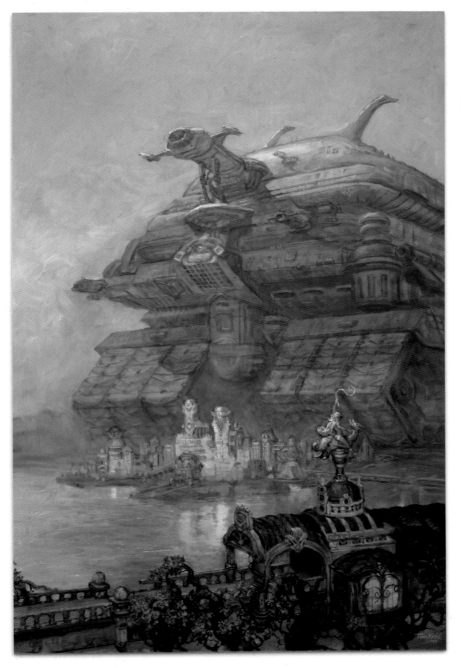

6 *Add Finishing Details*
Paint the final details of the tank using sable brights with sharp edges and sable rounds for the smallest highlights and curving filigrees on the bridge. The darks in the foreground are made with a mixture of Ultramarine Blue and Raw Umber. The brightest parts of the neglected city in the middle of the painting are Cadmium Yellow and Cadmium Orange. Place your white highlights by scooping up big gobs of Titanium White (use alkyd because it's gooey and dries fast) with a touch of Cadmium Yellow mixed in and touching them to the surface so you have a lifted or thick highlight.

The three elements on their distinct planes tell a story. These are three levels of contrasting areas that complement each other in color, tone and emotional content. As an artist, you can separate them out in a discrete manner. In the foreground is the dark mass, the dilapidated ornate bridge shows us this was once a place of artistic beauty but has become neglected. The vestiges of a once-great, possibly abandoned city shine as the light-toned mass in the middle ground. The midtoned towering tank looms over it all. We're not sure what action it will take. This is a mystery.

CREATE INTERESTING TEXTURE WITH EVERYDAY MATERIALS

Look around for interesting textural surfaces to press into the paint such as fabric, dry bread or rubber. If you find a particularly good surface that can't be pressed into the paint, press clay or a kneaded eraser into the surface to stamp the pattern and then press it into the paint. Anything you don't like can be painted out. Experiment with textures early in the painting to avoid messing up your detail work.

COMPOSITIONAL MASSING

Tonal masses occur naturally. These large areas of lights and darks are important tools for the fantasy illustrator. Use the tonal masses of a scene to draw the viewer's eye to the areas of the painting you want given the most attention. A common mistake of beginner artists is composing a scene by subject. Too often we think in terms of objects by what they are and then place them about: trees here, rocks there, people standing there. That's a mistake. A painting's composition should contain light values, middle values and dark values dealt with abstractly.

Whatever type of painting you do, you're creating a narrative. This narrative can have a multitude of layers in both story and subject matter. Compositional massing is an effective way to have your subject layers and your story layers work together to best communicate your thoughts in a visual way. Compositional massing is essentially the arrangement of a scene's light, middle and dark tonal masses. If your main area of interest is a light value, the area behind it should be dark and vice versa. You should always be thinking of how these tonal masses can help your subject instead of the importance of your subject on its own. A careful use of tonal massing can make up for the lack of depth by bringing objects forward or pushing objects back. By using tonal masses effectively, you can make a cowering mouse more important than a towering, fire-spitting demon. When you mix successful compositional massing with a strong use of warms and cools, your fantasy paintings will only benefit.

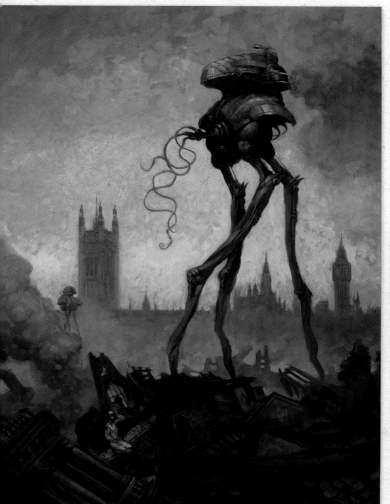

MAKE SIMPLE SHAPES WITH YOUR MASSES
The dark mass of the Martian war machine and foreground rubble form an L-shape. If you turn the painting counterclockwise at 90 degrees, the lighter mass forms an E-shape.

SOFT TONAL MASSES (OPPOSITE PAGE)
The middle tone of the castle covers the right third of this painting as a block. It's cut in half by the strong dark mass of charging horses carried through with the dark drawbridge. Although there's a great deal of action and detail present, the majority of the composition maintains a quiet feeling because of the midtonal masses. The light bouncing back from the rock in the foreground and back up onto the bridge creates a secondary shadow from the structural column.

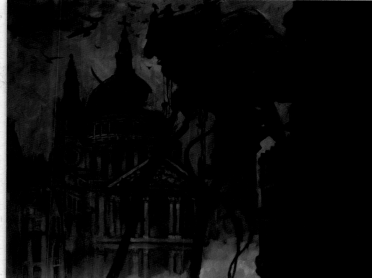

DARK TONAL MASSES DENOTE STRENGTH
Use black where you want to make the strongest statement. Here the background recedes because of atmospheric perspective creating a secondary mass behind the foreground's black forms.

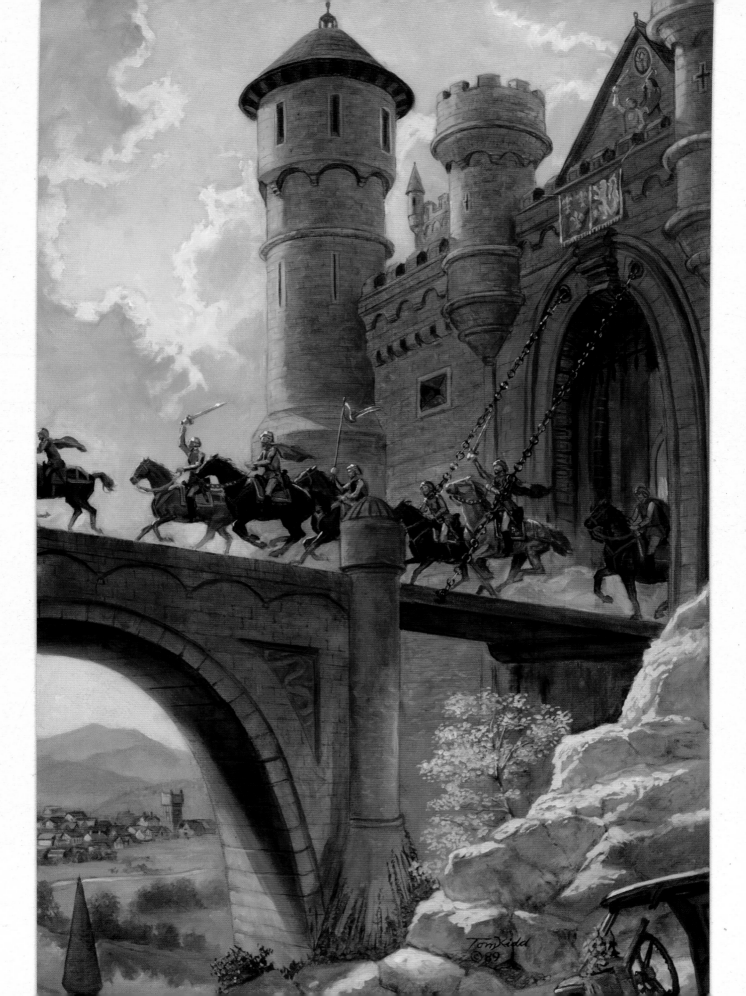

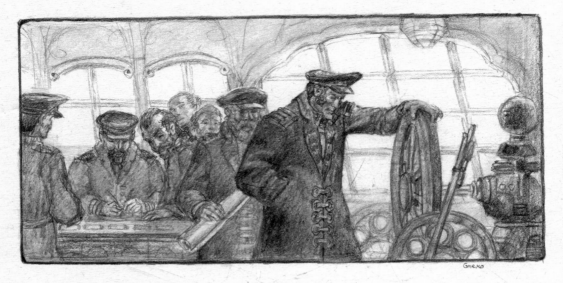

DRAMA WITH LIGHT & ATMOSPHERIC PERSPECTIVE

This gondola is lit by bright light coming from the windows in the background. This partially silhouettes the airship captain placing him as the main visual mass. Anytime something appears in front of an incandescent light or something significantly brighter, our eyes will see it as a bit darker and with less contrast. The crew is viewed almost as one object. The captain at the wheel stands out a bit from everyone else for the sake of drama and metaphorical interpretation. He's the center of attention and is pondering something serious while his crew is working hard to provide him with the best information for that decision. Will they stay with their mission or will they turn back?

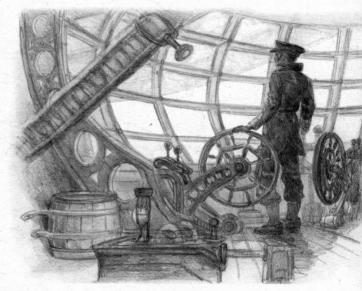

WINDOW LIGHT

On this calm day, a pilot stands surveying the aerial beauty in front of him. The captain's silhouette is a bit darker and bits of rim lighting are evident here and there. There is only one source of light coming from the windows that lights the entire scene.

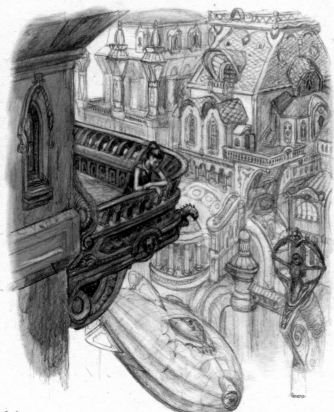

USING SHADOWS TO SEPARATE FORM

This is a complicated drawing that has been simplified using tonal masses. The building in the foreground is in shadow to help separate it from the city scene below. Note how the woman leaning over the balcony stands out from the dark balcony because of her light skin tone. When color is introduced, the foreground building will shift toward blue, the dominant shadow color, and the buildings in the distance will be warmly lit.

64

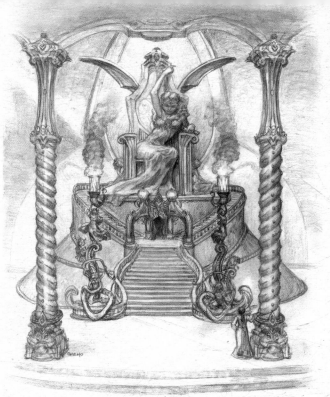

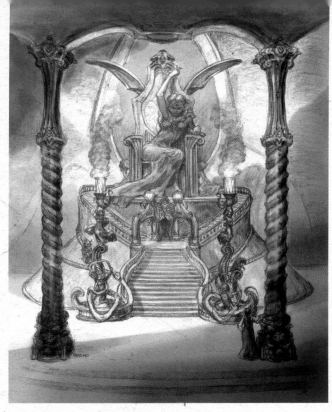

USING PHOTOSHOP TO ADD TONAL MASSING

Sometimes tonal massing is overlooked when you are sketching out the details of a painting. If this happens, you can always work out your masses later when you add paint or in Photoshop. In the original drawing at far left, many of the elements are fighting with each other for attention. I used Photoshop to soften the contrast in the background, darken the foreground and add some shadows. Improving the tonal massing added some mystery to the picture.

TONAL MASSES IN NATURE

Don't feel as if you're doing something unnatural by creating tonal masses to enhance your fantasy paintings. These everyday photographs illustrate it happens in nature, too. 1) The people standing in the backlit snow scene are framed as tonal masses in a similar way to the airship pilot on a calm day on the previous page. 2) If you blur your eyes slightly while looking at the picture of the castle, you see how the ground is one big dark mass separate from the sky and water. 3) This image is lit similarly to the castle/city scene on the previous page. The tonal mass of the foreground building is in shadow and forms a clear separation between the well-lit background.

ACTION MASSING

Often details can distract from the main thrust of a painting. Using massing is a way to eliminate those distractions. Avoid ubiquitously placing too many small areas of great contrast around the painting. The example below has only three basic tonal layers that correspond to the action. Notice how the greatest contrast is centered on Hercules while the foreground is a low-contrast dark area and the background is a low-contrast light area.

TONAL MASSES IN A BATTLE SCENE

There's a lot going on in this painting. There are twists and turns in all directions. It is, after all, a battle against a multi-headed Hydra. The composition remains simple because the foreground elements are basically a dark triangular mass.

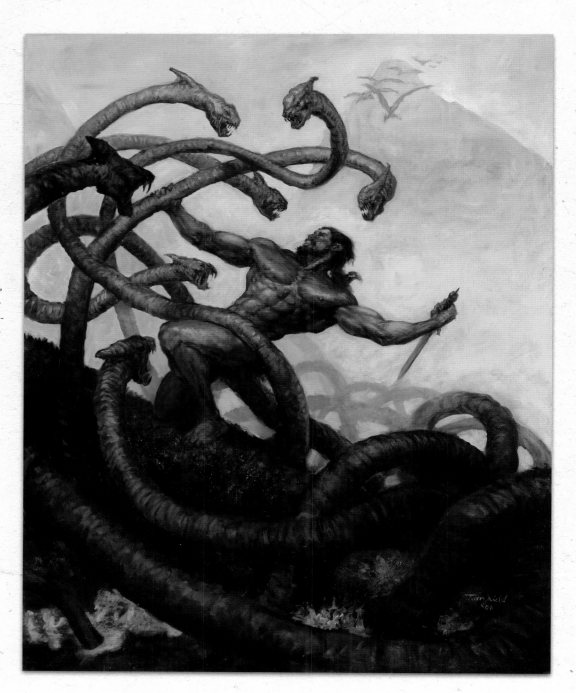

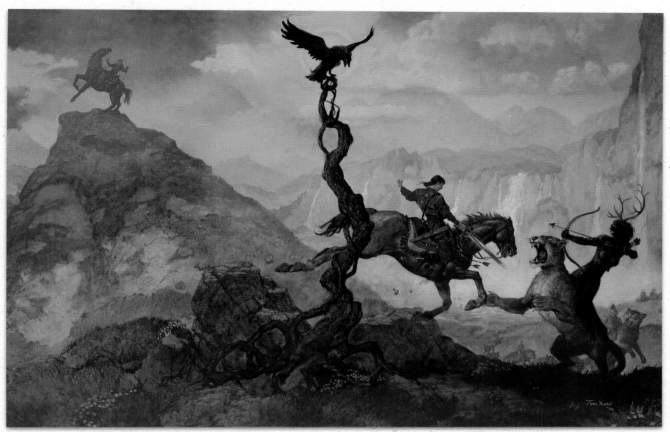

LAYERING MULTIPLE MASSES

You can create as many tonal masses as you like as long as they're simple and they exist on their own visual layer. Here we have mountains in the distant far background, some faded green hills in front of the mountains, a cliff side with a waterfall, a rocky outcrop and, finally, the main action scene. By anchoring the main action visually to the ground, as with the battle scene on the previous page, you can give the action the classic feeling of a sculpture.

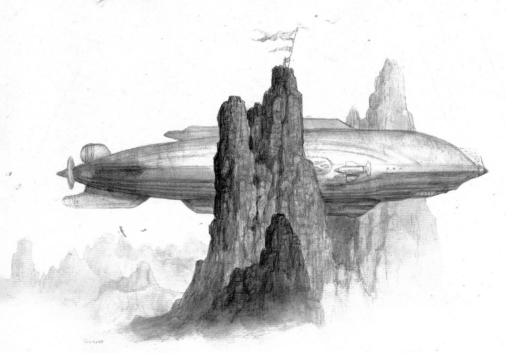

COMPLEMENTING MASSES

Perpendicular masses complement each other. Here the horizontal airship penetrates the vertical rock formations. Try mentally simplifying this into a horizontal cylinder and three long vertical blocks for the purpose of feeling the masses.

Mood

Among the many things to consider before beginning a painting is mood. You'll want to elicit some feeling in the viewer. Among your tools for doing this are color, light source, shadows, shapes and time of day.

Take a moment to go beyond the examples on the next few pages and then flip through this book. You'll find that almost every painting reflects some mood. Think of your paintings as scenes from a Greek opera. Allow the emotions of your characters to affect their surroundings. As an imaginative artist, all the elements of nature are at your command to elicit a feeling from the viewer.

If you want mystery, use dark somber colors and long mysterious light wells. Backlighting something softly produces a romantic feeling. A single oddly placed light source will give your viewer an uneasy feeling. Study how nature affects your own mood and use that knowledge in your paintings.

The shape of objects can also communicate a mood. Soft curves and balance are both relaxing while hard angled edges tend to put a person on edge. Throwing a picture out of balance will throw the viewer off balance or help produce a sense of movement. Conversely, perfect symmetry will stand out as an oddity in a painting.

Taking things in and out of focus and leaving out details is an effective way to give something a mystical feel to something. The rules of reality can be ignored for the greater need to elicit a feeling with your art.

Even texture will add an undercurrent of feeling to the painting, either physical texture, visual texture or the way paint is handled.

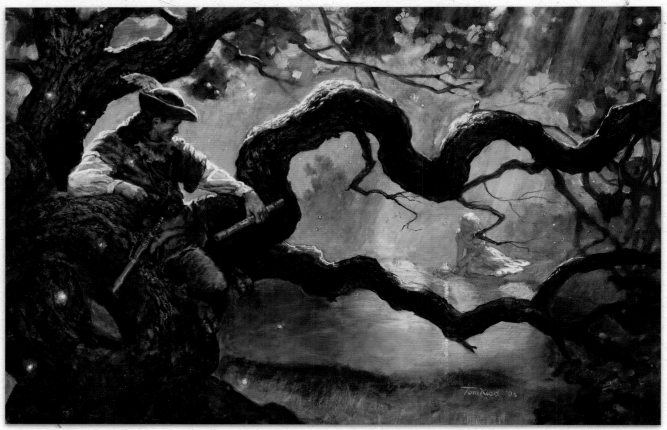

ROMANTIC MOOD

Here the romance of moonlight filters through tree leaves. The softness of the object in this picture and the halo off of the white rim lighting add to the romantic mood. Backlighting can make people and objects feel more ethereal. There's a bit of mystery to this painting because of the glowing lights floating around. You can mix your moods to great effect.

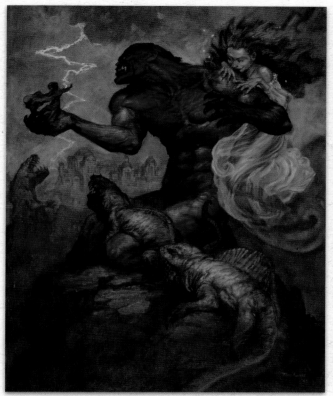

THREATENING MOOD

This is an example of the odd coloration of a dark, foreboding fantasy world. The deep reds enhance the anger expressed in the demon's face. His fury has made him so hot that the coolness of the ice lady in blue causes steam to rise from his shoulder. If you want a foreboding mood, go dark and misty. The sharp angles of the lightning also help create a sense of violence.

EERIE MOOD

The warm colors of firelight contrast with the cool blues of a starless night and, in the distance, the eerie green fire coming from a castle. Firelight from below casts ghostly shadows on your subjects. This is perfect light for an incantation.

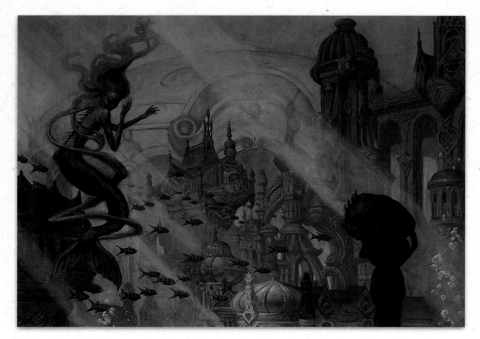

MYSTERIOUS MOOD

The dominating cool colors found deep in the ocean with warm streaks of light coming from the surface.

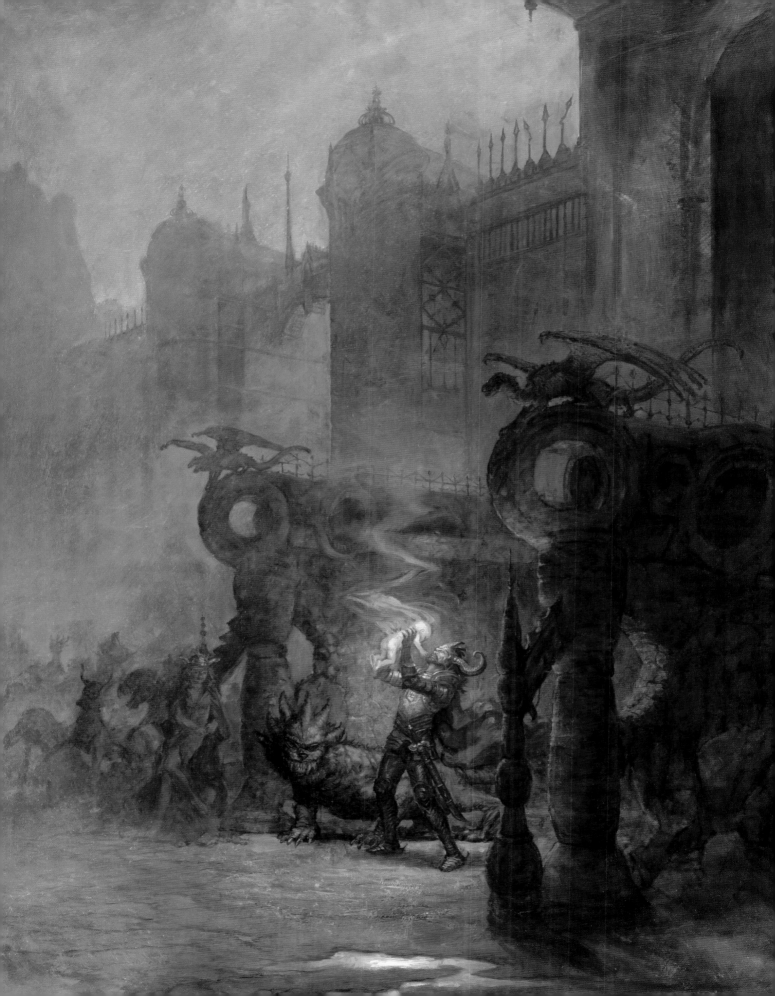

DANGEROUS/DISTURBING MOOD (OPPOSITE PAGE)

Starting clockwise from the left is a foggy world of monsters, demons and magical glowing babies. Cool colors have largely taken a vacation with only a few showing through. The ambient light comes largely from artificial light coming from within the unusual castle. The yellowish greens are abnormal to earth colors and are a bit disturbing.

EERIE MOODS IN NATURE

In this photograph, it's clear that the earthly world can also have some eerie coloration such as this pink, winter sky.

UPLIFTING MOOD

There's nothing more uplifting than seeing the sun break through the clouds. It denotes the end to a storm. Anytime you use the colors of a pleasant day in a scene you'll elicit an uplifting mood even when the subject matter is unearthly in nature. Create a file of pictures with a variety of moods and the emotions they evoke in you when you look at them. Refer back to them when trying to create a particular mood.

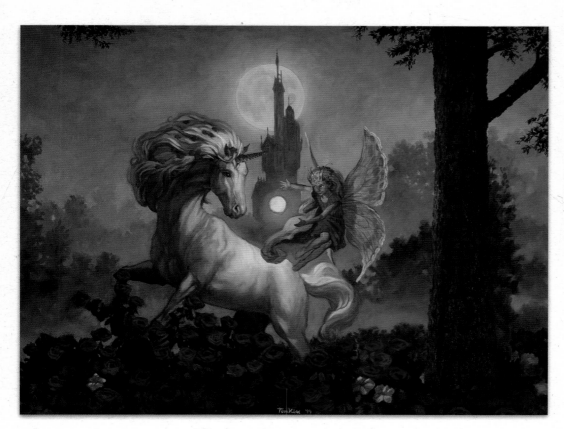

PLAYFUL MOOD

Here, the most playful colors—pinks, reds, blues, yellows and purples—show the fun time the fairy and unicorn are having as they frolic on a moonlit night.

Hamlet's Garden

Materials

SURFACE
Gessoed Masonite board

ACRYLIC COLORS
Phthalo Green

OIL COLORS
Burnt Sienna
Burnt Umber
Cadmium Red
Cadmium Yellow
Crimson Lake
Flake White
Indian Yellow
Ochre
Payne's Gray
Permanent Rose
Titanium White
Transparent White
Turquoise
Ultramarine Blue
Ultramarine Violet
Viridian

BRUSHES
4-inch (10cm) sponge brush
nos. 10–12 bristles
nos. 6–8 sable brights

TOOLS
HB pencil
Linseed oil
Sketch paper
Adobe Photoshop
Rag

The aesthetics of man and nature meet in the garden. People tend to put things in an orderly geometric manner, but nature's order always wins out over time. The threefold plan with this painting is to create a natural environment, to tell a story and to create a mysterious mood. This is a book cover and as you would expect from a book, it has a narrative and so will the painting, albeit a subtle one to avoid giving away the plot. Before beginning, there are editorial concerns to be addressed, mainly what will be painted. Let the sketching begin.

1 Sketch your Ideas

The best way to zero in on an idea is to do a number of sketches. There are hundreds of considerations for a cover that are only editorial. Simply put, a sketch may make a very nice painting but still not be right for a particular book. All of the sketches shown on these two pages are a combination of pencil and Photoshop to establish gray tones.

2 Selecting a Figure that Fits the Story

Even when an idea is settled on, there may be a small element that can make a major difference in how the picture is perceived. You can isolate out that element and try different solutions. In this case the element is a shadowy figure standing in an archway. Here are the choices; the last was deemed best for the book cover.

A YOUNG MAN ENTERING THE GARDEN INTENT ON SOMETHING EVIL WASN'T QUITE RIGHT.

SOMEONE RUNNING AWAY, ALTHOUGH INDICATIVE OF A CRIME, FELT TOO CONTRIVED.

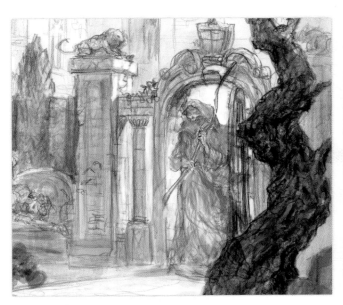

THE SPECTRE OF DEATH, ALTHOUGH CLASSIC, WAS A BIT OVERTLY SYMBOLIC FOR THIS PAINTING'S STORY.

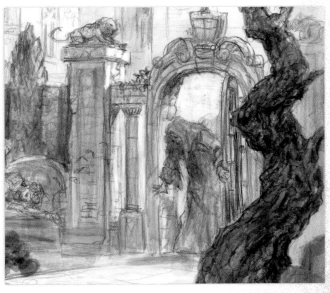

I SETTLED ON A HAUNTING FIGURE OF QUESTIONABLE ORIGIN. IT COULD BE A SPECTRE OF DEATH, A HUMBLE GARDENER OR PERHAPS AN ELDERLY MONK.

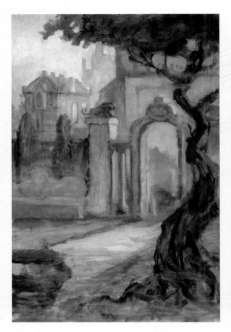

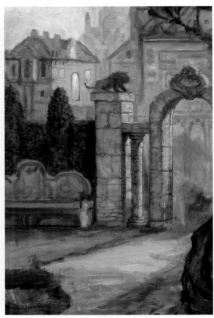

3 *Lay in the Ground Color*

Lay the ground color on gessoed Masonite board with watered-down acrylic Phthalo Green using any big soft brush you have such as a 4-inch (10cm) sponge brush. In this case the ground color hardly matters because the patina in this painting will come more from how the paint is handled.

4 *Lay in Forms & Color*

Put in your basic forms with Burnt Umber starting with bigger bristle brushes for big forms (nos. 10 to 12) and then use sable brights (nos. 6 to 8) for further details. While the Burnt Umber guides are still wet, add the main colors Viridian, Ochre, Cadmium Yellow, Ultramarine Blue, Ultramarine Violet and Titanium White. Within a couple of hours you should have something that looks like an impressionist painting. To change the forms push into light colors with dark colors and into dark colors with light colors. Keep things as textural and impressionistic as you can. Working this way will keep you from being distracted by details and help you establish the most important part of the scene: mood.

5 *Add Detail*

Your plan from here on is to add information to the painting without destroying the mood. This isn't a simple task because detail often distracts from the mood. Make sure your first layer is dry, then dunk a rag or paper towel in drying linseed oil and rub it across the painting. Then take a dry rag and wipe away any excess. It's usually best to work from the back of the painting forward because each session of painting will obscure a bit of what's underneath. Because this is a misty morning, you want to give objects in the distance less contrast than those in the foreground. It's important not to over-render here but if you do, you can go back and change it. Working into the linseed oil medium will make your paint go on easily. You can even blend into it as you would blend two colors together.

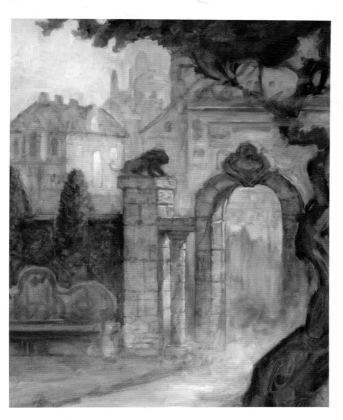

6 Correct the Contrast

Lay down a thin layer of fast-drying linseed oil so you'll have a clear surface to blend into. Using a soft sable, glaze in semiopaque color (also called semitransparent or translucent) to lessen the contrast in the distance and add mist. This type of paint will allow some of what's beneath to show through depending on how thick it's applied. Use a soft sable brush for this. You will need three whites—opaque (Titanium), translucent (Flake) and nearly transparent (Transparent)—mixed individually with a little Indian Yellow. Use Titanium White where the mist is thickest, Flake White where it's medium-thick and Transparent White at its thinnest. Mix the whites to achieve the in-between mist tones. You can also begin with Titanium White and feather outward with Flake or Transparent White.

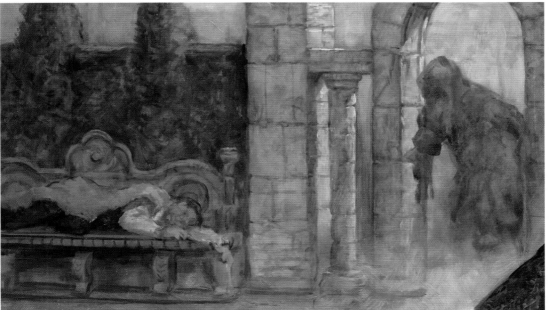

7 Populate the Painting

It's best to paint the large areas of your scene to establish the mood before you add any figures. If you paint a figure first, the environment will have to be adjusted to fit the figure. Because the environment is more important to this painting, the figures are best put in later but not too late. Like the garden in step 4, lay in the form of the figures and then place the basic colors in—Payne's Gray for the ghostly figure, and Ochre, Cadmium Red, Viridian, Burnt Sienna and Titanium White for the reclining figure. While this layer is still wet, add some basic shadows for form using a mixture of Burnt Umber and Payne's Gray. You'll be coming back to add more form and detail later.

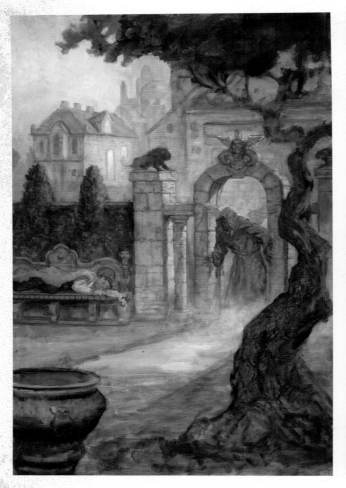

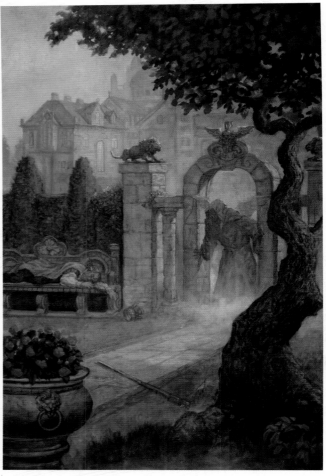

8 Paint the Shadows & Arch Details

Paint the shadows in this shadowy figure with a mixture of Titanium White, Burnt Sienna and Ultramarine Blue. The backlit area of the figure is a mixture of Burnt Umber and Turquoise. Paint the shadows a little darker than you intend them to be and then use a lighter mixture to brighten them. This helps variegate the color and keep it interesting. Glaze Ochre in transparently to brighten and backlight the tree's leaves.

Allow your mind to wander as you work to see things happening in the paint. It may seem obvious now that the ghostly figure standing at the entry to the garden should be a bit transparent, but the thought came well into the painting process.

9 Add Detail to Foreground

Paint the flowers in the flowerpot first. Paint the leaves in the flowerpot using Viridian, Ultramarine Blue, Titanium White and a touch of Burnt Sienna. While this is wet, add shadows and a bit of form with a mixture of Phthalo Green and Burnt Umber. Take a rag and remove some of the green where you want to paint the flowers. To paint the flowers, dab in Permanent Rose mixed with Titanium White to create irregular forms. Add shadows and more form into the flowers with a mixture of Crimson Lake and a touch of Burnt Umber.

10 Make the Final Adjustments (opposite page)

Always expect some loss of mood when you add detail but still do your best to avoid it. Add some details and forms in the vase's flowers as well as highlights to the vase. By working in layers you can add detail on top of detail as many times as you like. Mix the brightest green with transparent Phthalo Green and transparent Indian Yellow. Because leaves arrange themselves at all angles, their reflection color may vary. Backlit leaves are the brightest green, light hitting leaves directly has highlights and leaves in shadow reflect a strong blue from the sky.

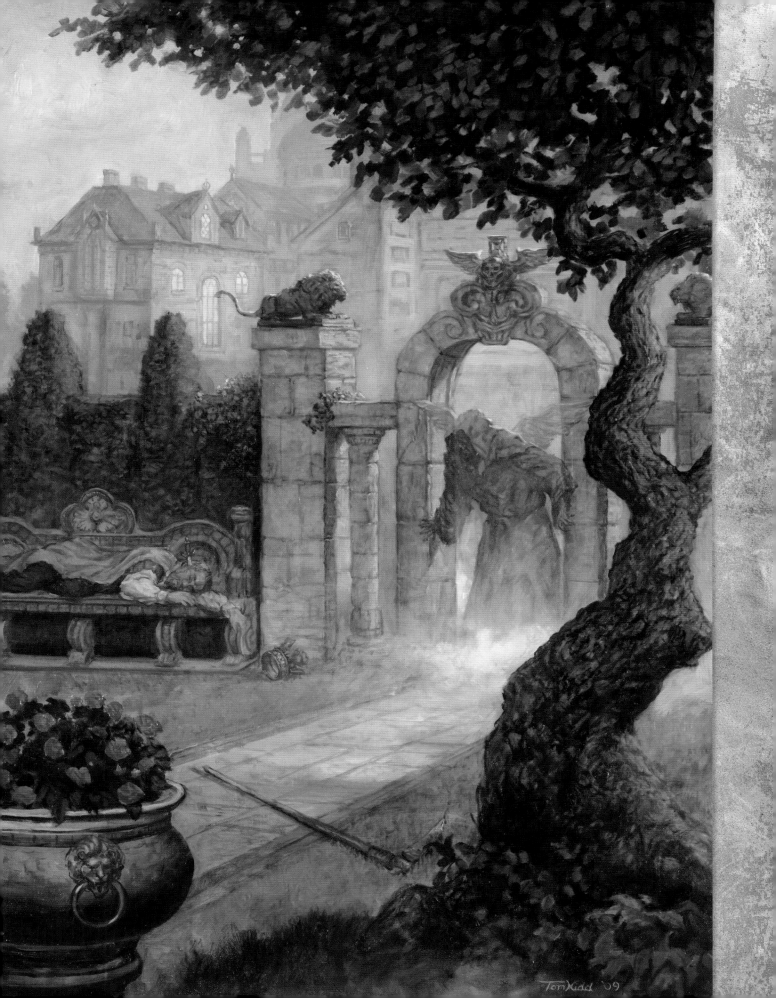

Tom Kidd '09

INVENTING LIFE

You have godlike power when creating plants and animals. You can invent the animal and then make a world that it would most likely live in, or you can create a whole world and invent the animals that are appropriate for it. The worlds I prefer to invent are based on the science of evolution. Using that science as an extrapolating tool, you can come up with some amazing things. You only have to look as far as nature to know that there are some odd creatures in the world. All you have to do is imagine a changing environment and the billions of years that pass for your living thing to evolve. Your imagination can control time, geology, ecology, physiology and biology to make whatever you want as fast as you want.

The process of inventing life is much easier if you have studied plants and animals closely. Understanding how they work structurally will go a long way in making believable life. It's also worthwhile to understand animals from the inside out starting with the skeleton, the muscles and the outer layer of skin, fur or scale. Knowledge is your most effective instrument for success even when you don't know you're using it. So study up, start drawing and have some fun.

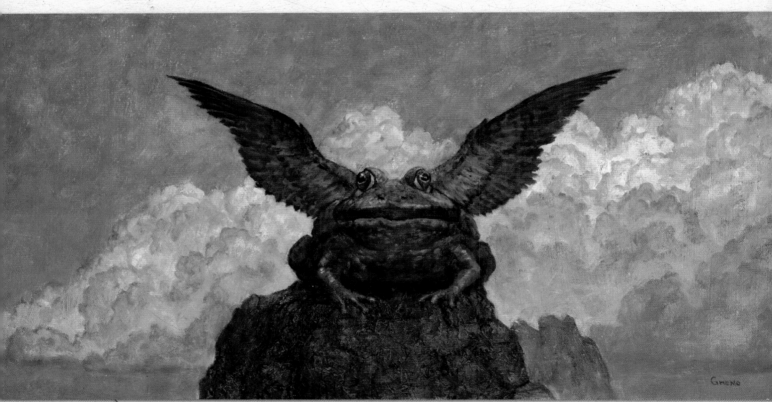

WHAT IF: FROG WITH WINGS?

A "what if" question is a great tool to help you invent creatures. What if pigs could fly? Several images should come to mind of pigs flying in different ways: bird wings, bat wings, balloons, airships or inflating themselves into an airship by sucking up some helium.

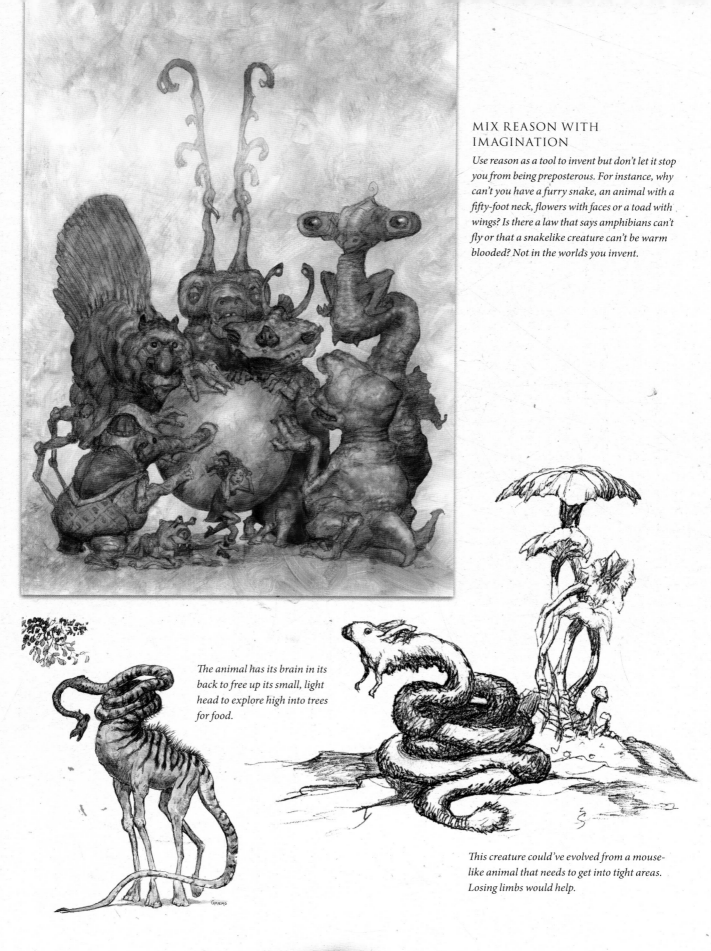

MIX REASON WITH IMAGINATION

Use reason as a tool to invent but don't let it stop you from being preposterous. For instance, why can't you have a furry snake, an animal with a fifty-foot neck, flowers with faces or a toad with wings? Is there a law that says amphibians can't fly or that a snakelike creature can't be warm blooded? Not in the worlds you invent.

The animal has its brain in its back to free up its small, light head to explore high into trees for food.

This creature could've evolved from a mouse-like animal that needs to get into tight areas. Losing limbs would help.

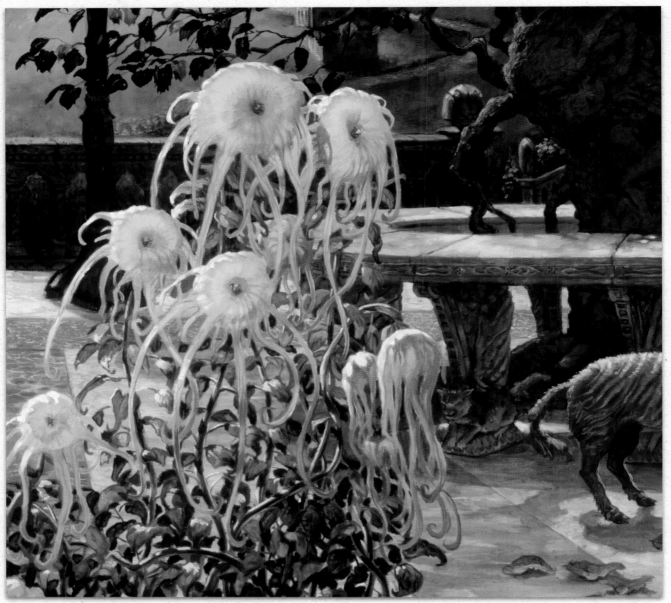

INVENT PLANT LIFE FROM REAL LIFE

Above is a close-up detail of a painting that has invented flowers based on the real thing. The entire scene has a variety of elements of which the flowers are a minor part, but if careful attention isn't given to the flowers, the painting as a whole will suffer. Note how they reflect the structural properties, irregular but repeated similarities throughout, of the photograph of pink flowers at right.

PHOTOGRAPH REAL FLOWERS FOR REFERENCE

As beautiful as they are, flowers serve a purpose in their beauty. They are road signs for insects and birds that food in the form of nectar is available. In exchange for that food, birds and insects help spread their pollen.

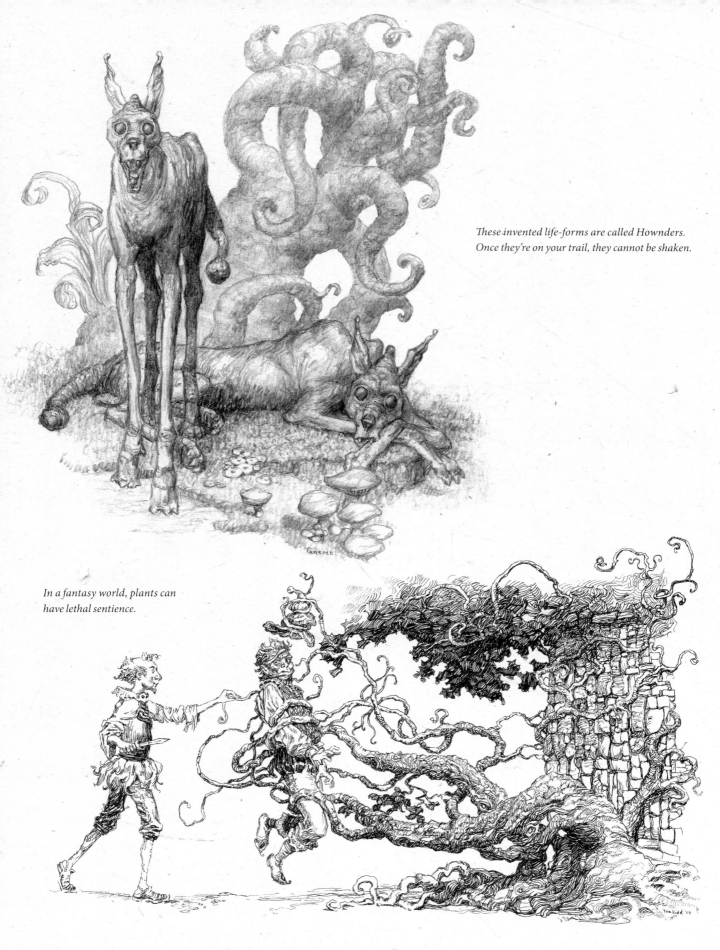

These invented life-forms are called Hownders. Once they're on your trail, they cannot be shaken.

In a fantasy world, plants can have lethal sentience.

Dragon Anatomy

Thoroughly understanding animal musculature and movement is important if you expect to use any type of creature often in your paintings. Building a visual catalog of animal imagery is a good place to start.

Study animal anatomy books to provide a factual jumping-off point to imagination.

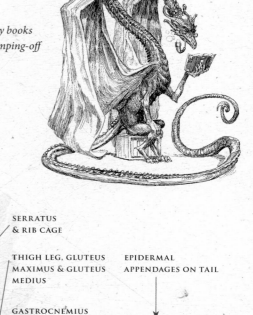

DELTOID (ARM & WING)

EPIDERMAL APPENDAGES

THUMBS ON HUMAN

WING IS LIKE HUMAN ARM & HAND

LATISSIMUS DORSI: WING & ARM

SERRATUS & RIB CAGE

THIGH LEG, GLUTEUS MAXIMUS & GLUTEUS MEDIUS

EPIDERMAL APPENDAGES ON TAIL

GASTROCNEMIUS (CALF)

ON HUMAN, UPPER ARM

NECK MUSCLES & TRAPEZIUS

THIS WOULD BE A HEEL ON A HUMAN

THIS WOULD BE HUMAN TOES

FOREARM ON A HUMAN

THIS WOULD BE THE BOTTOM OF A HUMAN FOOT

DRAGON EXAMPLE 1

Making up creatures takes high-powered imagining. Mammals, reptiles and birds are all four limbed. This dragon has four legs that it runs on plus two additional arms used as wings. To invent a creature with six limbs, as this dragon has, you'll need to place two extra scapulas and a second set of pectoral muscles.

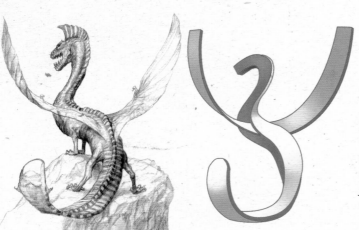

THINK IN 3-D

Simplify forms to understand how it works in the third or fourth dimension. Here, motion is implied by the alert position of the dragon. The tail should look as if it's flicking back and forth like an agitated kitty cat. Much of inventing life is associating one creature in your mind with another. You really wouldn't go to a cat to use as reference for this animal, but the memory of how a cat moves can be a great influence in the gesture of the invented dragon.

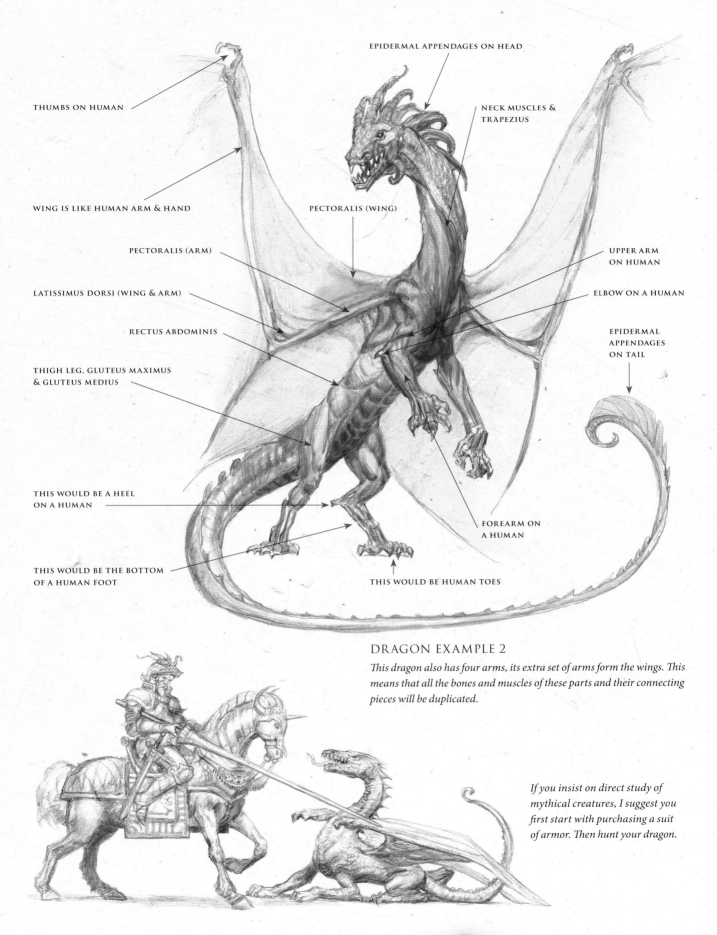

THUMBS ON HUMAN

WING IS LIKE HUMAN ARM & HAND

PECTORALIS (ARM)

LATISSIMUS DORSI (WING & ARM)

RECTUS ABDOMINIS

THIGH LEG, GLUTEUS MAXIMUS & GLUTEUS MEDIUS

THIS WOULD BE A HEEL ON A HUMAN

THIS WOULD BE THE BOTTOM OF A HUMAN FOOT

EPIDERMAL APPENDAGES ON HEAD

NECK MUSCLES & TRAPEZIUS

PECTORALIS (WING)

UPPER ARM ON HUMAN

ELBOW ON A HUMAN

EPIDERMAL APPENDAGES ON TAIL

FOREARM ON A HUMAN

THIS WOULD BE HUMAN TOES

DRAGON EXAMPLE 2

This dragon also has four arms, its extra set of arms form the wings. This means that all the bones and muscles of these parts and their connecting pieces will be duplicated.

If you insist on direct study of mythical creatures, I suggest you first start with purchasing a suit of armor. Then hunt your dragon.

THE WHAT IF FACTOR

All kinds of life are in the depths of your imagination. To access, all you have to do is ask yourself a "what if" question and then draw it. What if ... a mountainside was so rich with nutrients that the viney trees that grew within it pushed the mountain higher and higher as its roots expanded? What if ... while exploring high in the mountains in your airship, you found an oasis warmed and fueled by geothermal energy? What if ... trees were so large they had their own ecology and were teaming with gigantic life-forms like arboreal elephants?

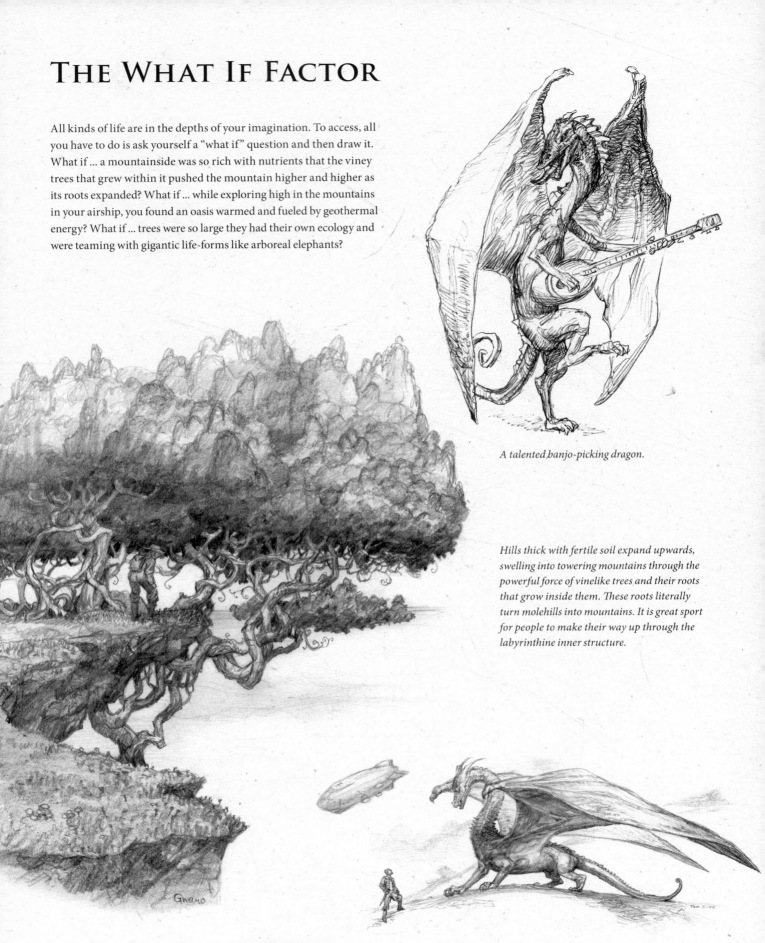

A talented banjo-picking dragon.

Hills thick with fertile soil expand upwards, swelling into towering mountains through the powerful force of vinelike trees and their roots that grow inside them. These roots literally turn molehills into mountains. It is great sport for people to make their way up through the labyrinthine inner structure.

84

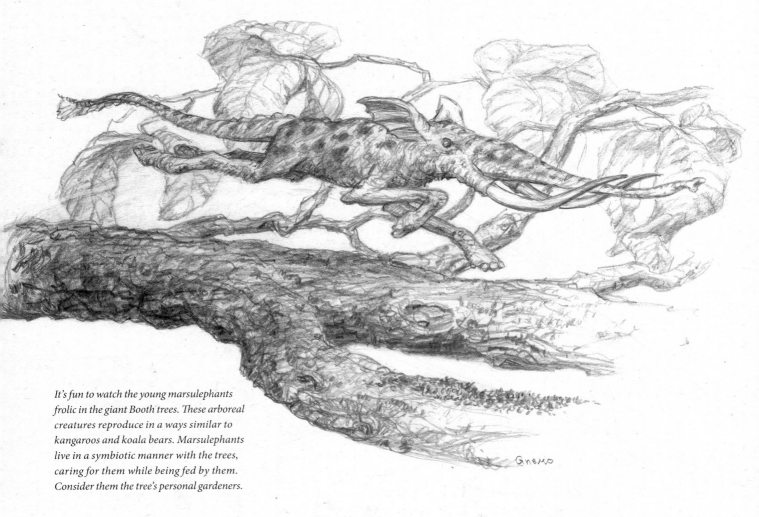

It's fun to watch the young marsulephants frolic in the giant Booth trees. These arboreal creatures reproduce in a ways similar to kangaroos and koala bears. Marsulephants live in a symbiotic manner with the trees, caring for them while being fed by them. Consider them the tree's personal gardeners.

Similar to life found in the depths of the sea where none was expected, this oasis of the air was discovered by the airship below.

The Evolution of a Creature

If you're a fantasy artist, you're probably asked all the time how you come up with your crazy ideas. The truth is that most people don't know where their ideas come from; however, there is a process. It starts small. In the beginning you have a germ of an idea. Then, magically, the idea germinates and grows much bigger than expected. This idea started as small thumbnail sketches that I forgot about for months, maybe years. A bloated flying elephant with a propeller tail—how could such a creature be? With a little scientific knowledge and knowing a lot about drawing and painting, a fantasy artist can make it all seem possible.

When we humans look out beyond our planet, we see extraordinary things we never anticipated. The helioderms are such a discovery. As comical as such creatures seem at first, under the right conditions, they simply had to exist somewhere. We found those conditions a few short parsecs away on a planet now named Deutro.

Since the discovery of helioderms (also known colloquially as dirigiblephants and blimpephants because of their resemblance to elephants), a wide variety of lighter-than-air life-forms have been found throughout the galaxy. The ubiquity of such animals is now established fact. The delicate balance of the flora and fauna of Deutro well illustrates the lighter-than-air ecology.

The key to the success of the helioderm is its skin. Their lightly pebbled epidermis is ultra impermeable and super light. Air flows over it with little resistance because of the swirling currents created by its dimpled surface. Even with their massive bodies, helioderms cut through the sky like a spear. Helioderms use helium to become buoyant and for defense against their one enemy, the fire-breathing dragon. It's a battle between hydrogen and helium. Hydrogen is ignited within the dragon and extinguished by the noble gas within the helioderm.

Helioderms collect helium through their tusks. The tusks have the ability to remove all chemically active and heavy gases from the air. Helium is all that remains and is pulled from the tusks into their envelopes—a series of gas-tight bags within their bodies. Naturally radioactive areas of their planet produce an unusual amount of alpha particles that result in a constant supply of helium into the atmosphere. Helioderms siphon off most of that light inert gas for themselves. Their tusks, which both male and female have, are also used in mating rituals.

There are many helioderm forms. The giant rigid-bodied helioderms never leave the air. But the smaller, pressure-shaped blimpoderms can land and bounce across the land to feed. Some even can walk lightly on near vestigial legs, although most prefer to feed from the tops of trees. These are communal animals that work together to defend their families, small groups or flocks.

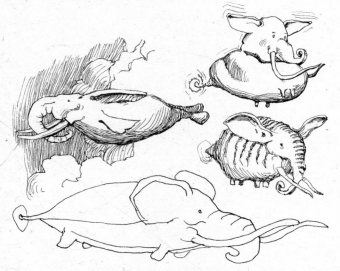

Rediscovered sketches formed the germ of the idea

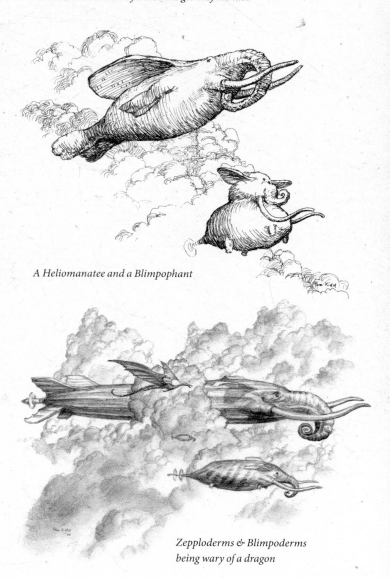

A Heliomanatee and a Blimpophant

Zepploderms & Blimpoderms being wary of a dragon

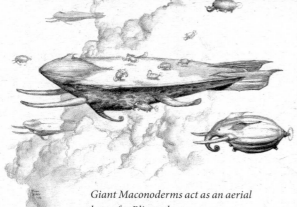

Giant Maconoderms act as an aerial home for Blimpoderms

A deflated Blimpophant

The unique anatomical muscle arrangement and mechanism that operates the Helioderms' propeller

Many blimpoderms work and live within a symbiotic relationship with larger carrier helioderms. The floating behemoths, maconoderms, are like aerial aircraft carriers that have evolved to live in the sky. They rely on a community of smaller dirigiblederms or blimpoderms to survive. The blimpoderms bring variety to the diet of the larger maconoderms. They also eat moss from the flat tops of the carriers to keep them smooth and aerodynamic. In return they have a floating nursery to lay their eggs on. The larger zepploderms have live aerial births although their offspring remain attached by an umbilical-like connection for the first few months of life.

The worst situation for a young blimpoderm is to become deflated. If she's lucky, her flock will discover her before predators come along. She'll quickly be loaned precious helium by a sympathetic group.

Most helioderms have evolved propellers. The well-oiled joints that operate them are spun with powerful internal muscles. It's thought these propellers evolved when they were sea animals.

Helioderms come from sea creatures that learned to walk the land. They went back to sea and then returned to land, but when the land became too dangerous, they took to the trees and then the air. Now this seems a perfectly logical evolutionary direction to have taken.

These lovable giant gas bags will amaze you. They have no fear of humans and are fond of giving rides and doing tricks. Make sure your clothes are carefully zipped, buttoned and otherwise sealed because helioderms are unusually curious and have been known to remove garments just to see what's underneath. If you avoid the designated radioactive tectonic faults, you should have a fine time visiting this wonderful planet.

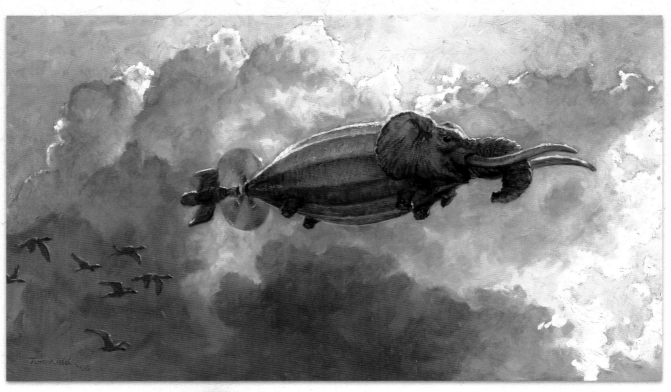

MAKING YOUR ANIMALS MORE BELIEVABLE

Beyond anatomy, texture, light and form, animals require some sense of movement. If you want to make your creatures believable, you'll have to know how they move. How a creature moves will be based on its anatomy. For example, if a creature has human-type shoulders, it won't run like a dog or cat does. Scapula (shoulder blade) placement is mightily important to how an animal moves. Study how mammals, reptiles and insects move to help with your otherworldly fauna, unearthly creatures and even your alien machinery.

CREATE A MENTAL REFERENCE LIBRARY
Study animals to the point that you have a mental reference library to work with when drawing new exciting creatures. The dragon above could be part mollusk while the dragon on the left has the demeanor of a puppy.

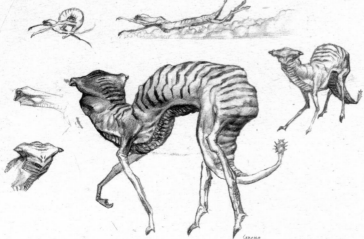

GESTURE DRAWINGS CAPTURE MOVEMENT
To create convincing characters focus on the movements that make an animal unique. Draw it from a few angles as well as in action. Here we have a caterbush. It can speed across the surface of the planet as if it's frozen in time, but our eyes only see a blur and the dust trail left behind.

USE GESTURE DRAWINGS TO CAPTURE MOVEMENT

These two gestural drawings of hissing kitties are an example of how an animal's posture tells a story. Typically a cat straightens its tail and arches its back in defense. Do a gesture drawing like this in profile first to get an understanding of the movement and then try other angles. The dragon at right was clearly inspired by the cats.

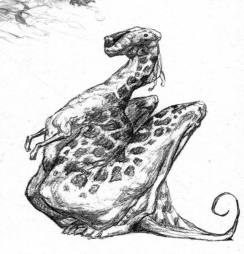

DEFINE AN ANIMAL'S FORM BASED ON ITS ENVIRONMENT

Here we have an animal that lives among rocky peaks packed closely together. It leaps from rocky cliffside to rocky outcropping like a bouncing ball,

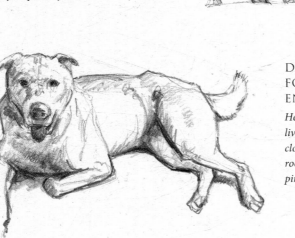

PRACTICE DRAWING RELAXED ANIMALS

Don't forget to study how animals relax. It's actually harder to learn than drawing them in action. Any pets in your neighborhood will do.

DRAWING FROM PHOTOGRAPHS

Try drawing an animal from pictures or movies you took at the zoo. Most digital cameras allow short movies. Study the basic structure of the animal as best you can and then try making up drawings of that animal. Go back to your reference to compare before trying again. Doing this will train your brain to remember the details better.

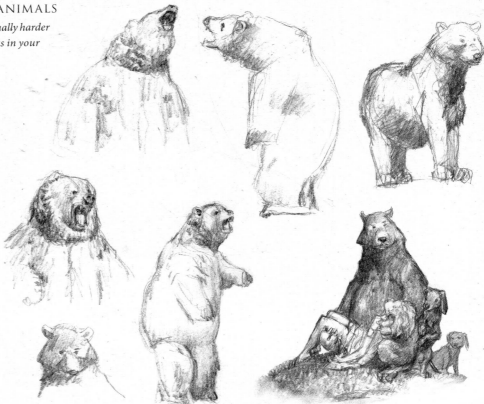

ANIMAL GESTURE

Gesture is an important part of movement. If you have an animal that has some basic makeup similar to earthly creatures, and you'll find that they probably will to at least some small degree, then you can borrow from earthly animal-type gestures. There will be an even greater amount of variation in gesture (movement as it conveys feeling/personality/meaning) than ambulatory movement (related to walking). On their own, humans primarily move forward along the ground by crawling, walking or running. Although there's some variation in that, there's tremendously more variation in how we jump, throw, sit, stand, stretch, squat, lean, express anger, triumph or even relax in a reclined position. Each one of those gestures displays a feeling. Humans aren't the only creatures that express feeling in a gesture. There's no mistaking the feeling expressed by a wary deer, a hissing cat or a quizzical puppy. With all the nature documentaries out there, artists in this era have abundant visual information they can use for study. If you have access to one, go to your local zoo.

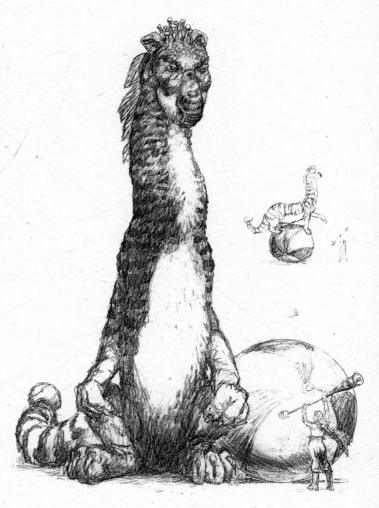

COMBINED ANIMAL FORMS

Although phantors are primarily found in the circus these days, they have been work animals for centuries. Their large bearlike bodies can perform the kind of tasks a giant human would. If you invent a creature that has the characteristics of more than one animal, figure out how the two types merge.

ALL IN THE FAMILY

Any gathering of species will have something of a combined family gesture. Often one will be the lookout, ears perked, while the rest lounge around confident that they'll be warned if any danger approaches. The tree impit is a communal animal that is quite clever and terribly impish. It's unique in its slapstick sense of humor.

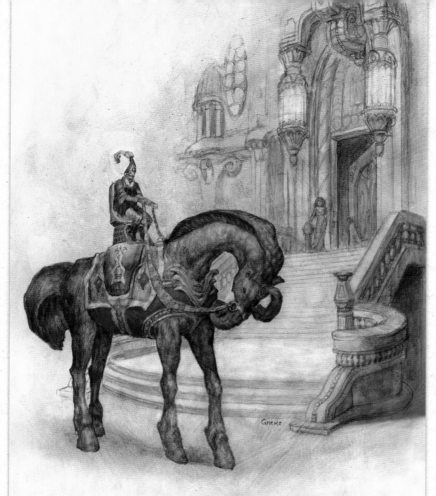

CONSIDER EACH ANIMAL'S MAKEUP AND CULTURE

Where you have humans, you have domesticated animals and a culture that adores them like this great strallion. The strallion's form is similar to a horse but as big as an Indian elephant.

How does this creature stand and move like a horse despite its great size? Elephants have joints all the way down to their toes that act as shock absorbers to absorb their weight when walking. Our strallion has extensions on its hooves to accomplish this. Note how the rider can't straddle the strallion's wide thorax like he would a horse. Instead he rides more comfortably in a saddle chair. Just like an elephant, a strallion can pick up objects with its long trunk.

BONEHEADS AND PARALLEL EVOLUTION

This giant mastodonlike creature with its massive curling bone-horn flattens the land all around. On the different continents of our world animals often evolve independently to fill certain niches. The marsupials of Australia are a good example of this with Tasmanian tigers and lions, beaverlike platypuses and creatures that largely eat ants. Like mammals, dinosaurs such as the mastodon existed in predator types or grazing types. Consider different conditions on earth when you create your animal worlds. These boneheads are similar to bison in terms of their ecological niche, but their form is closer to a pachyderm (elephant or rhinoceros). This stampede is a merging of the two animals' types of movement. They are furry because some mastodons survived in a cold environment.

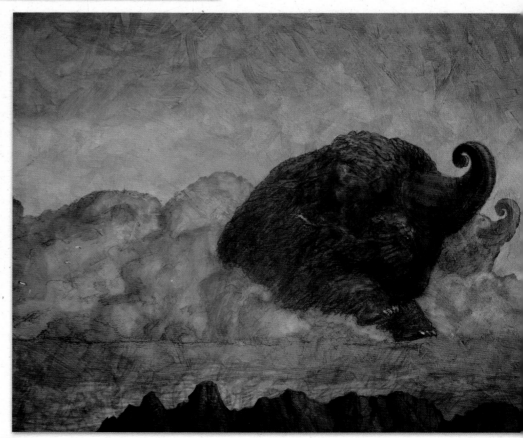

ASTRONOMICAL AND SPACE PAINTINGS

The same principles governing dripping watercolors and mashed oil paint also apply to giant nebulas millions of light years in girth filled with hundreds of trillions of stars. Not to mention the terrific energy emitted by exploding super novas and colliding galaxies. What does it mean that we can re-create these incomprehensibly massive and powerful natural phenomena by simply using the natural qualities of a viscous medium? Leave that to scientists and philosophers. For us it means fun.

Space paintings, even more so than astronomicals, present a number of lighting and compositional problems. On earth ambient light fills shadows but not in outer space. Ignore this fact and make sure to include bounced light coming from somewhere to fill your shadows. These types of paintings also reveal that the qualities of a physical medium can and should be exploited for their natural tendencies. Demanding absolute control over your paint is a mistake. Let it help show you the way.

NEBULA

The blackness of space will be a strong compositional mass that you'll need to compose around. Although humans really can't see them in space, nebulas can be employed to break up the blackness of space.

NO AMBIENT LIGHT IN SPACE (OPPOSITE PAGE)

If you look at photographs of space or of the moon landing, you'll notice that without an atmosphere, shadows tend to go black without any bounced light from other objects. This is because our atmosphere diffuses some of the light that enters. These dark shadows may feel uncomfortable to our internal aesthetics as well as hide information you want the viewer to see. To overcome this, simply set up your scene to have an object bounce light into the shadows. Here the earth handily accomplishes this.

STAR SPACING

Stars will vary in intensity, size and color. Also, be careful not to space them evenly apart. Nature repeats itself in terms of its structure so you can use any randomly created specks as reference for your star placement: a variety of marbles tossed on the floor, splattered paint or billiard balls on a pool table will all work.

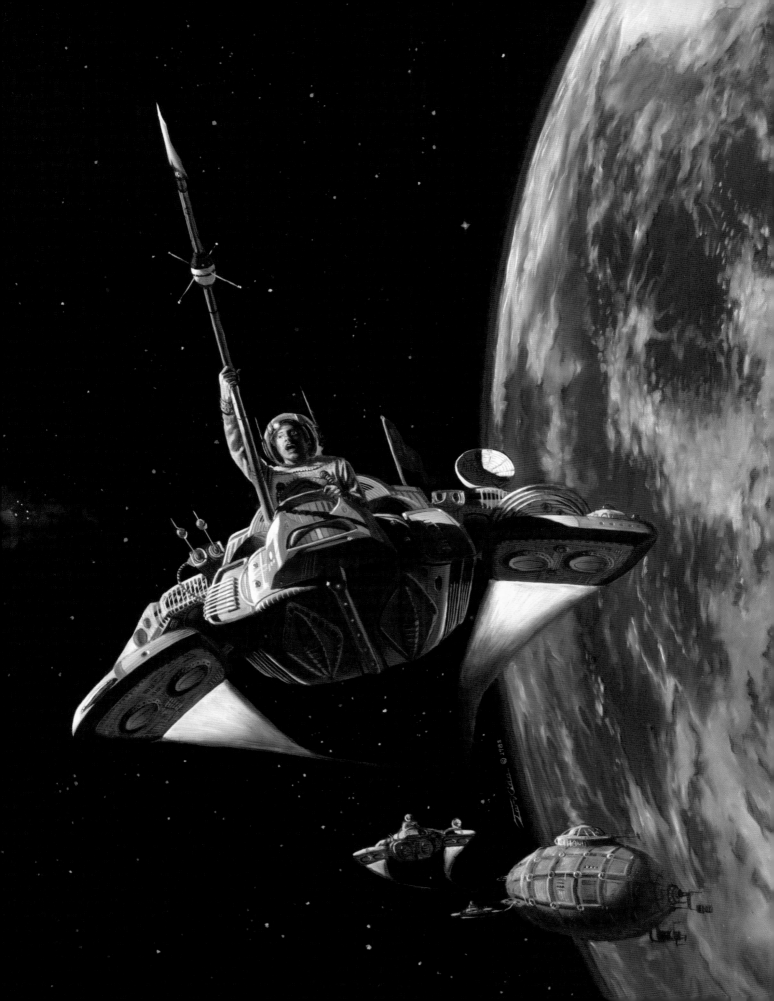

IMAGINING SPACE

Close your eyes for a minute and imagine that you're sitting outside looking up into the night sky. What do you see? Stars and planets likely, but how are they arranged? Are they different sizes and do they come in different levels of brightness? The sky can be a variety of dark colors from deep blue to an unhealthy maroon. It's unlikely the night sky will be a uniform color. Clouds may block all heavenly light, blackening the sky, or they can be wisps of pale white that the stars shine through. The moon in any of its phases can be in any part of the sky depending on which way you're facing and how high it has risen. Wherever it is, it will light up the ground and the sky (primarily clouds) to show a great deal of form and shadow.

If you're going to imagine this night sky, you'll need to know where the moon is as much as you'll need to know where the sun is when painting a daytime landscape. With the bright sun gone beyond view, the moon's reflected light is quite prominent at night. When painting the night sky consider dust, pollution and humidity. Though these substances are the bane of astronomers seeking to see deep into space, for the artist they add a romantic atmosphere. In space painting, be thinking about atmospheric perspective and the glow from light that reflects off the moon, stars, streetlights, meteors and planets.

DRIP PAINT TO CREATE A PLANET'S TEXTURE

Let paint drip, flow and separate to create the surface of a planet. Drip turpentine on paint mixed with a good portion of linseed oil. Angle the painting so that the flow of the paint simulates the oval shape of the planet. This detail work just takes minutes.

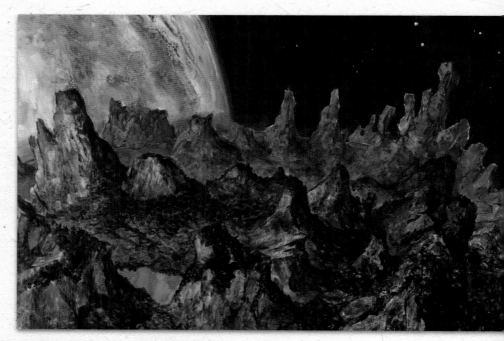

LIGHT IN SPACE

Light in space follows the rules of light on earth. The earth's natural light sources are only the sun and the moon, but space light can have more. As you create nebulas in space, light them from many different angles. I like to think of nebulas as space clouds, but they are really any kind of particle that picks up light and reflects or blocks it.

EINSTEIN RING

Use ideas from science as a way to stimulate an interesting picture. The science idea behind the Einstein Ring is that a great gravitational force like a black hole can bend the light of something behind it to the point that you can see it in a distorted form.

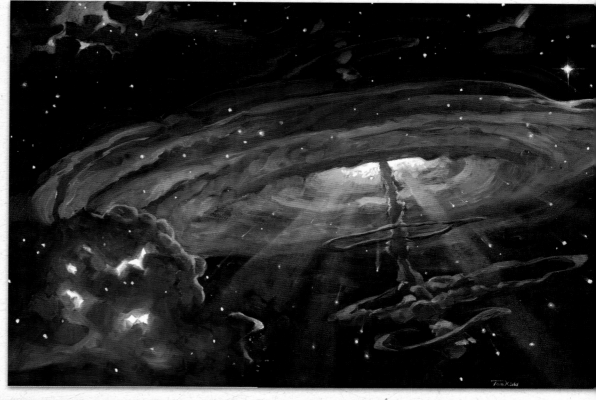

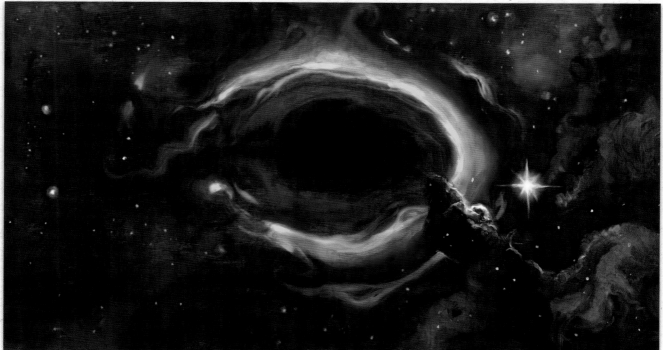

INTERNAL LIGHT

If you've ever watched lightning from an airplane, you'll notice it makes the clouds glow. Any earthly phenomenon can be interpreted for space art. Here a supernova is exploding inside a nebula and giving off tremendous light. Much like fire, the light is white in the center, shifts to yellow and then to red as it moves from its hot center to its cool edges. In the foreground nebula, the white light coming from the openings is something powerful about to burst loose.

A Castle in Space

<div style="writing-mode: vertical-rl;">DEMONSTRATION | CREATING A CELESTIAL LANDSCAPE</div>

Materials

SURFACE
Gessoed Masonite board

ACRYLIC COLORS
Phthalo Blue
Phthalo Green

OIL COLORS
Burnt Sienna
Burnt Umber
Cadmium Yellow
Crimson Lake
Ivory Black
Manganese Blue
Ochre
Payne's Gray
Raw Umber
Titanium White
Ultramarine Blue
Ultramarine Violet

BRUSHES
nos. 4–6 sable brights
nos. 2–4 bristles

TOOLS
Adobe Photoshop
HB pencil
Linseed oil
Sketch paper
Rag
Turpentine

Our mission here is a simple and quixotic concept: a castle that can carry its residents through space from solar system to solar system. How is something like this possible? What sort of propulsion is used? How can it travel at the faster-than-light speeds necessary to accomplish this? Although this scene is based on magic, try to work it out through rational extrapolation. Free association and logic go hand in hand to produce unique fantasy landscapes.

1 *Thumbnails, Smumbnails!* Instead of thumbnails draw a small structure and add to it until you hate your drawing. Purposefully take it too far.

2 *Simplify your Idea* Now that you're distinctly dissatisfied, redraw your original drawing a bit smaller. Take away some details and break the form down to larger shapes. Look to make your shapes unique but not overwhelming.

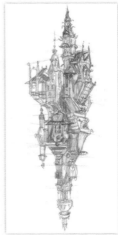

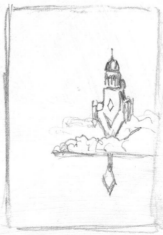

3 *Pinky-Nail* Draw a pinky-sized drawing to keep things simple and to resolve your problem areas.

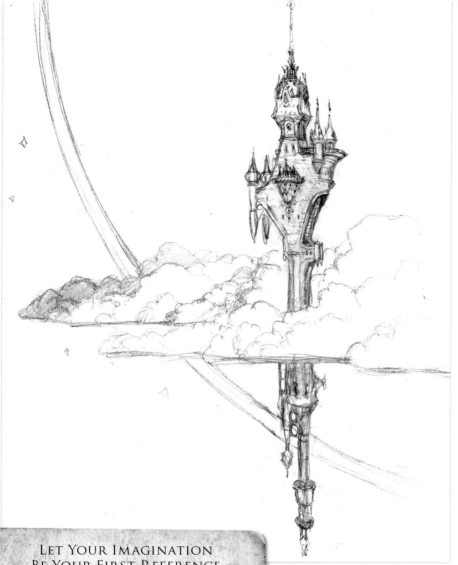

4 Pump it Back Up
Now that you know what should be left behind, go ahead and redraw your castle a bit larger. Follow your small thumbnail from step 3 to know when to stop. You'll certainly be adding details beyond the smaller drawing, but these should only be tiny extensions to the end of small bits, not larger ones. This general design rule is taken from nature.

5 Save your Ideas
Don't be afraid to try a few different ideas as well and choose the one that best fits the assignment. You should save all those drawings though because they're likely to come in handy for something else. They're little problems you've solved even before the problem comes up.

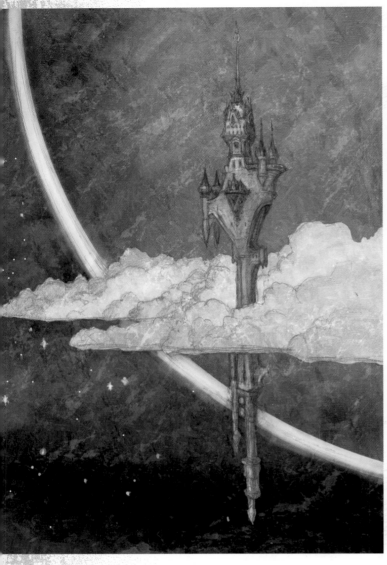

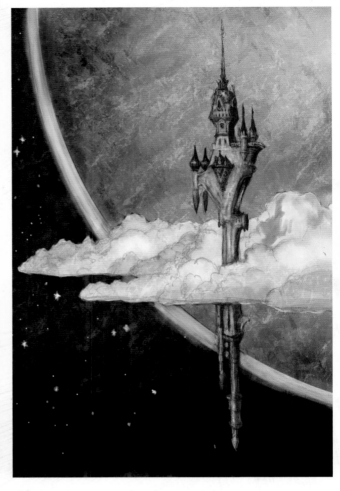

6 *Digitally Establish the Tonal Masses*
Even in space, despite the absence of a strong gravitational pull, you'll need to be concerned with tonal masses. Scan your drawing and work on it in black and white in Photoshop. The clouds and castle form a light mass against the darker mass of the planet and space. Also establish the light source and shadows as well.

7 *Digitally Establish the Warms & Cools Before you Paint*
Import a texture from your texture library trying out a number of color choices before you begin painting. Here, an imported texture, scanned and saved from an existing painting, is used to give the planet character. Note how the castle now casts a shadow on the clouds. If you want an object to stand out, put its complementary color behind it. Here the cools follow the general rule that cools recede and warms come forward. The goal is a tranquil scene so there will be no crazily colorful nebula to disturb the peace.

8 *Establish the Background Wet-On-Dry*
Paint the ground color with a watered-down mixture of Ultramarine Blue and acrylic Phthalo Green on gessoed Masonite. Umbers or siennas are often the colors chosen here, but that dominant color will be blue so blues and greens are chosen. Once completely dry, apply an oil mixture Phthalo Blue, Manganese Blue and Ultramarine Blue with a small amount of drying linseed oil. More of the warmer blues and white go into the planet and the cooler blues go into space. All of this establishs basic shapes and prepares for adding texture.

9 *Drip Turpentine for Texture*
While the paint is still wet , set it on its side and drip turpentine across the surface of the planet letting it run down the painting. This will produce a complex organic pattern to the surface of the planet. Adjust the angle of the painting and amount of turpentine to alter the pattern. Introduce more color to the turpentine as you drip, if needed. For another unique look, dab the surface while wet or semidry with a rag. To create a clean edge around the planet, attach a brush to a string, tie it a distance from the painting and use the flexed string distance to make a perfect curve with Titanium White. Use Ivory Black to vary the rim's darkness.

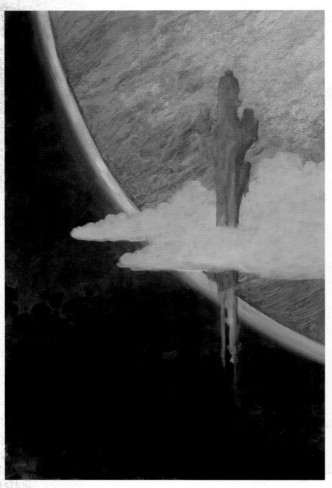

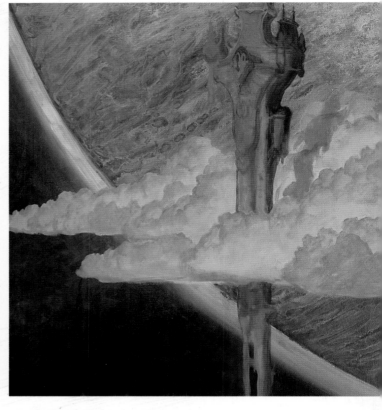

10 *Create the Castle & Clouds*
Now that you have your background established, it might seem counterproductive to try to paint the warm colors of the castle over the cool colors of the planet and sky while it's still wet. Simply wipe away the paint where you wish to place the castle and clouds. If you feel that you haven't removed enough paint, dab a rag lightly in linseed oil and wipe further. Don't remove paint over all the area you'll be painting; you will want to keep some texture of the planet where it's needed. Once you've cleared the area, lay in the basic form of the castle and clouds using any old bright brushes nos. 4 to 6. Vary your strokes and colors to keep the castle rough in visual texture. More Titanium White and Ochre will go into the clouds and more Burnt Sienna into the castle. You don't want the clouds or the castle to be too smooth.

11 *Add the Cloud Details*
Paint the cloud details alla prima (while still wet) using Raw Umber and Manganese Blue to shift the color of the clouds to a brownish green. The paint should be thin so you can use a sable bright to push in the shading with your brush. Give your brush a twist to create curved, darker edges of the clouds. These clouds are lit by yellow sunlight perhaps filtered through space dust.

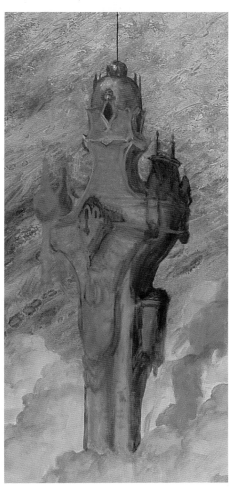

12 *Begin the Castle Details*

Your castle should be something of a blur at this point, simply basic forms and touches of painterly texture that resemble stone. You don't want your castle's surface to be smooth. It should look rough and aged. Use old brushes to do this, ones that have bits of dried paint stuck to them. You can also use small stiff bristles nos. 2 to 4 to push into the paint, scraping paint away in places to vary the texture. Return to your sable brights in the areas you want to control the paint carefully.

13 *Refine the Details*

From here to the end you'll be adding details and refining the painting. There are three main colors that make up the castle: an orange-brown, gold and red. Paint shadow details into the main area of stone with an orange-brown mixture of Burnt Umber, Titanium White (a tiny amount) and Burnt Sienna. Mix it up in at least three different ways to vary the hues. The paint is dry now so these will be mostly hard lines. Use either sable brights or sable rounds to paint sharp edges or sharp points. If you don't like something, wipe it away. After a day of painting, don't expect this to look finished.

14 *Details on Top of Details*
Mix Ochre, Cadmium Yellow and Titanium White to match the basic color of the stone part of the castle. Paint light areas into the details of the dark areas you painted in step 12. You can repeat this process many times in different areas of the painting and come back at any point to do it again.

For your green areas, use a mixture of Ultramarine Violet and Raw Umber. For your red areas use Crimson Lake and Burnt Umber. For gold use Burnt Umber and Raw Umber.

After you've gained experience as a painter, try to block a few structural or small design ideas that pop into your head, keeping what you like and painting out what you don't. Here, balconies have been added. If the castle is surrounded by air, it makes sense to have them. Other walkways, open-air rooms and filigrees have also been added.

15 *The Final Details (opposite page)*
Save the fine details for last. Make the castle feel less inviting by added various statues, a giant demonic mask and gargoyles to create mystery. Glaze deeper shadows with a mixture of Payne's Gray and Ultramarine Blue. Manganese Blue is glazed in transparently over the predominantly white oxygen halo circling the planet to make it a deeper blue.

Paint your stars last and in two steps, first by dotting in a halo color that's blue, green or even orange-red. When dry, add a light-colored speck of color or Titanium White at some of the star centers.

Cloud Theory

I can well remember the day I became fascinated by clouds. It was on a flight to Texas and the sky was filled with cumulus. I drew and drew and took down detailed notes of what I was seeing. For the first time I noticed that clouds didn't follow the lighting rules of anything else. For one, they shifted in color to orange as they receded into the distance. For a diffuse substance their edges seemed especially sharp, and the clouds weren't always uniform in value even though they were lit by the same intensity of light. The closer the airplane got to a cloud it seemed to become less sharply focused. Odd I thought.

It all has to do with density. Clouds are made up of tiny opaque specks. When pressed tightly together, they reflect back a fairly strong white. The less dense they are, the more light makes it into the cloud and the less light is reflected back. The edges of a cumulus cloud appear unusually dark because they are less dense than the rest of the cloud. The warm center and bright edges of a backlit cloud can give the illusion that it's made of a transparent substance, but if you study it closely, you'll see that it's opaque but diffuse.

CLOUD DENSITY

In any area of a cloud painting you can paint the lit area of a cloud a darker color. Even if directly lit by the sunlight, clouds aren't all the same brightness. This applies to areas of the same cloud. Sometimes this is due to a shadow, but often it's a matter of the density of the cloud. You can use this to your advantage when working out your composition.

If you're painting clouds, especially if you're inventing them, keep in mind that clouds are a matte surface. You won't find big specular highlights on them in nature though you can break that rule if you like. I have. Like anything else clouds cast shadows and reflect light back on themselves. Whatever you invent for a cloud form you'll find a more extraordinary one in nature.

Because smoke and clouds are both diffuse substances, they follow the same rules of lighting. Smoke tends to be darker so you'll have to take that into account.

Knowing all of this shouldn't diminish the beauty or variety of clouds or their ability to surprise me. They're never alike.

PHOTOGRAPH OR DRAW CLOUDS FROM AN AIRPLANE WINDOW

Always get the window seat on an airplane if you can. It's there that you'll see the most amazing clouds. Now you might think that if you've seen one cloud then you've seen them all, but you'd be wrong. Not only do they come in all varieties, but there is also an amazing range of conditions that you might not expect.

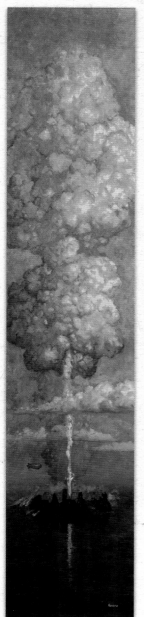

VOLCANIC PLUME AND GEYSER FORMS

The same basic qualities that make cumulus cloud shapes are what you'll see coming out of a volcano or geyser. There are a number of seemingly minor things that might go unnoticed in the natural world that you'll need to take note of to paint the fantastical. Even the heat from this eruption is included in this painting as it distorts the air around the bottom of the volcano.

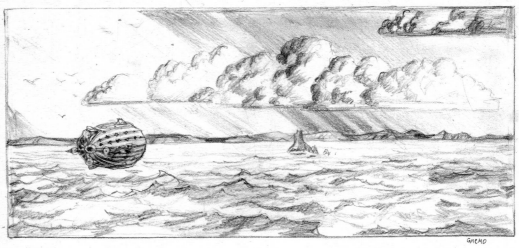

STORM BREAK

This is an imagined scene of the H.M.A.S. Wyeth gondola just as its crew sights a yet undiscovered continent as the sun breaks through the clouds. They've just come through a terrific storm.

CLOUDS AND REFLECTED LIGHT

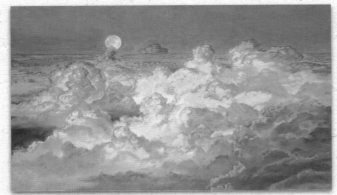

In diffused light, clouds can pick up warm colors in their shadows shifting them to violet.

Clouds tend to shift to orange as they recede. This is especially prominent near sunset.

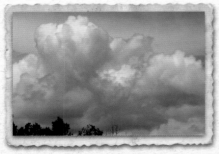

Clouds reflect whatever color that bounces off of them because they are white.

A sunset reflecting off the underside of thick stratus clouds.

Wild things happen when warm air on top mixes with cool on the bottom, called an inversion.

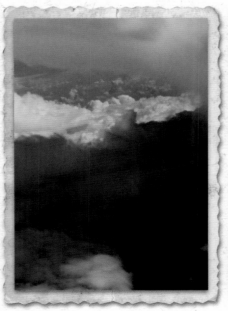

This soft cumulus cloud is lit by soft light on a slightly hazy day. (top)

Heavenly clouds in between other clouds with the sun directly behind them. (bottom)

Cumulus clouds under the shadow of stratus clouds. This was taken from an airplane seat, a great place to take reference photos.

A little light shows through the less-dense center of this dark cloud as it reflects the cool tones of clouds. (top)

Clouds reflecting warm sun. (bottom)

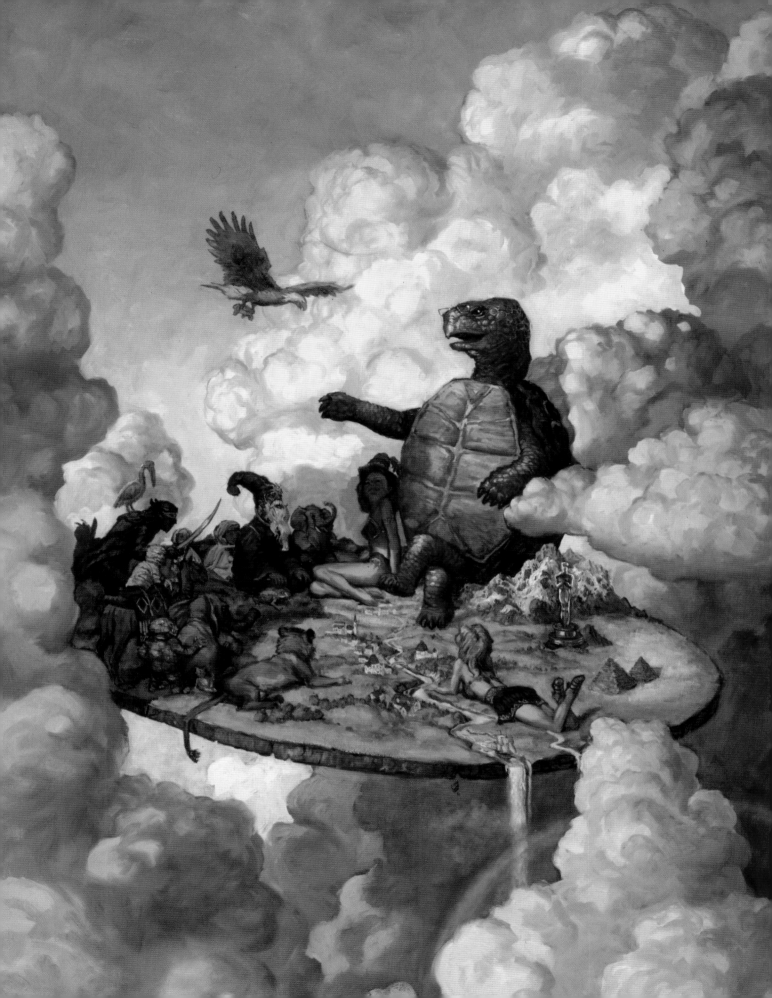

SNOW AND ICE

Nature is your best source of ideas. All you need to do is change the proportions of something you see to make something unique. A good naturally forming phenomena for landscape art is snow and ice. One is soft and the other hard. I know this from a reckless childhood leap off a roof to a gentle landing into snow, and then later with a hard landing onto ice deceptively covered in a light dusting of snow. It was a lesson learned very much the hard way.

Yes, ice is hard. It also looks hard because ice is a crystal and tends to take more angular shapes unless it forms from droplets. All earthly ice will break like glass into angular shards. Ice is transparent and refracts light like glass. When it's in its smooth form, such as icicles, it will also reflect light in specular highlights as discussed in the section on light (see page 34). Visually, icicles are the purest form of refracted and reflected light. Scientifically, ice comes in fifteen different forms under different temperatures and pressures but for the sake of fantasy art, we will deal with snow and ice in its everyday forms.

Snowflakes are scores of individual crystals that can be very clingy and, when moist, will form delicate rounded mounds on any relatively flat surface they land on. No other substance falling into a pile will look quite like snow. If you're going to paint snow, you'll need to study it firsthand. Although snow is primarily a matte surface, it sparkles with the occasional specular and even spectral (rainbowlike) reflection. As with clouds, the denser the snow the whiter it will appear.

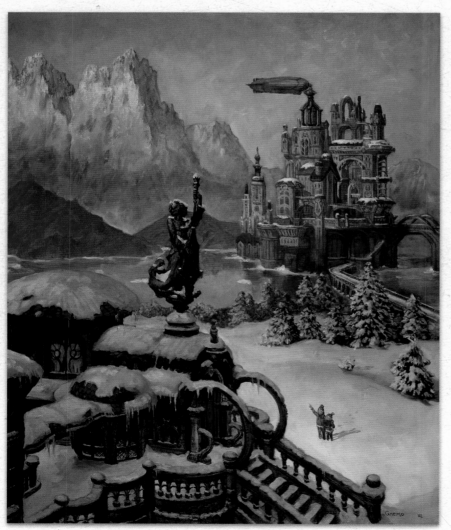

COMBINING DIFFERENT TYPES OF SNOW AND ICE IN A SCENE
Here, snow has fallen, melted and then frozen again. During winter snow can fall several times, so you can have many types of snow in a scene. Dry snow will easily blow around in the wind and cause snow drifts creating a velvety sheetlike effect. Wet snow will clump and cling to even the smallest branches.

PAINTING SNOW IS MORE THAN JUST WHITE (RIGHT)
Here, the snow is fresh fallen and moist. White snow is a perfect reflector of direct and ambient light. You readily can see the warm and cool values in it on a sunny day. Although snow is one of the whitest whites you'll see in nature, it's not a simple matter of adding white wherever you have snow. Both the lit side and the shadowed side of snow have a form and a variation of tone and color.

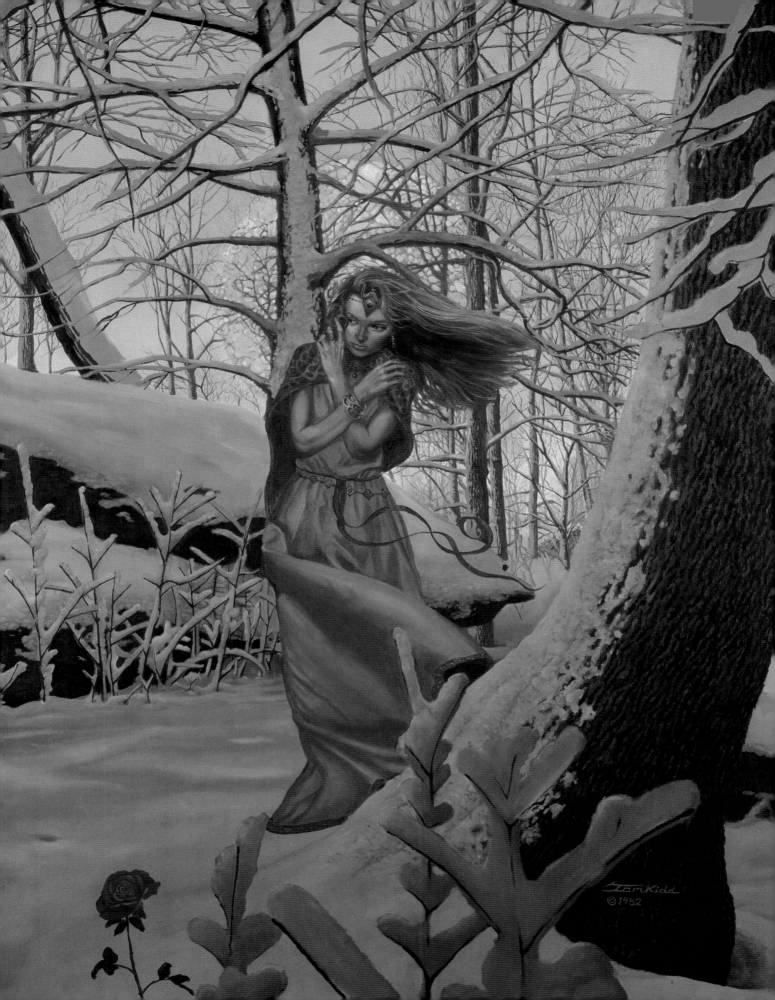

HOW TO PAINT ICE

Falling snow can pile up and squeeze itself into towering ice chunks in the northern regions on the world. You can create the natural forms of ice by painting a dark color underneath. I used a thin mixture of Payne's Gray and Phthalo Blue here and let it dry. Over that, I placed a thick layer of fast-drying alkyd Titanium White. Scrape into it with an old stiff bristle brush to remove paint and make crevices that will show through some of the color underneath. Once dry, drybrush over that and paint in thin, dark crevices with a no. 6 sable bright or no. 1 sable round using the Payne's Gray and Phthalo Blue mixture.

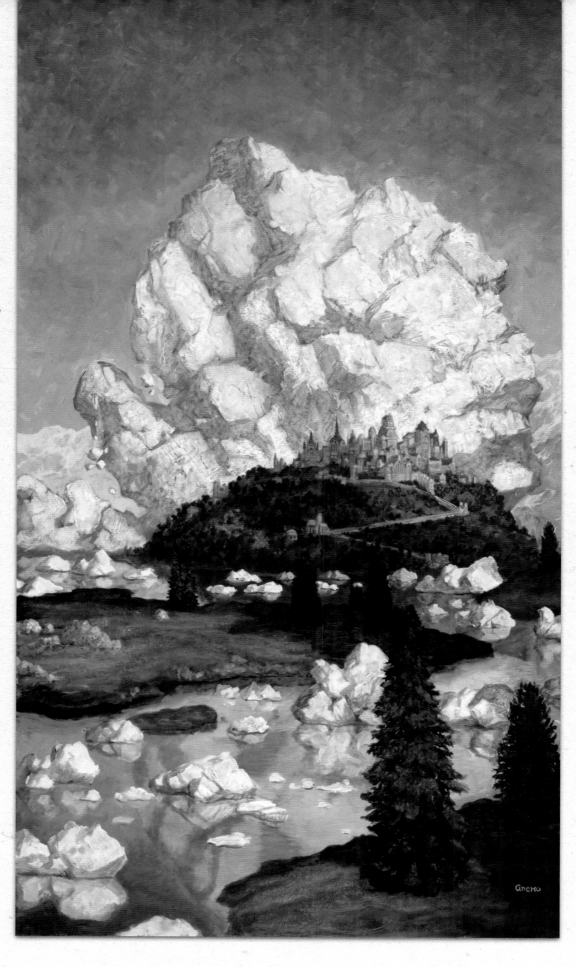

IMAGINE BEFORE USING REFERENCE

We tend to remember the more dramatic things we've seen, and this can make it into our artwork. When trying out ideas, imagine first, then go and study pictures of ice and snow. Working back and forth like this will help you understand principles rather than learn only to copy or to become unconsciously stylized. A stylized look isn't necessarily bad, but it's good to be conscious that it's happening.

TAKE PHOTOS OF FRESH SNOW IN THE MORNING LIGHT

If you want to take pictures of fresh fallen snow in the early morning light, you'll have to be fast. The sun will make the sticky snow slide off branches quickly. Notice how the lit side of the snow is almost white while where the light hits obliquely, it takes on a pinkish tint. The snow on the ground reflects warm light into the shadows of the snow on the lower branches of the tree.

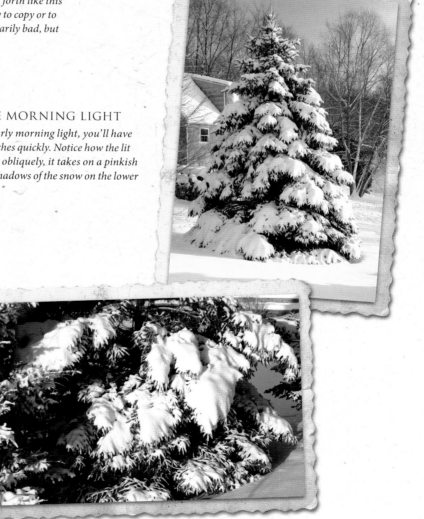

STUDY THE WHITE STUFF

Take the time to study how snow creates forms and texture. Snow can be mighty sticky. If it falls wet and freezes, it will hold and pile up high on the thinnest branch. If it's dry snow, it won't pile up much at all. Show form in sticky snow by revealing some of the shape of what's beneath and making it round.

Thomson Ice Shelves

Materials

SURFACE
Gessoed Masonite board

ACRYLIC COLOR
Burnt Umber

OIL COLORS
Burnt Umber
Indian Yellow
Manganese Blue
Permanent Rose
Phthalo Blue
Raw Sienna
Raw Umber
Titanium White
Turquoise
Ultramarine Blue

BRUSHES
no. 12 stiff bristle
nos. 4–8 sable brights
nos. 1 and 4 sable rounds

TOOLS
HB pencil
Adobe Photoshop
Linseed oil
Rag
Sketch paper

If you live someplace that has a cold winter season, you've seen water freeze and melt and freeze again producing endless forms. It's worth studying this phenomenon. Unlike other liquids, solid water (ice) is lighter than its liquid counterpart so it forms on the surface. Water levels rise and fall so that makes ice shelves possible. In the brook behind my house, I've observed shelves or sheets of ice frozen well above the water beneath. It seemed to me that it was possible to have double layers of ice form to create the illusion of elevated flat lands—a good example of how observation turned into an idea, a drawing, a color sketch and, ultimately, a painting.

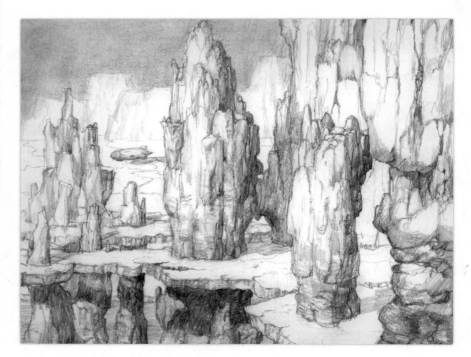

1 *Pencil Sketch*

A concept isn't a visual thing. It's an idea that can be drawn or painted many different ways. When you draw out your ideas, try drawing without letting your hand touch the paper. There are two or three advantages to this. It keeps you loose, causes useful idea-forming mistakes and less smudging. Also, try holding the pencil in unfamiliar ways. Avoid holding it the way you do when you write.

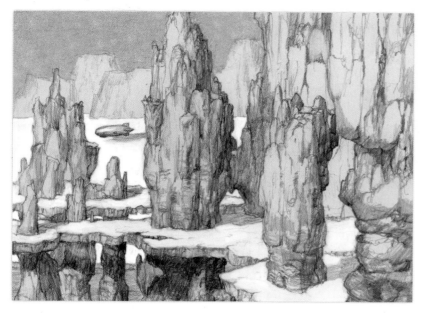

2 Use Photoshop to Augment the Pencil
The pencil has its limits when painting snow and ice. It's hard to tell that there is ice in the pencil sketch because it's missing brighter whites. Use a computer to adjust the contrast, add darker tones on multiple layers or erase. Erasing is equivalent to using white chalk on a drawing. With greater contrast you get greater separation of objects because gray tonal masses have been created. This looks much more like ice and snow now although some areas are still a bit ambiguous.

3 Digitally Plan your Colors
Use Photoshop to get a sense of the color for the painting stage. Here I used the Rubber Stamp tool and a color sample that I had from scanning in another painting to create a snowlike texture. This certainly feels a lot colder now. Experiment to achieve the color you want.

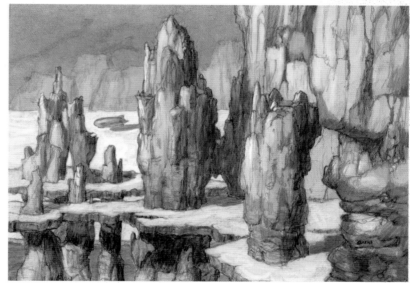

4 Sample Ideas on Layers
Test your ideas on layers so you can go back and forth to compare. Here I added fresh snow and shifted the rocky parts to a warmer color. This painting will have three states of water in it: liquid water, ice and snow. There's a layer of snow over the ice. It's vital to remember this as you paint because the snow is opaque and the ice is transparent. This can't be said enough: Live in the world you're painting.

5 Lay in the Base Tones

Paint the ground color with acrylic Burnt Umber and let dry completely. Using a no. 12 bristle, glaze in a thin amount of Manganese Blue mixed with linseed oil over the entire surface of the painting. Paint into the transparent glaze with Titanium White to begin the form of the snow. Make sure to leave some of the ground color to form the basic shapes of the rocks. Notice how the snow picks up a bluish tint. Burnt Umber (oil) is further used to help shape the rocks. From here on out, we'll use nos. 4–8 sable brights with the exception of the finer details.

6 Hone the Whites Wet-Into-Wet

For the next few steps, have a selection of sable brights ranging from no. 4 to no. 8. If it seems that the blue you're painting into is too dominant, wipe a little away with a rag and paint in more white. You can keep painting wet-into-wet for some time with this process. As the blues turn white, the forms take shape. Let dry completely before applying the next layer of paint.

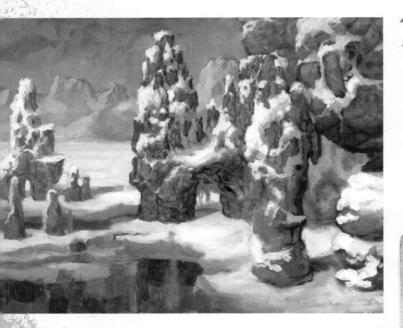

7 Build the Snow Forms

Because snow is white, it will pick up the colors of the ambient light in its shadows and reflect the color (typically a warmer one) of the direct light. Shift the cast shadows toward purple with a mixture of Ultramarine Blue and Titanium White. Note how the edges of the ice shelves are a greener color in the shadows. This is because some light is passing through the snow and then through the ice. Paint the turquoise transparent ice with Turquoise and Titanium White.

KEYS OF PAINTING STICKY SNOW

To create sticky snow you have to reveal some of the shape of what's beneath as well as depict round forms. Snow accumulates on the flat surface of rocks and gets trapped in the hollows of where the wind doesn't reach.

8 Add Snow Details & an Airship

Paint the detailed snow in the crannies with a no. 1 sable round and Titanium White. Use this brush on its edge, back and forth to paint interesting random shapes in the snow. Notice how the rocks directly beneath the ice shelves have little or no snow on them. The ice canopy acts as an umbrella over them.

Now that the painting is developed, we can add small objects like the airship. Thin down some Raw Umber with linseed oil and mix it with a touch of Phthalo Blue and Titanium White. Pick up a small amount on a no. 4 sable round and paint an oval where you want your airship to go. Fill the oval very thinly with paint to create the main shape as a somewhat flat color. This airship is shaped like a teardrop to portray a more aerodynamic shape. Wipe a little of the paint off on what will be the lit side of the airship and then paint in some lighter, warmer colors such as Burnt Umber and Raw Sienna using a no. 4 sable bright with a sharp edge. Also add the tail fins, propellers and a highlight on the front of the ship with Titanium White.

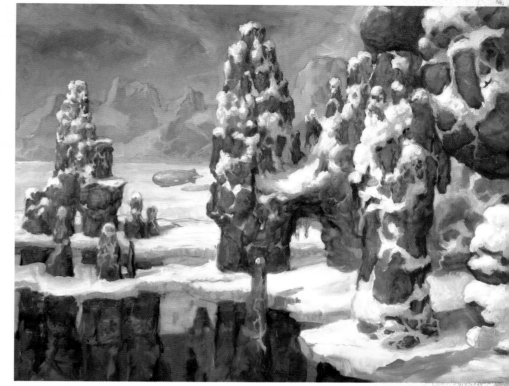

CLOSE-UP OF UNFINISHED AIRSHIP

SHADOW TRICKS

Let's say you want to place something in space so it's clear how distant it is. You can always put it partly behind something that, based on other overlaps, is in the distance. However, you may want to see the entire object. You may even want to put it far into the distance and there's nothing to have it overlap with. Such is the power of shadows. An object's shadow visually places it where it is better than the object itself. There's no doubt that this airship is just above the surface of the lower ice in the distance. Its shadow gives away its location.

9 Add the Finishing Details

Add details to help the story that don't fight too much for the viewer's eye. When the painting is dry, glaze Indian Yellow mixed with Titanium White to highlight the jutting pinnacles in the foreground. If you try to add highlights wet-into-wet, the yellow will mix with the blue and make green.

Add some chunks of ice falling off the edge in the foreground with nos. 4 and 5 sable brights using the same mixture used for the ice shelves. This tells the viewer that the ice isn't permanent, and in time it'll likely all fall down into the flowing water below. Also separate the distant lower ice by shifting its color toward pink using a no. 5 sable and Permanent Rose.

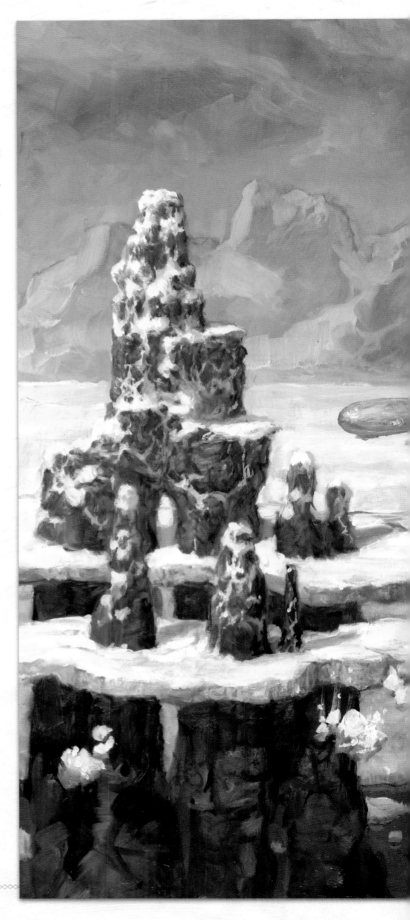

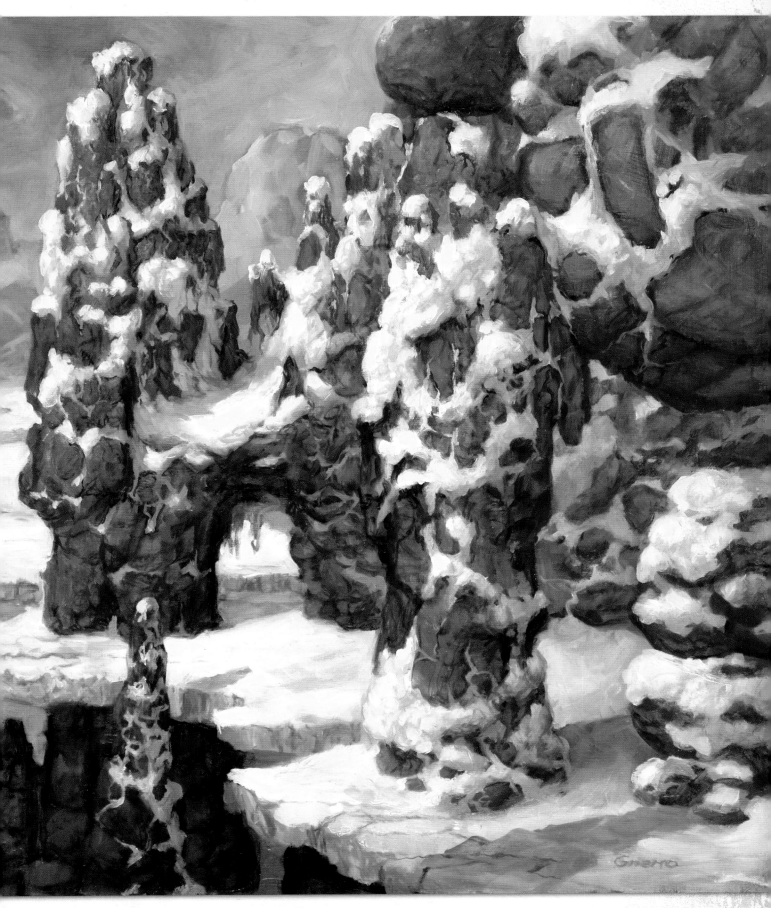

The Wonder of Trees

Let's start by studying tree trunks and limbs, the parts that expand and grow throughout a tree's life. Trees have an outer protective skin (bark) to keep it from breaking apart while expanding. When you select a tree to observe and then paint, understand how it handles this expansion. I've observed the growth patterns of many trees: expanding like wire mesh, flaking off, stretching tight and patterned cracking. Palm trees often grow in sections that stack on top of one another and banyan trees seem to thicken by adding successive limbs that meld together. Observe trees and create your own connections. Understanding how structures are formed will aid you in inventing new trees.

Most limbs and trunks have a distinctly matte surface. You will see no highlights in the bark. The exception is the bark that tightens as the tree expands. That tight, smooth skin will have shiny areas.

The other main aspect of trees is the leaves. They can be frustrating to imagine and paint because each leaf has a unique, specific pattern. Leaves are often arranged randomly with each leaf surface at a different angle. It's best to view leaves as mere texture by looking at trees from a distance. Too much detail can get in the way of observing, so squint to blur your vision. Ignoring the details will help you see the greater structure.

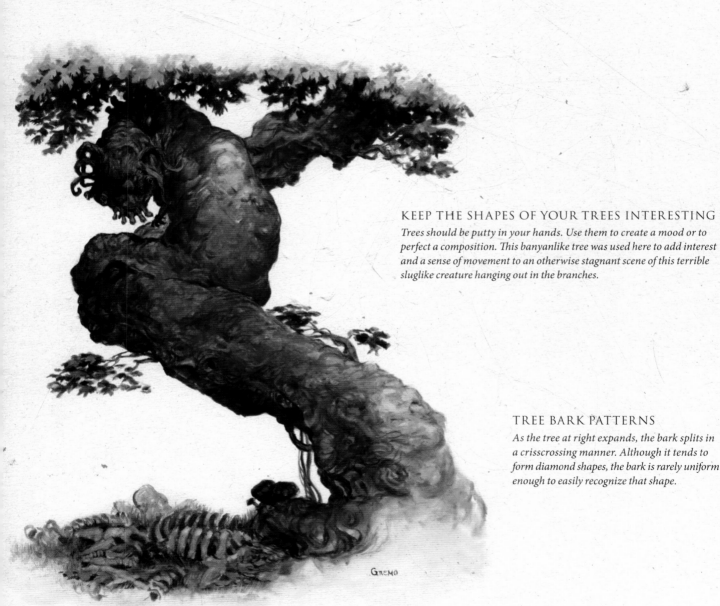

KEEP THE SHAPES OF YOUR TREES INTERESTING
Trees should be putty in your hands. Use them to create a mood or to perfect a composition. This banyanlike tree was used here to add interest and a sense of movement to an otherwise stagnant scene of this terrible sluglike creature hanging out in the branches.

TREE BARK PATTERNS
As the tree at right expands, the bark splits in a crisscrossing manner. Although it tends to form diamond shapes, the bark is rarely uniform enough to easily recognize that shape.

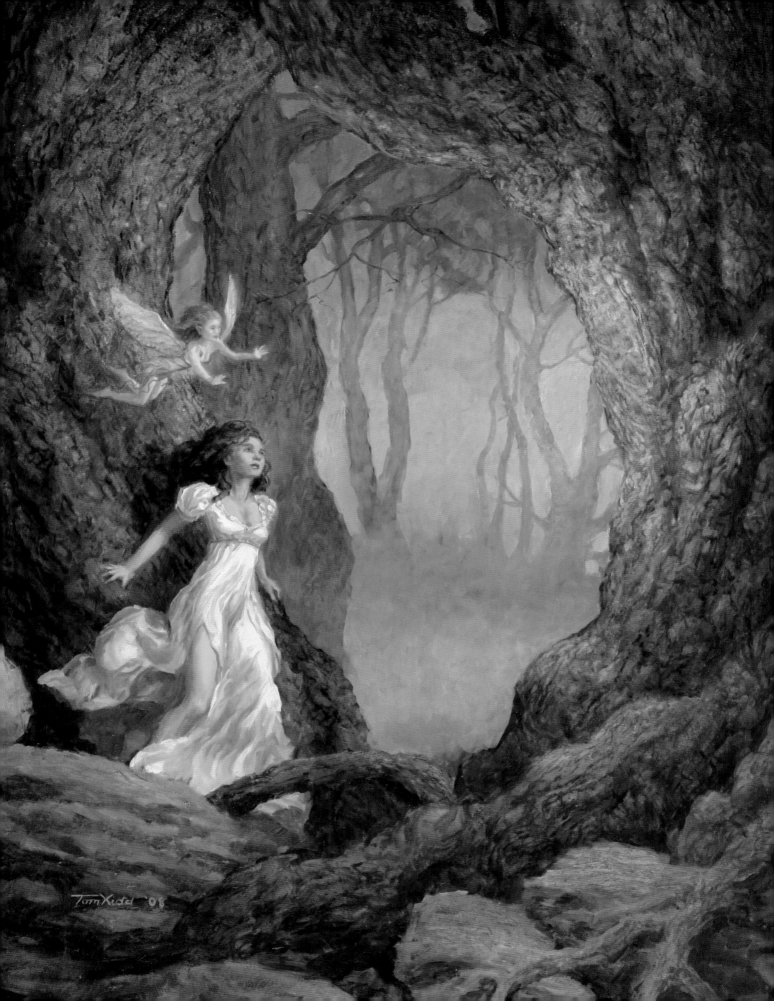

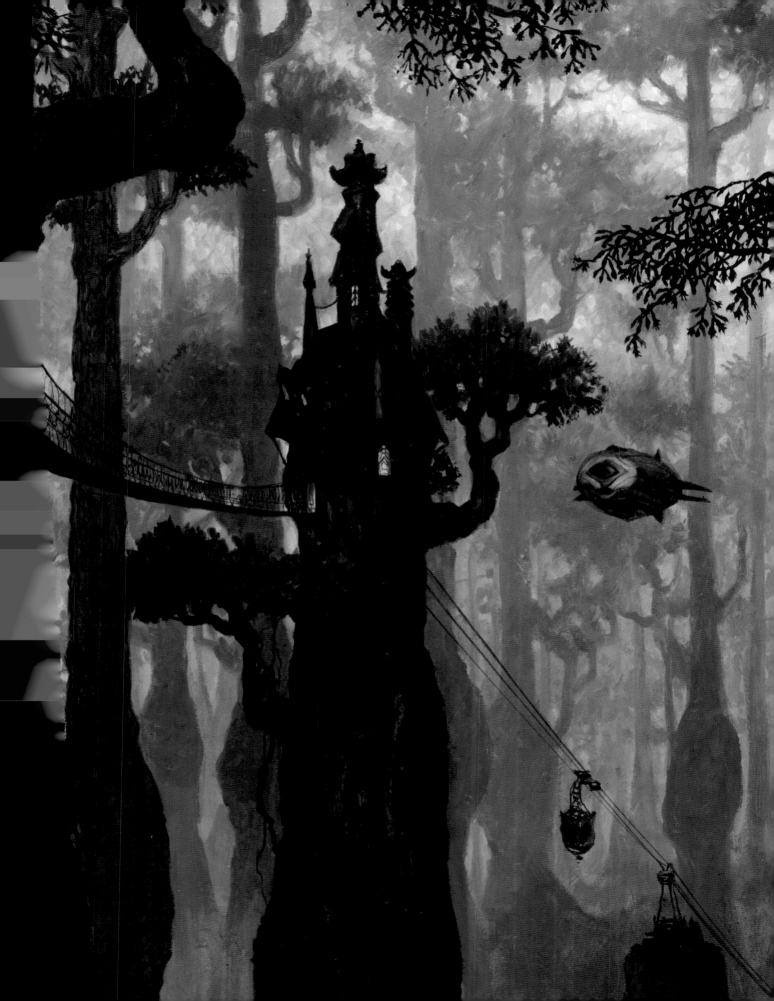

USE THIN PAINT TO MAKE BARK

This type of tree holds its nutrients in a bulge toward the bottom of its trunk. In this deep woods, it loses a lot of its color so you can barely see its green leaves. The roughness of the bark here is achieved by thinning oil paint with turpentine, letting it act like watercolor forming organic patterns, then painting the darker details.

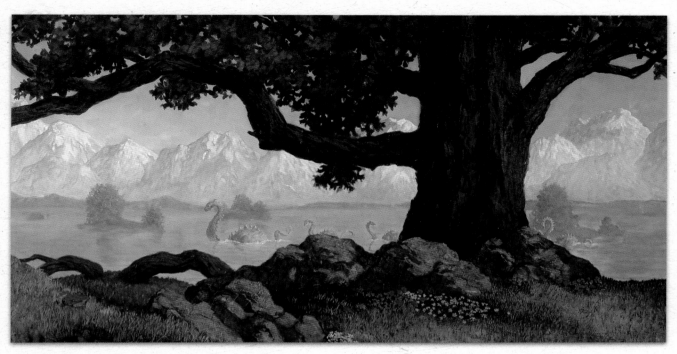

USE DRY-BRUSH TECHNIQUE TO CREATE THE TEXTURE OF BARK

Over a pretextured surface, build up paint with a dark color like Burnt Umber mixed with Ultramarine Blue to create a rough, physical texture (one you can feel) and let it dry. Then drag a brush lightly across the surface to leave detailed bits of paint that give the feeling of bark. This is called drybrushing.

EXAMPLE OF FLAKING BARK

The photograph above depicts the type of tree that flakes off its bark as the tree expands. Notice how the green from the grass bounces into its shadows; how the blue from the sky is in its shadows; and how light from a brightly lit branch bounces up to warm up the underside of another.

REALITY MEETS FANTASY

This was drawn from life to study tree form and a lady fairy faun was imagined into the scene. Mixing your fantasy and reality is a method for learning.

STUDY THE DIFFERENT COLORS OF LEAVES

Although leaves come in many shapes, they typically have similar properties that affect how they look. A backlit leaf glows a warm green. Front lit leaves are a darker cooler green, and leaves, because they are often smooth, can have strong specular highlights. They will often reflect some of the blue of the sky as well. Sometimes all these properties can be seen in one leaf. These leaves show many of these properties.

EVOLUTION OF A TREE (OPPOSITE PAGE)

This painting is a scene of a world being explored by airship. Among its crew of traveling naturalists is an artist who paints and draws what he sees, a common practice of the seventeenth and eighteenth centuries. The artist also has the job of naming the new species of life discovered. In this case, he named this tree species after an artist he admires: Franklin Booth, the great pen and ink illustrator.

GNARLY TREES SUGGEST EVIL INTENT

Give your trees some personality. Harsh or jagged edges tend to express danger. This tree suggests a stormy night.

A LUSH AND INVITING ROUND TREE SHAPE

Round tree forms signal that all is safe and wholesome. This tree reminds us of rolling cumulus clouds.

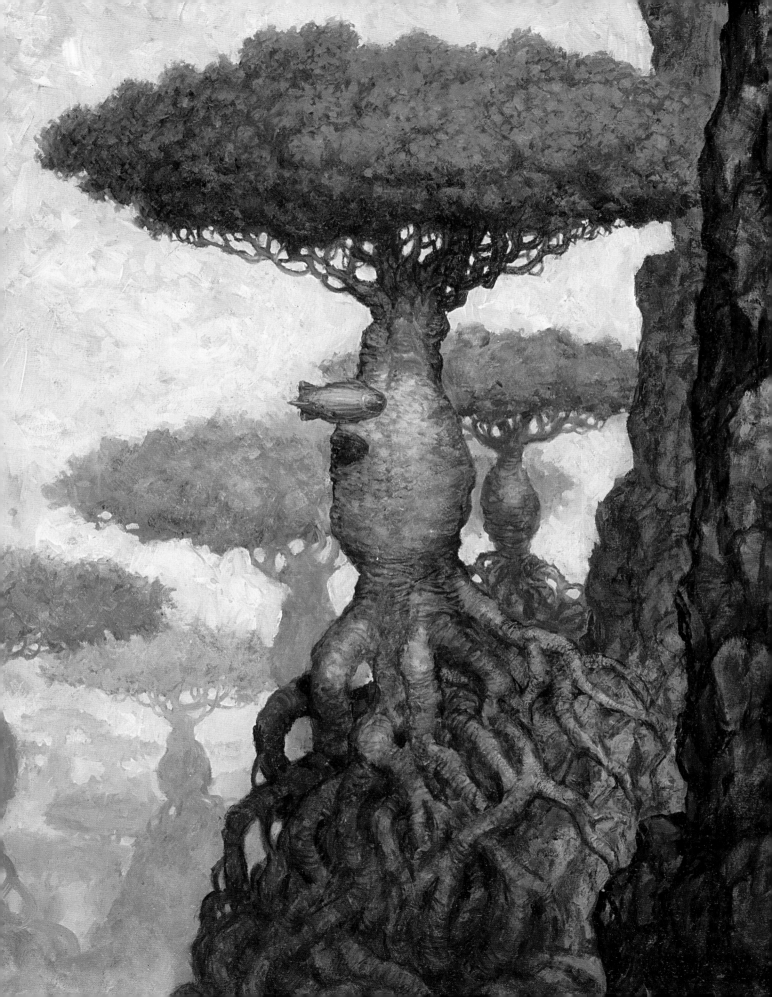

Songs of the Waltzing Trees

Materials

SURFACE
Gessoed Masonite board

ACRYLIC COLORS
Burnt Sienna
Burnt Umber
Ivory Black
Raw Umber

OIL COLORS
Burnt Sienna
Burnt Umber
Cadmium Orange
Cadmium Red
Cadmium Yellow
Flake White
Payne's Gray
Raw Umber
Sevres Blue
Titanium White
Ultramarine Blue
Viridian

BRUSHES
no. 4 bristle brush
no. 6 sable bright
no. 6 sable

TOOLS
no. 2 pencil
Linseed oil
Rag
Sketch paper

If you study nature, you'll see it has some unusual flora and fauna. Try to image it's 1831 and you're Charles Darwin traveling on the H.M.S. Beagle, exploring a part of the world very few have seen. We artists all have something of an adventurous spirit. Exploration is exciting for us. We want to see the world and more. Who's to say that the things we can invent through imagination and extrapolation can't exist somewhere? Some of the creatures I've invented, to my surprise, were later found to exist or to have existed. It's a funny thing when reality mimics fiction. Maybe one day on a distant planet we'll find ambulatory trees that waltz in the wind singing their particular siren song.

INITIAL SKETCH
This first sketch gave me the foundation of the idea—a torch within a tree of many branches.

1 Generate Multiple Painting Possibilities

How is it possible for trees to walk? They don't have muscles, they have roots. It would take a great deal of energy to move a large tree so how does it get its energy? Why would it walk anyway? Questions like these get the mind working to generate ideas for a painting. From my initial sketch, I reworked the idea of a torch being held inside a tree of many branches. This drawing was done primarily with a no. 2 pencil held on edge. This is a good way to get broad grays and tonal variety in a drawing.

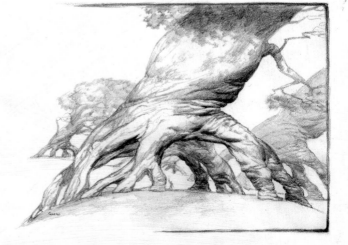

2 *Lay the Base Color*
Paint an acrylic ground of a varied mixture of Raw Umber, Burnt Umber, Burnt Sienna and Ivory Black over gessoed Masonite board, then dab and wipe with a moist rag to achieve a rough texture. The speckled, dark tone will give the paint that goes over some natural patterns of nature.

3 *Block in the Main Tree Trunk & Sky*
Lay in the main trunk with a transparent mixture of Titanium White, Flake White and Sevres Blue using a no. 4 bristle brush, refining with a no. 6 sable. Move the paint around to allow more or less of the ground color to show through suggesting the texture of stretching bark. Lay in the basic shapes of the trees using the colors above and random varied strokes, then dab the wet paint with a rag to add an alternate textural quality. Use Cadmium Orange and Burnt Sienna to hint the torchlight's reflection in the underside of the tree using a no. 6 sable bright. Using Sevres Blue, Ultramarine Blue and Titanium White, paint the sky so you can fix errant speckles and modify the tree's edges. Let dry.

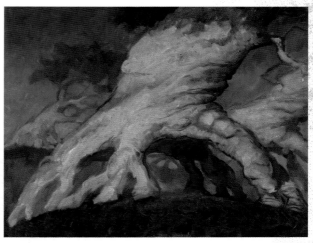

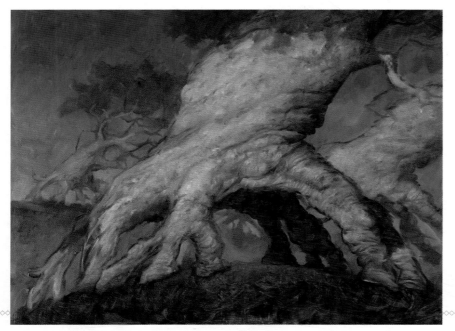

4 *Add Bark Detail & Balance the Warms and Cools*
Place an ultrathin layer of drying linseed oil over the trees. Use a no. 6 bright and Payne's Gray—transparent bluish gray—to add details to the bark. This paint will allow details underneath to show through but is dark enough for your shadows. For most details, the brush should be on its edge but use the flat side for the subtler shading. This same paint is useful in toning down the orange of the torch.

5 *Paint the Lady & Leaves*
When the painting is dry, create a mixture with Cadmiums (yellow, orange and red) and Titanium White (in its alkyd form to give the white a bit of a lift) to paint the figure and the torch. Mix Viridian with Payne's Gray to add shadow details to the tree in the foreground over the lighter strokes of Viridian that are already there. Viridian mixed with Titanium White is used to paint the highlights on the leaves and grass. These trees have a way of using the power of the wind to pull up and replace their roots to move across the land in a slow motion waddle. The figure of the scientist in the billowing dress and the blowing fire helps create a sense of the wind. Try to avoid symmetry to maintain a sense of movement.

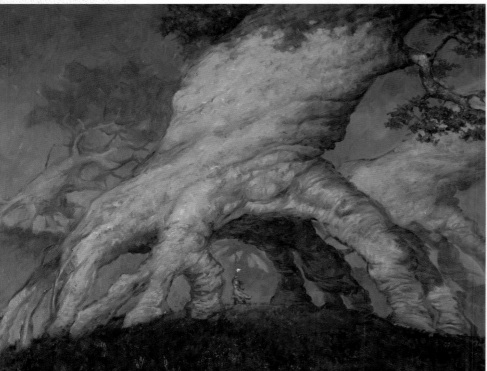

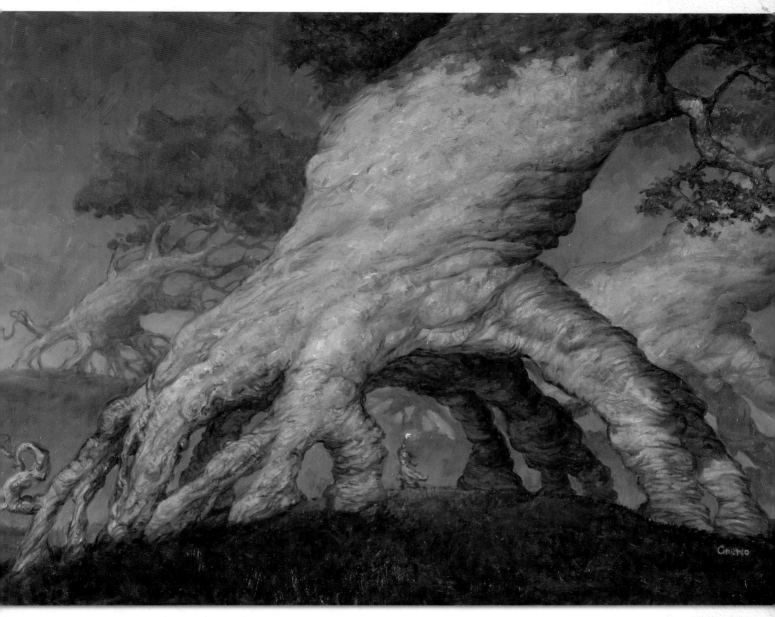

6 *Add the Finishing Details*
It's unlikely anyone would look at this painting and know quite what's going on, but it should make them wonder. Most people enjoy having their imaginations stimulated. I do. Your job with a painting like this is to intrigue the viewer enough to seek an explanation even if he has to come up with his own.

Look for the little details in this painting in its finished form. These are what give the picture verisimilitude. Too much detail would kill the picture but putting your details in smartly is the key. That will take practice and a lot of observation. You'll get a sense of it over time.

Add final touches, primarily shadows, by mixing a little of the basic colors of each object with a touch of Raw Umber, Payne's Gray, and sometimes Ultramarine Blue. The concept here is that the shadows will shift toward the sky color, which is the ambient color for this scene, except where the orange light underneath bleeds into those shadows. There you should use more Burnt Umber to fill the shadows. Little extra details like smaller floating roots are added to give the tree more life using the same colors as used in the tree trunk.

WATER

We have reached the crux of the matter. We've discussed ice, snow, clouds and atmospheric perspective caused by humidity; now we're talking about the root form of them all. After all, water makes up almost three-fourths of the earth's surface, and around 60 percent of the human body.

Water viewed from an oblique angle is a reflective surface. To paint water successfully, you must accurately capture its reflectivity. Water waves are similar (imagine a wavy mirror) except they are clear and refract (bend) light. It's best to consider the transparent quality of water and the reflective quality separately.

Water darkens what it covers because it's reflecting away some of the light entering the water. It deepens color the way a shiny varnish deepens color when applied to a painting.

Moving water has a tendency to form peaks and valleys, and peaks and valleys on its peaks and valleys. It can become violent and seem complicated, but it's really a series of concavities. Imagine it as ice cream that has scoops taken out of it many times with a variety of different sized utensils. Water becomes opaque when it foams. In this foamy form, it is made up of loosely connected bubbles that break apart into irregular islands of bubble groupings with oval breaks in the foam.

This liquid's ability to distort, reflect, refract and go opaque makes it a joy to paint. Even if you're not painting it directly, you can show the inexorable force of water's ability to cut through rock with erosion.

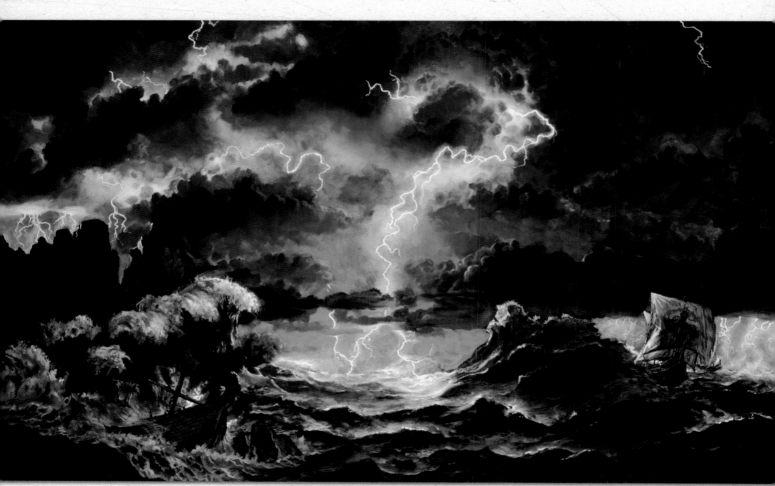

SENSE SHAPES IN MOVING WATER

Water is most interesting during a storm. It forms its tallest peaks and deepest valleys. It's also at its foamiest as water breaks over itself. If you can sense the shapes of these curving concavities, you should be able to paint them.

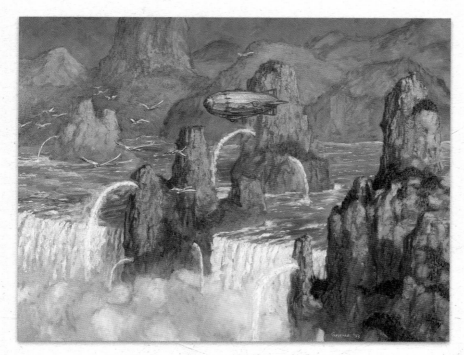

THE FURY OF WATERFALLS

Waterfalls are one of the wonders of nature. If you've ever been near a massive waterfall, you come away with a sincere respect for this formidable force of nature. I can no longer look at a painting of a large waterfall without imagining its deafening roar.

To paint waterfalls well, it helps to imagine them from above to sense the rushing water. The fall itself is 99 percent foam and that foam forms a shape of its own, separate from the water.

USE FOAM TO HINT AT WATER'S SHAPE

The foam that forms in water is composed of bubbles that cling together and float on top of the water. As such they're primarily white and opaque. This is unlike water, which is transparent or a mirror surface. Even though foam flows with the water, consider foam separate in terms of the area in light and the area in shade. This is easier if you're painting than drawing because you can paint the water first and then add foam. When drawing or painting foam, think of it as white continents that have been pulled apart by pressure to form irregular islands.

PAINT THE GROUND THEN THE REFLECTIONS

When painting a shallow, clear stream, I suggest ignoring reflections at first and painting the surface beneath (keeping in mind the distortion caused by refraction), then glaze in the reflections later. Try to paint the reflections from the point of view of looking up from the water, as if a wavy mirror is placed on the ground.

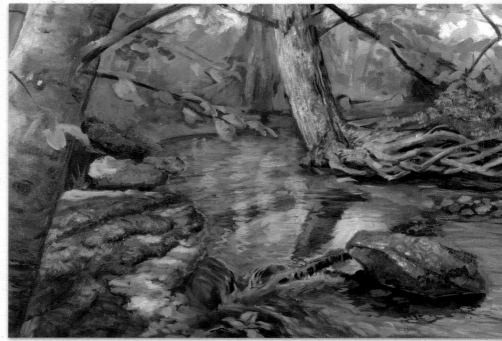

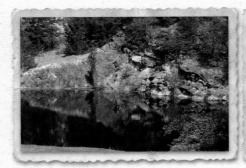

Water can act as a mirror surface. Turn your painting vertical when painting a scene like this to test your symmetry.

Even when water is forced apart by other influences, it holds together as best it can in the form of globules like this splattering water.

Look for the basic pattern of foam on the beach. Foam is opaque and clings together, then eventually breaks apart.

RANDOM SPRAY REQUIRES AN UNSTEADY HAND

Water spray can be difficult to make up because the human mind tends to arrange things too evenly. When painting the bubbly foam in water, use your brush in a random manner or use the hand you normally don't paint with to make these forms. Despite being white, the foam has a lit side and shadow side. Like clouds and snow they display both direct and ambient light.

CONSIDER THE EROSIVE PROPERTIES OF WATER

As with all natural wonders you create in your imagined world, take into account the erosive properties of water. Over time the water will eat at the stone beneath it and create unusual patterns and paths through the rock. By extrapolating from this reasoning, you will be able to paint something no one has seen before. For example, how many classic gardens are found next to a series of tiered waterfalls?

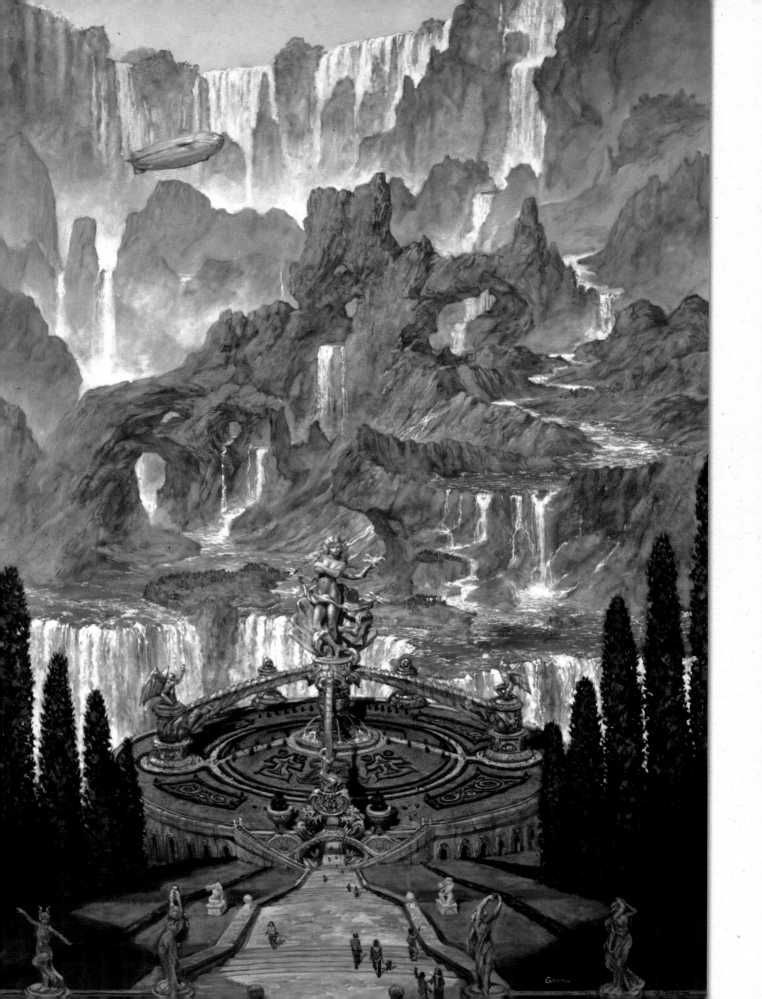

Night Scenes

How do you light your worlds after the sun goes down? The light from the sun lights the atmosphere for a while after the sun goes down. If you've ever taken a walk on a moonlit night in a rural area, you know that it's possible to see quite well. For the sake of better sight our eyes give up a bit of their ability to see color in dim light. The world becomes a pale place with deep soft shadows. Yellows are almost absent and red turns maroon or black. For this reason, a cloudless sky isn't a deep solid black filled with stars as it looks to be. The atmosphere still diffuses light from the moon or other man-made lights. As your eyes adjust to a moonlit night, you'll be able to see more and more. If you look at any homes around you, any lit room will glow orange with incandescent light or send the dominant color of a brightly painted wall out its window.

The moon casts deep shadows that can add mystery to any fantasy scene. The dark sky allows very little ambient light to fill them.

A city is dotted with thousands of weak light sources that create an ambient glow that can be seen in the form of atmospheric perspective and are visible even from an airplane. Each light source will illuminate only a short distance from its origin. Keep this in mind as you light all the subjects of your painting. Everything will be lit from different angles and sometimes multiple angles. Some will even become silhouetted by the light. Your light will also have color, and those colors will not all be the same. Place your light where it serves you and your narrative best.

ARTIFICIAL LIGHT AT NIGHT

Like the daytime sky, the night sky will pick up the color of the dominant diffused light. The weak light coming from buildings can cast some odd colors and create the feel of an alien world even when you're on earth.

USE A COOL PALETTE TO PAINT NIGHT SCENES

There's nothing more romantic than a night sky lit by the cool soft colors of the moon. And if you're lucky, you might see the first ship of a Martian invasion streak across the sky. As you observe the world at night, you'll notice the spots in shadows with little discernible shapes but, for the most part, the world is still full of light. This means that night scenes needn't be painted especially dark. If you use less intense colors and shift your palette to cool colors, a person will see the scene as taking place later in the day. Filmmakers shoot night scenes in the day with a blue filter on the camera lens.

CAPTURING THE MOMENT (OPPOSITE PAGE)

As your eyes look around at night, they'll adjust to the amount of light that's entering them. Look at the full moon and you'll pick up some of its details. Look away and it'll become a white ball as your eyes adjust to the darker scenery. As a painter you have a choice in how you paint things. You can show the moon, or moons, with a great deal of detail while showing detail throughout the scene as well. This painting is based more on the full memory of something rather than only a moment.

LIGHT-COLORED OBJECTS BEST PICK UP THE MOON

The light from the moon is diffused somewhat to create some ambient light at night, but only light-colored objects will pick up enough of it for a person to see in shadows. Even middle tones will lose all their details when in shadow at night.

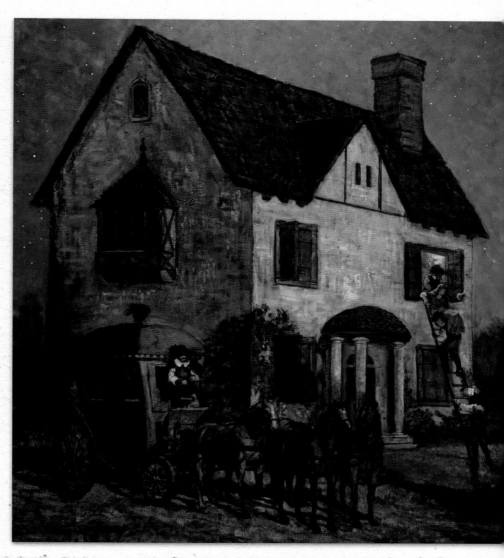

STRUCTURES WITH ARTIFICIAL LIGHT

Photographing at night captures numerous building lights, but a camera does not see the night as clearly as your eyes. Taking photographs and studying how artificial light works will help you invent scenes using magical light.

THE VARIETY OF ARTIFICIAL LIGHT

Artificial light has many sources and colors so it creates more complicated light and dark areas than the uniform light from the sun and moon. Artificial light also diminishes more than sunlight over distances.

IDENTIFY ALL OF THE LIGHT SOURCES

Before painting a city at night, work out most or all of its light sources. Keep in mind that not everything will be lit by the same light source.

On a sunlit day, warm colors come in more directly through the atmosphere, and cool colors are diffused and fall into shadows. With incandescent light at night, you can throw all those notions out. You should still compose with warm and cool masses though because that's what we instinctively feel as natural.

This night scene is composed of tonal masses. The center part of the picture forms a lighter mass and is surrounded by what amounts to a dark rhomboid. In the distance is another lightly glowing mass placed to provide a sense of depth. The center of interest though, is the strangely lit, light blue tonal mass of the giant skeleton. All of this is to create a strong feeling of mystery.

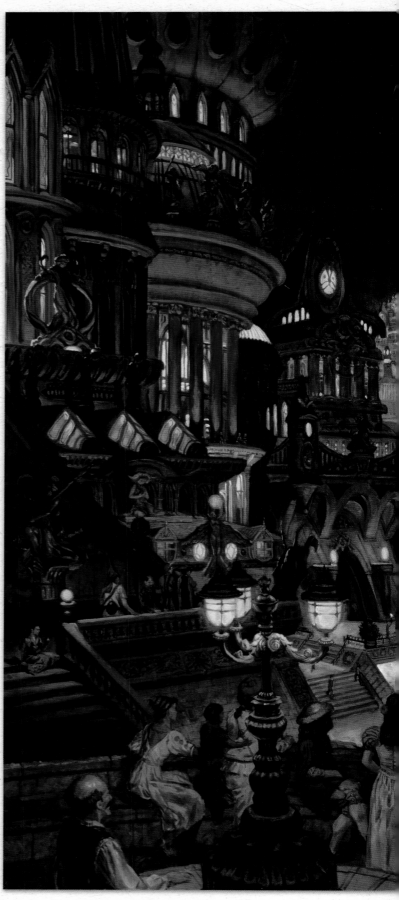

The night is, of course, for mystery, romance and intrigue. Study it like a master detective would, but don't be afraid to stretch the rules a little for the sake of effect.

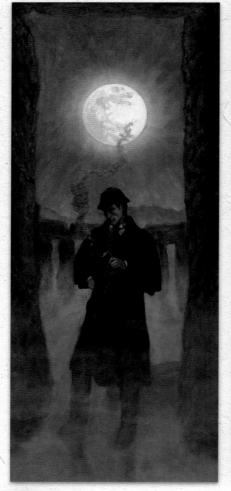

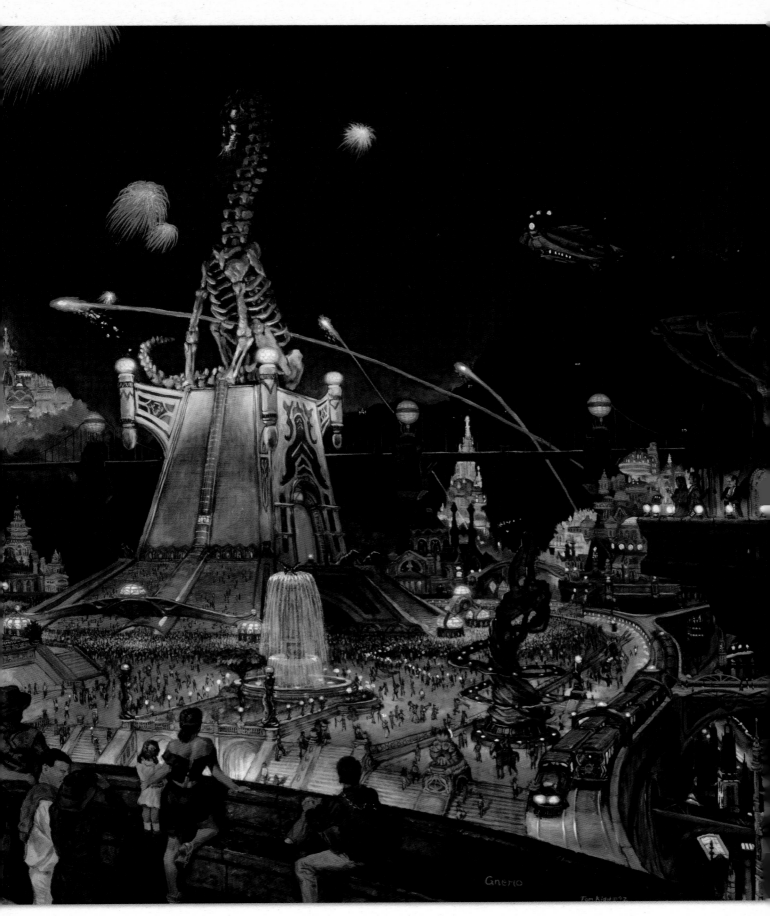

Gnemo

Tom Kidd '97

137

Birds of the River Night Scene

Materials

SURFACE
Gessoed Masonite board

ACRYLIC COLORS
Burnt Umber
Phthalo Green

OIL COLORS
Burnt Sienna
Cobalt Blue
Flake White
Ivory Black
Manganese Blue
Ochre
Payne's Gray
Permanent Rose
Phthalo Blue
Raw Umber
Titanium White
Turquoise
Ultramarine Blue
Ultramarine Violet
Viridian

BRUSHES
no. 4 bristle
no. 8 sable bright

TOOLS
HB pencil
Sketch paper
Linseed oil
Rag
Adobe Photoshop

A fantasy book cover should be intriguing, capture the feel of the book and tell a story of its own. If available, you should always read the book when you do a cover for it and trust the art director to steer you in the right direction. This book, The Bird of the River *by Cage Baker, came with a manuscript but no clear scene that represented the book well. A cover differs from an illustration in that it represents the whole. It doesn't have to be a literal scene from the novel, but it shouldn't be something unlike anything in the novel or a scene not representing the book. A fantasy or science-fiction book cover should have something of a fantastic nature on the cover even if the book is largely dialogue. Concepts can be portrayed visually.*

GETTING THE IDEAS FLOWING

When you're trying to generate ideas for a book cover, it often works to just draw anything that might be in the story rather than being particularly directed. The idea process is more about problem solving than drawing. Aesthetics are not important at this point.

- *A small element or a character from the book. In this case, demons were the right springboard into ideas. (right)*

- *Getting the genre right is important. Caged demons leering at the beautiful protagonist seemed more like an editorial on men and women than fantasy. (bottom left)*

- *Though acceptable, this scene of demon pirates planning an attack wasn't quite right for the art direction. (bottom middle)*

- *Here's a good concept, but bad cover. The story takes place on a barge that cleans a giant river of dangerous debris. A scene of the ship lifting a massive fallen tree out of the water seemed like a nice idea, but was not dramatic enough. (bottom right)*

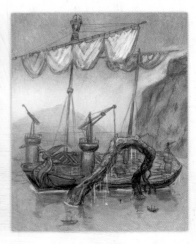

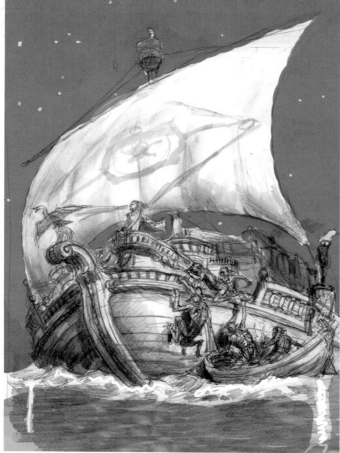

1 The Selected Concept

You can see how the pieces of the earlier exploratory sketching and resolving of problems come together in the drawing submitted—and chosen—by the art director. This drawing has a greater sense of anticipation than the other sketches.

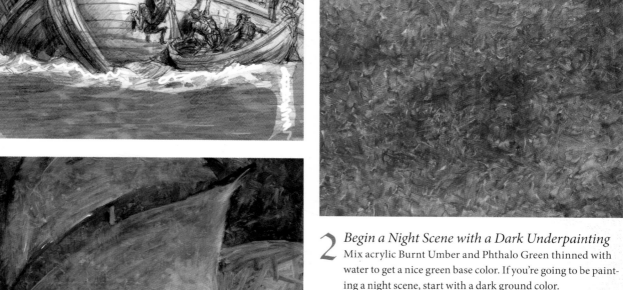

2 Begin a Night Scene with a Dark Underpainting

Mix acrylic Burnt Umber and Phthalo Green thinned with water to get a nice green base color. If you're going to be painting a night scene, start with a dark ground color.

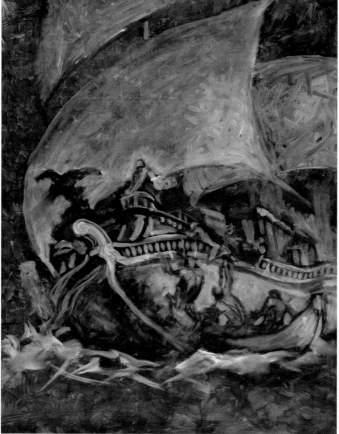

3 Block in the White Forms and Shadows

Build your basic forms on top of the dark ground with Titanium White thinned with linseed oil. Keep a rag handy to wipe out and modify your light forms as you would dark ones. Use Burnt Umber for the darker areas like cast shadows using a no. 8 sable bright, and for thinner areas, a no. 4 bristle brush.

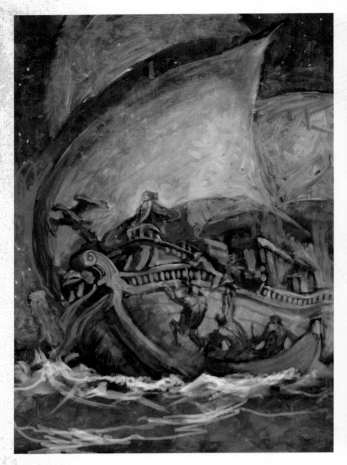

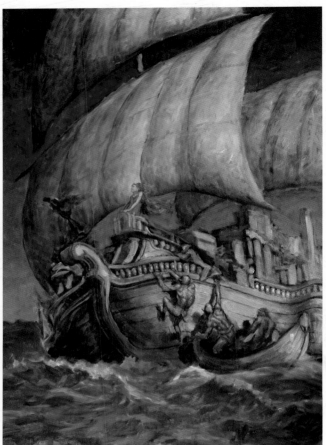

4 *Perform a Digital Color Test*
On the computer, do a digital color sketch on a photograph of the painting after step 3. On the computer, you can be much more experimental with color and form until you figure out the direction you want to go. Before the digital age, Norman Rockwell did color sketches over photographs of his sketches and underpaintings. This approach is not that different.

5 *Add Midtones With a Limited Palette*
Using your digital color sketch as a guide, glaze in color in a semi-translucent manner to save some of the patina beneath. Use a limited palette because the eye sees less color at night. The colors I used at this stage are Manganese Blue, Phthalo Blue, Flake White (for its translucent qualities), Cobalt Blue, Turquoise and Ultramarine Blue. A mixture of Burnt Sienna with a touch of Manganese Blue is used to add a warm coloration to the ship and the white in the sails. Because this is an old ship, you'll want to avoid blending smoothly. Every bit of it is weather worn, especially the sails.

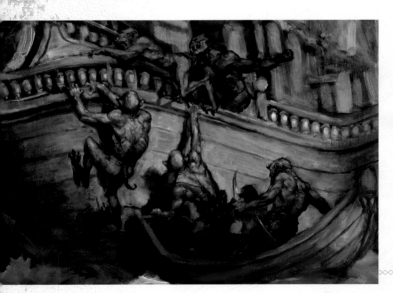

6 *Block in the Figures*
Typically you will work from background to foreground in a painting, but at this point it makes sense to resolve figure placement first. The demons are interacting with the ship so both are roughly painted in at once using a no. 6 sable bright and Raw Umber. To refine and paint the moonlit areas, use a no. 4 with a mix of Raw Umber, Viridian and Titanium White. Use Burnt Sienna and Ultramarine Violet in the two boats.

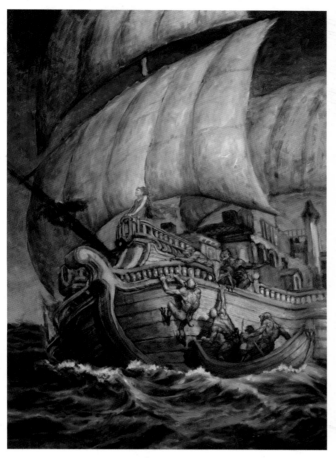

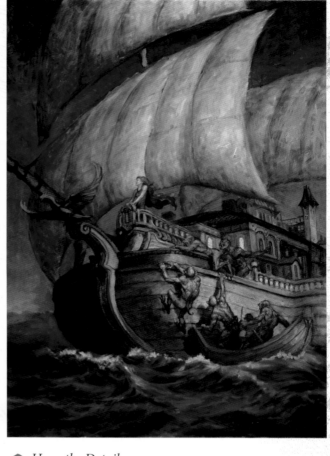

7 Add the Darks and Highlights

In this night scene, the water is the darkest dark because it is absorbing the light into its depths. As a rule, highlights are opaque and darks are transparent. Glaze Ivory Black, Ultramarine Blue and a touch of Viridian for the darks. For the opaque highlights, mix Phthalo Blue and Manganese Blue with a bit of Titanium White.

8 Hone the Details

Let the vague forms in the background lead you to interesting details. The loose forms will help stimulate your imagination. Paint a few details with a mix of primarily Raw Umber with Payne's Gray and a bit of Manganese Blue to keep it moonlit cool. Background details shouldn't be distracting and are important to establishing place and mood. Don't go too dark in the background. Keep your shadows light.

Always be ready to change your plan but don't be capricious: Here, I've changed the masthead so the bird is more prominent and the wings are more sweeping. The railing in the front of the ship has been removed and replaced with a solid color—a mixture of Ultramarine Blue and Ultramarine Violet. The sky and water in the distance has been lightened and warmed with pink using Permanent Rose and Titanium White. I also altered the girl's gesture to make her seem even more oblivious to the demons.

This sepia pen and ink still follows the basic shape of water and breaking waves even though it is made up of lines and not paint. No matter the medium you can follow the pattern of nature.

9 Tie the Painting Together with Final Details

Well-balanced details give your painting solidity and make it more interesting. Though you'll want to add them in sooner than later, it's best to exercise patience. By coming in closer, much bigger than the original painting in this case, you can see better how the paint is handled. Paint, being a natural substance, doesn't apply evenly or in an additive manner only. Often a brush takes off more paint that it puts down, depending on its stiffness. This is something you can take advantage of along with the paint's varying translucency and fluidity.

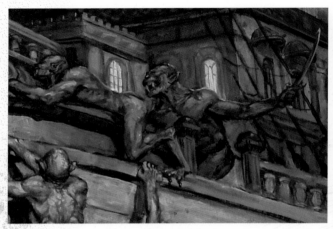

Add in some weaponry and reflections of the glowing cabin light off the backs of the demons, as well as in the water.

Notice how the brushstrokes are quite pronounced. Some of this is the result of the underpainting showing through.

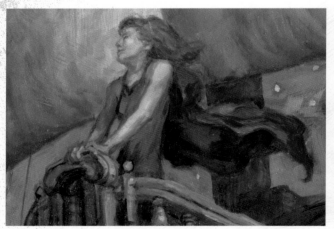

Add touches of additional color to the rigging and mast. The girl's hand gestures, expression and head angle were changed to make her seem more relaxed, happy and oblivious.

The sails are painted with translucent thin paint (Phthalo Green, Manganese Blue and Turquoise) for their darks and heavy (thick) whites (Titanium White mixed with Ochre and Burnt Umber) for the lights. The brushwork is consciously random and physically textured to imitate the effects of aging on the canvas sails.

142

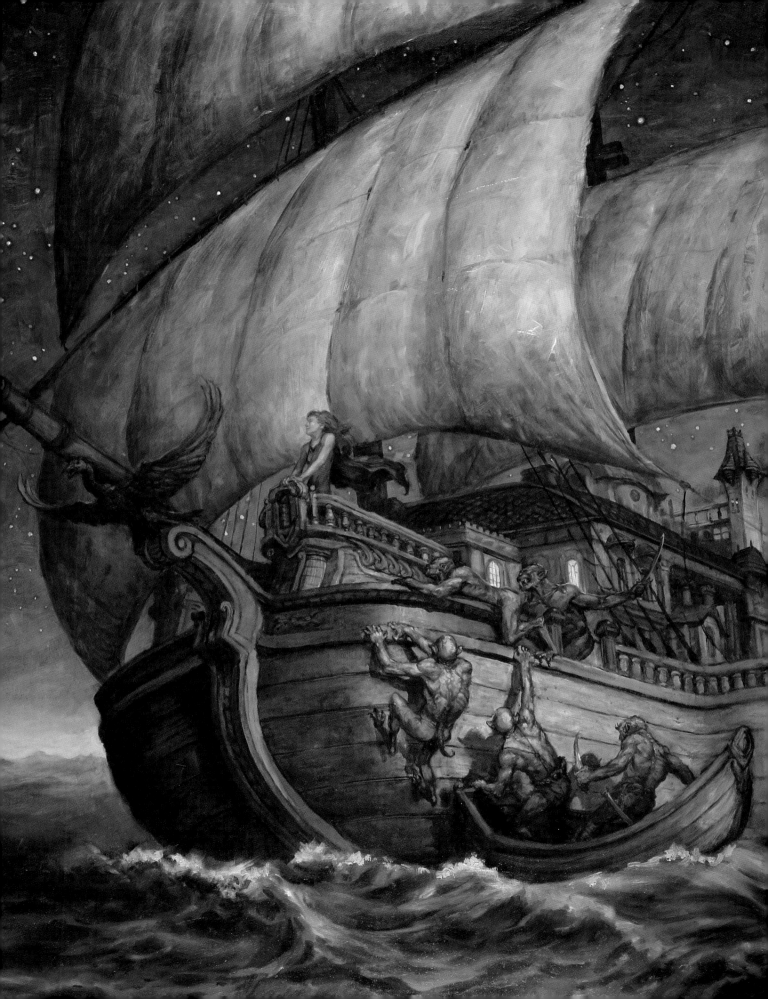

HARD ROCK

Let's compare rocks and clouds. As soft and insubstantial as clouds are, they are opaque. Same with rocks. Though some rocks are transparent and more are translucent, most are as opaque and matte as clouds. Unlike clouds, rocks have a great variety of forms and textures. They are both objects of nature and follow fractal geometry in their greatly differing shapes. The pressures of weather create clouds, and the force of erosion gives most rock formations their shapes.

There are a few approaches to creating rocky shapes and textures. It's best to plan your rocks, rocky cliffs, outcrops and eroded mountainsides in terms of their shape, tactile texture and patina. Begin with the shape to get a sense of the three-dimensional ins and outs of your subject, then add in texture and patina. You can also begin with texture, then lay or glaze in shadows to reveal the shape. Yet another approach is to paint carefully all of the forms and to glaze in the texture transparently. Watercolor is a great medium for rocks, though the key to success will be to let the medium do much of the work for you.

DIMENSION, TEXTURE AND LIGHT (RIGHT)
Wherever you go in the universe that humans can personally explore will likely have some rocky surfaces. Erosion or tectonic upheaval will likely reveal it. As long as you think in three dimensions, age your rocks with discoloration and texture, and light them according to their surroundings, as a rock artist, you can't go wrong.

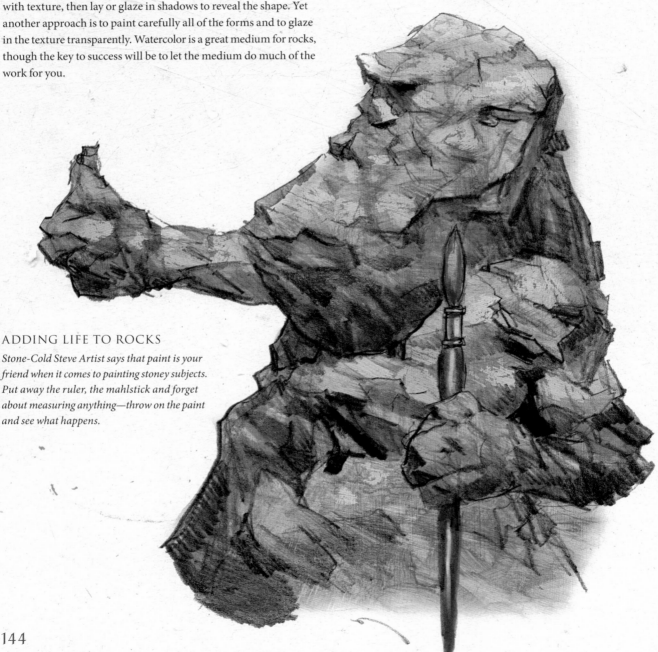

ADDING LIFE TO ROCKS
Stone-Cold Steve Artist says that paint is your friend when it comes to painting stoney subjects. Put away the ruler, the mahlstick and forget about measuring anything—throw on the paint and see what happens.

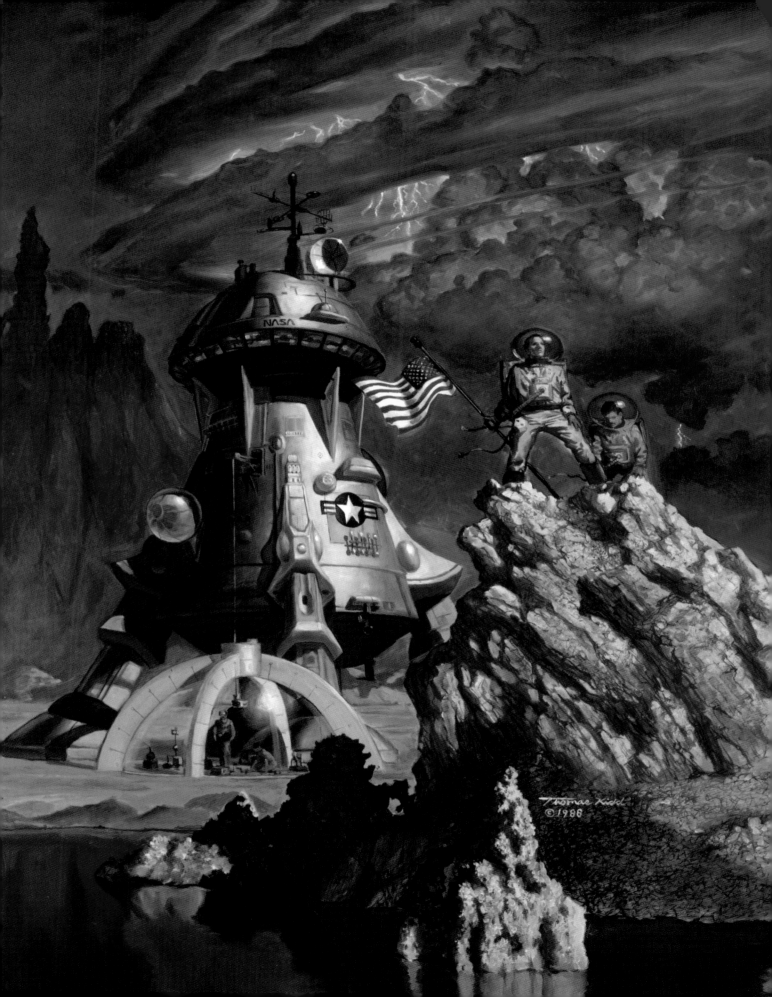

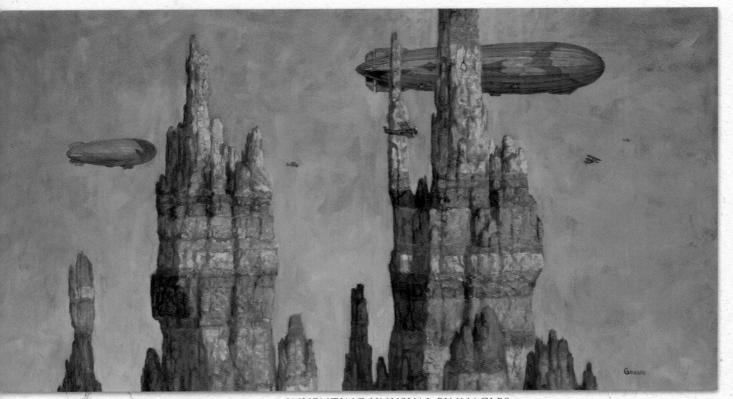

INVENTING UNUSUAL PINNACLES

If rocks follow the rules of form and texture, however garish, under the right conditions they can exist. Like flowers in the spring, these cliffs take on brilliant colors because of the lichen attracted to their strata. This lichen uses the natural minerals in the rock to change its color and attract insects that will carry its spores far and wide.

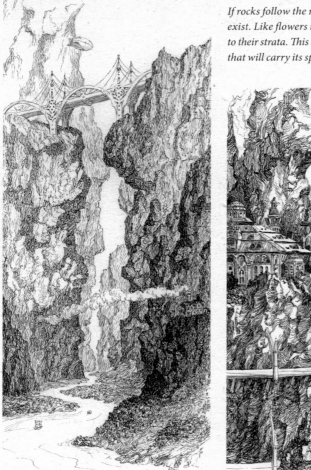

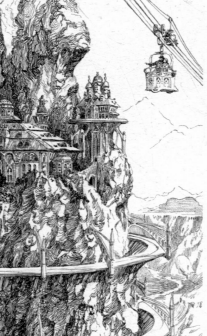

USE PEN AND INK FOR ROCK TEXTURE

Pen and ink can work well as a medium to depict rocks. You can vary your line in a way that reflects the texture of stone in, at least, an associative way. You can also show rock in pen and ink with jagged edges, rough broken lines or by defining the shapes with many flat planes.

TALL ROCK SHAPES EXHIBIT A FORBIDDEN QUALITY

Towering rocky cliffs with sparse vegetation can be used to express inhospitableness so it makes any structure built atop it even more impressive. If you want to give the viewer a bit of vertigo while you're at it, suspend people in the air by wire.

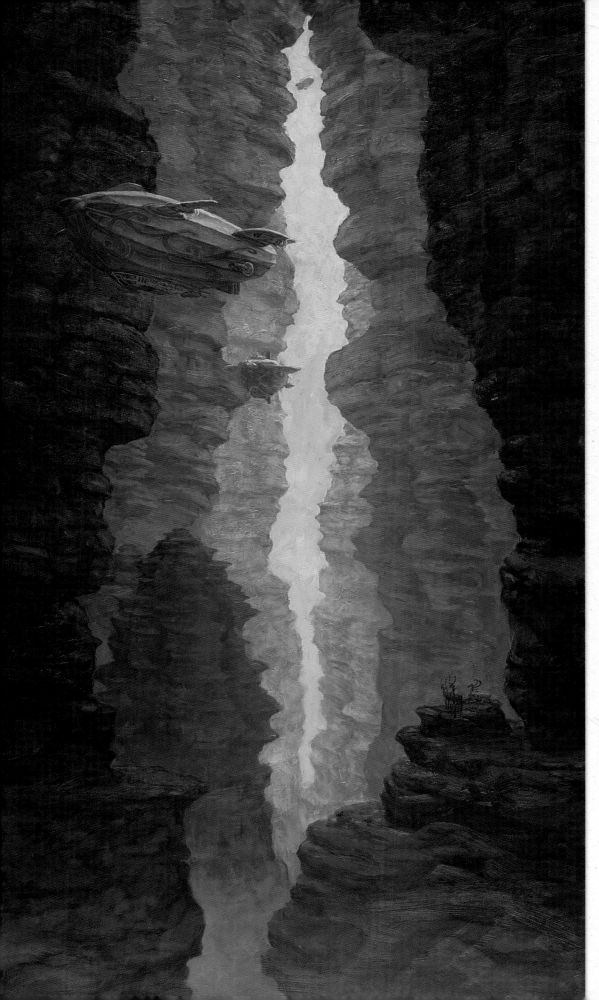

ROCK READILY PICKS UP AMBIENT COLOR

Rocks tend to be of the gray, brown or white variety so they reflect the color of the light hitting them as seen in this unusually lit piece. The warm light making it into this scene is all bounced light coming from sun. Each time it hits the cream-colored rocks as it works its way into this crevasse, it loses some of its warmth. Eventually the rocks are only in shade and reflect back the color of the sky's ambient light, a deep blue.

Grand Pebble

Materials

SURFACE
Gessoed Masonite board

ACRYLIC COLOR
Burnt Sienna

OIL COLORS
Burnt Sienna
Cadmium Yellow (alkyd)
Cadmium Orange
Indian Yellow (alkyd)
Ochre
Payne's Gray
Permanent Rose (alkyd)
Raw Umber
Titanium White
Titanium White (alkyd)
Transparent White
Turquoise
Ultramarine Blue
Ultramarine Violet
Viridian

BRUSHES
no. 8 sable bright
Various old brushes for texture

TOOLS
HB pencil
Sketch paper
Plastic wrap
Turpentine

Our world has many wonders created by nature, awe-inspiring places such as Victoria Falls in Africa, Grand Canyon, Mount Everest, Yellowstone National Park and Meteor Crater. As a painter of fantastic places, you have to imagine yourself as an explorer who is seeing something amazing for the first time. The key is to always be thinking and looking. Ideas for your epic scenes can come from the small things you'll see on a walk, from unusual things you see from a train or car, by extrapolating from a science article you've read, or as the answer to a "what if" question you ask yourself. In this case the question was, what would it look like if a giant oceanic volcano shot a massive rock out—like a pea through a pea shooter—to land miles away on land.

 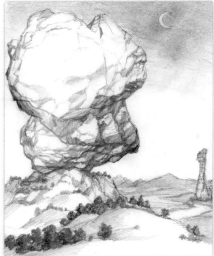

1 Save your Ideas with Quick Sketches

The idea sketch is essential to your fantasy landscape. Get that idea down while it's fresh. Collect and save your ideas even if some never get painted. Often one idea leads to another or ideas get combined into something new.

2 Create the Basic Rock Shape

Alkyd oils are a bit gooey and dry quickly, making them a great choice to create physical textures like rocks. Mix some alkyd Titanium White with a touch of Ochre, and apply it thickly to a surface. Let it dry partway, then press dry plastic wrap or a dry balloon into the thick semiwet surface. When you pull it up, all sorts of interesting peaks will be left. That is the beginning for our rock but not the only texture-forming trick to be used.

3 Block in the Sky

While the rock dries, paint in the background. An overcast sky will help define the shape of the rock and help lead the viewer's eye. Apply a variety of subtly contrasting colors such as Ultramarine Blue, Ultramarine Violet, Permanent Rose, Cadmium Yellow and Turquoise but mostly Titanium White. Apply the paint in a crisscrossing, random manner with a no. 8 sable bright.

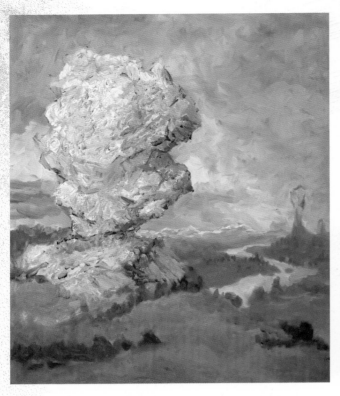 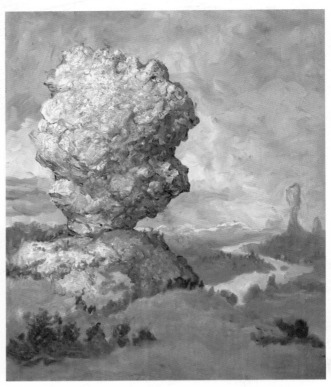

4 *Paint Background & Add Details to the Rock*
While textured paint on the rock finishes drying, paint loosely into the sky and background. This step should be completed alla prima, meaning all at once or in one sitting. Because there are a number of clouds in the sky, much of the far background is painted in shadow. First, paint these shadow tones with the same sky colors used in step 3 but with less white. Paint the grass with a warm mixture of Viridian, Cadmium Orange, Cadmium Yellow and Titanium White to bring this area forward in terms of depth and make the distant areas seem more distant.

When the rock is nearly dry, embellish its texture to make it stand out more. Create a mixture of Raw Umber, Burnt Sienna and Indian Yellow and mix it with turpentine until it becomes watery. Drip it into the surface of the paint while the painting is flat. It will seep into the valleys of the paint. Apply a bit more of that paint in its runny form to add shadows and shape without losing detail. Let the painting dry.

5 *Drybrush Texture into the Rock*
Sand or scrape into the surface of the paint to vary the texture so it doesn't have one textural note. Many forces are at play in nature giving surfaces their variety, so seek to mimic these multiple influences. To further highlight some of the physical texture, mix Titanium White with Cadmium Yellow. Hold the brush on its side and lightly drag across the rough surface of the rock texture so that bits of paint are left behind.

6 *Glazing Back Toward the Finish (opposite page)*
The rock is the center of interest in this painting, but it isn't the closest object. We established the level of contrast in the painting first by painting in the trees. This helped to place the rock visually. Push back the rock and other objects such as the mountains by glazing glaze into objects to lighten them and lessen the contrast. Use a mixture of Transparent White with a touch of an opaque white such as Titanium White as well as a blue found in the sky.

Add more trees and vegetation if the foreground feels empty. Paint them with a light layer of Viridian mixed with Titanium White and a small amount Burnt Sienna. Start adding in darks with a mixture of Viridian and Payne's Gray. The process of adding darks and lights to trees can go back and forth until you're satisfied with the results.

Gnemo

Structures

As a fantasy artist, you'll be called on to paint all sorts of structures—steampunk alien radio towers, massive killer insect nests or towering robot drilling wells that have taken over a city. It's best not to become too set in your ways or your next assignment is sure to throw you. All our discussions up to now have been about natural phenomena—water, rocks, clouds, etc. I wouldn't call architecture or any other man-made structure unnatural. To me humans are as much a part of nature as any other creatures, so how can what we make ever be outside of nature? The key to designing excitingly beautiful and interesting structures is to follow the rules of aesthetics while allowing your imagination to run wild.

Castles are some of the most beautiful structures, even though they were merely built as fortresses to hold off armies. Often they were built over time with new wings and extensions added on and new buildings constructed within. Though the purpose of the castle walls and turrets was defense, they developed organically and are therefore as pleasing to see as an orchid.

The key to inventing a nice structure is to limit yourself to designing for its purpose. Beyond that you can look to nature for hints on how to build. Too much repetition, too many details in one spot, perfect geometry and perfect symmetry are abhorrent. Like plants, structures should repeat their important structural qualities in a varied way.

Many structures in ruin are more beautiful than they were the day they were built. Eventually nature will come in to right the wrongs of bad architecture and give it the character it was missing when it was designed.

CLEAN, STRAIGHT LINES CAN INDICATE THE FUTURE

A gleaming city of the prefabricate future, nearly windowless, barren and scrubbed clean hourly. Life here is perfectly orderly and you can paint it with a ruler and a few quick strokes.

MULTIPLE LAYERS CREATE CHARACTER (OPPOSITE PAGE)

Here is a city in ruins with life and entropy are working to consume it. This city will take many layers of paint to portray with all its character intact despite being in shambles.

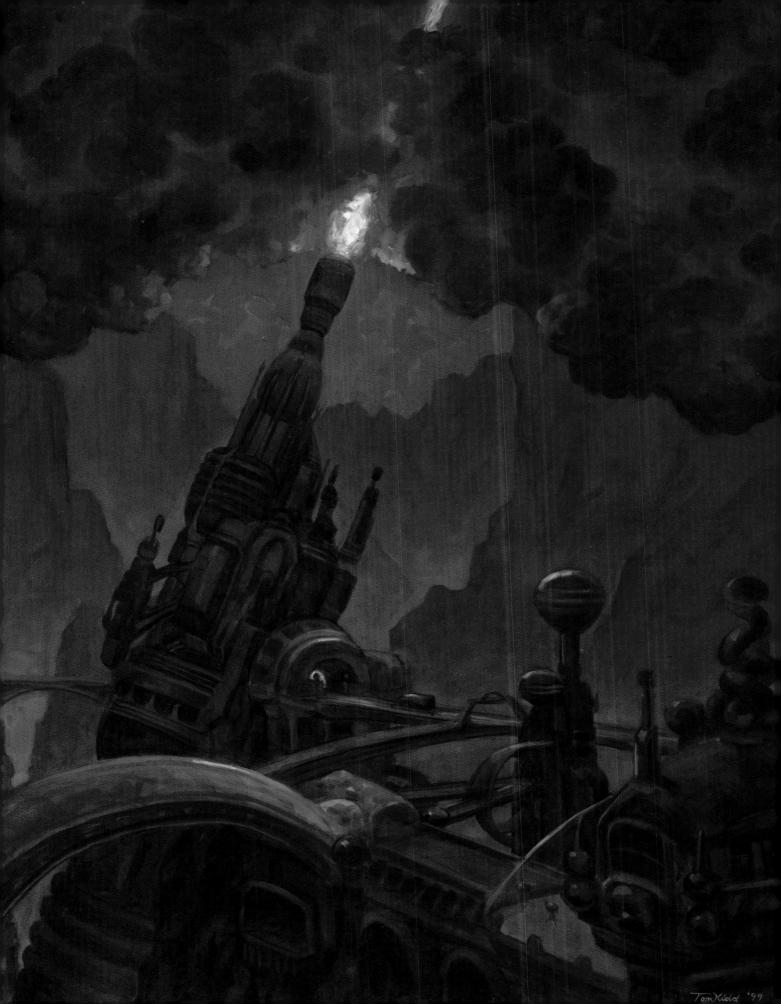

NOT ALL STRUCTURES ARE BUILDINGS (OPPOSITE PAGE)

This is a launch pad at night on the Red Planet that uses a colossal cannon to fire Martian pods into space toward Earth (see it arrive on page 133).

CONSIDER THE ENVIRONMENT

When inventing strange new cities and architecture, consider the environment it's going in first. Often the rest will fall naturally into place. The weather, the landscape, the need to protect against enemies and technology will greatly affect the structures in your cities.

TAKING IT TOO FAR OR NOT FAR ENOUGH?

You can certainly go too far when designing an ornate city. I have many times. But how do you know you've gone far enough? This takes some time and experience but mostly trial and error. Often you'll need to go overboard and then go back and simplify areas of your picture. These are all rejected structures that became a tad too gaudy, though they do have useful elements that will work their way into future paintings.

155

Aerial Yachts & Wild Thymes

Materials

SURFACE
Gessoed Masonite board

ACRYLIC COLORS
Burnt Sienna
Phthalo Green

OIL COLORS
Burnt Umber
Flake White
Indian Yellow
Manganese Blue
Titanium White
Translucent White

BRUSHES
no. 1 sable round
nos. 4, 8, 12 brights
large bristle
sponge brushes

TOOLS
Rag and/or paper towel
HB pencil or charcoal
Sketch paper
Adobe Photoshop
Linseed oil

On nice days I like to go sailing in my flying yacht. Strangely, my yacht is not as luxurious as the giant skyliner in this demonstration. Although they both only exist in my imagination, I prefer my sky ship to be small, fast and maneuverable. This exercise combines strong tonal masses, clouds, and even though it's a man-made object, the fractal geometry of nature. The best design always has its roots in nature.

My plan is to create an exciting otherworldly scene that is inviting and has a familiar feel to it. This painting will be used on a book cover for an anthology so I want it to carry the feeling of the book. The book's title is Wild Thyme *by Jack Vance. Much of it takes place in a future where amazing things are possible, although clearly not a utopia.*

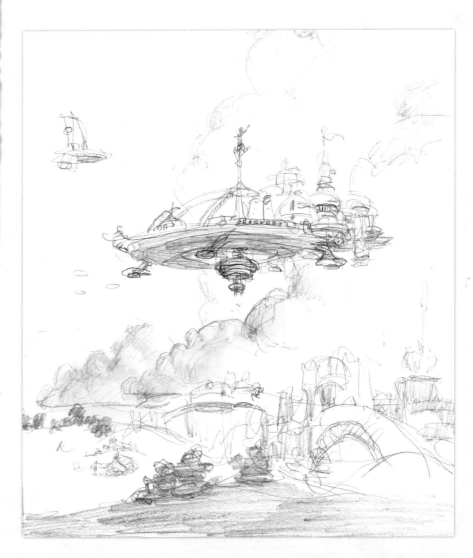

1 Scribble Out your Initial Ideas

If you want to get the most ideas out of a drawing, scribbling is the best way to accomplish that. Get the ideas down fast and have no worries where your lines go. They can lead you to strange places, solidify vague ideas or determine an idea ineffective. After each sketch, close your eyes and try to imagine the drawing fully painted.

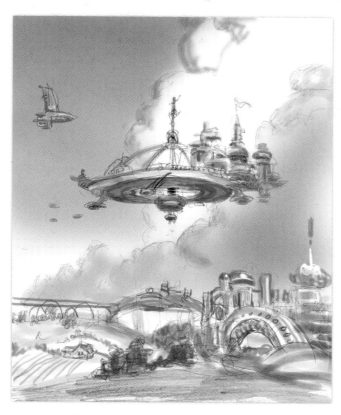

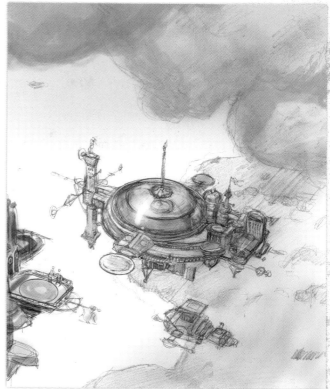

2 *Digitally Plan Out Compositional Massing*
To quickly resolve the compositional masses, scan your thumbnail drawings in gray scale and work on them in Photoshop using multiply layers.

3 *Plan the Tonal Masses & Shapes in Photoshop*
I used my Wacom tablet and Photoshop to block in big gray areas across the drawings. Setting your stylus to vary the darkness of the line makes it feel similar to using the edge of a pencil. Press softly to shade in a light area or press hard to shade in a dark area. If you want a sharper edge somewhere, you can go back and use the eraser tool to make a hard perimeter. Working in layers keeps me from erasing the drawing or layers underneath. I also used the Marquee tool Circle mode to create perfect ovals, but mainly I'm laying in a variety of large tonal masses.

4 *Prepare the Painting Surface*
Although I've used the computer to plan this painting, it's going to be painted in a traditional manner with oil paint. On gessoed Masonite, brush down the base layer with thinned-down acrylic Phthalo Green and Burnt Sienna on a big, house painter's sponge brush. Rub the surface with a rag or any semiabsorbent item that will leave a variegated pattern to paint on. It will show through the painting to a degree depending how thickly you paint or in how many layers are applied. Its purpose is to add unexpected color and textural surprises.

157

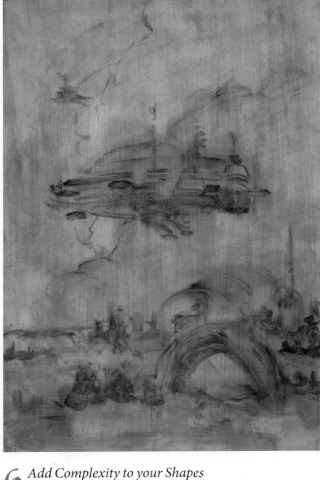

5 *Lay in Vague Shapes*
At this point, you can draw onto your surface with pencil or charcoal, but I suggest laying in your shapes with paint. Start by forming vague shapes using a big bristle brush with Burnt Umber painting into a very thin layer of drying linseed oil. Let your paint lead the way. Look for inspiration within the accidental forms that invariably happen when working this loosely. It's fine to occasionally look at references such as travel or magazine photos of older cities, but don't let them handicap your imagination.

6 *Add Complexity to your Shapes*
The painting is beginning to take shape now. The process is a matter of paint, wipe, paint and wipe. Use the thickness of this transparent paint to create your lights and darks. You should have a brush in one hand and a rag or paper towel in the other. If you put a little linseed oil on the rag, it'll make an effective eraser. You'll have greater control of your forms with softer brushes such as brights. Push the paint around with a range of bright brushes no. 8 to no. 12, leaving behind ridges of paint. Architectural ideas and pictures are popping into my head, and I'm looking for the perfect merging of them. On this cover job, I'm not tightly bound to my original sketch because it's for an anthology. This scene symbolizes all the stories rather than a particular scene.

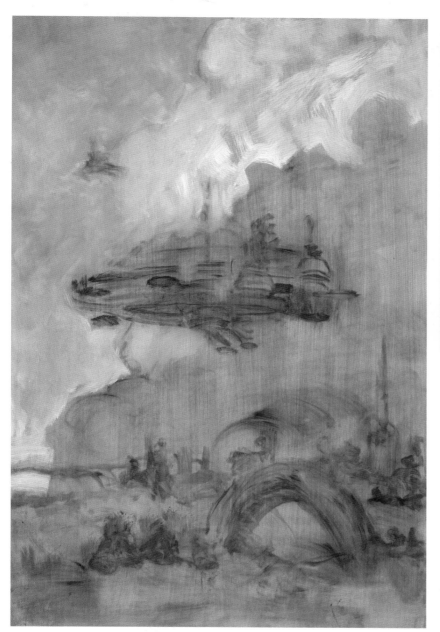

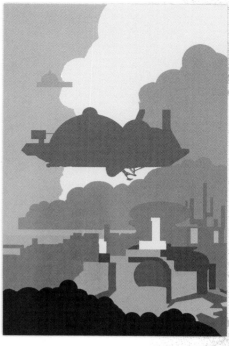

8 *Consider the Compositional Masses*

As you paint, think abstractly about the tonal masses in the painting. This is a helpful, mental step in the painting process. A strong arrangement will help your narrative and create a pleasant feeling in the overall painting. Typically, if your focal point is dark, you want it to stand out against a light background. If your center of interest is light, make it pop from a dark background.

7 *Paint Opaque Layers Before the First Layer Dries*

Before the first layer of paint dries, begin a second opaque layer, painting Titanium White into the Burnt Umber with a bigger bristle brush. The Burnt Umber is very thin so there's little worry it'll muddy the colors. As you paint, refer back to your earlier sketches to take what you like from them and leave behind what you don't. Here, I want the central craft to have an imposing nature—to make the viewer feel small.

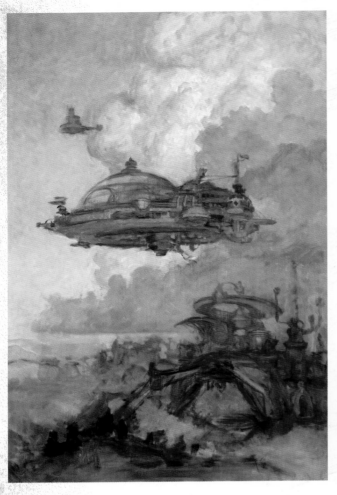

9 *Back & Forth With Values*
After waiting overnight for the painting to dry, begin working in more color and neatening the structures. Paint in basic geometric shapes that you can make more complex later with details such as windows, railing and walls. Paint in large, light areas where you'll later add darker details and large, dark areas where you'll add light details. Notice some of the ground colors showing through in the clouds. This scene is early in the morning so I've shifted the clouds to a warmer color. Keeping things rough will help to maintain an ancient feeling—a world where this great technology is already old. It'll be easier to soften the texture later if needed.

10 *Hone the Details*
Lighten the clouds with a mixture of Titanium White and Indian Yellow. Also lighten the lower section of the ground with Titanium White and Manganese Blue. In the shadows of the city in the distance, shift the dark areas to blue with some Translucent White, Flake White and Manganese Blue. You can go on infinitely adding smaller details to already small details. Each layer of paint I apply is in preparation for the next layer. You can still see much of my underpainting showing through. As you paint, keep a critical eye and make necessary changes as you see fit until you reach a good stopping point.

11 *The Finish (opposite page)*
From here to the finish think about the subtler shadow placements and what direction you want the architecture to go. Keep large areas simple and small areas more intricate. As you work in more details, use smaller and smaller brushes such as no. 4 brights and no. 1 sable rounds for tiny details such as highlights, filigrees, window molding and cracks in the structure's surface. In the end, texture, color and shapes all come together to create a mood and make a statement. You'll know when you've gotten it right.

Putting it All Together

3

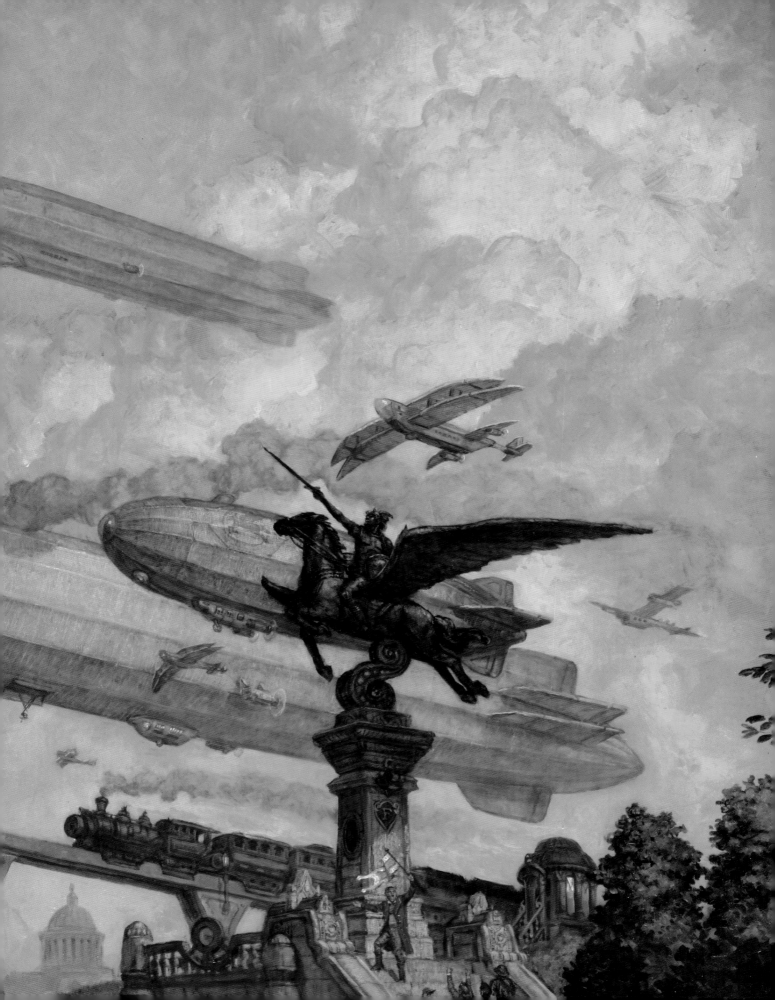

CREATING OTHERWORLDS

This is where all you've learned comes together. The key here is using water, snow, ice, plants, animals, rocks and the appropriate atmospheric qualities to build a unique and otherworldly landscape. You don't have to do something wildly bizarre. It can be a world that has many of the aspects of ours but with a key difference. Think about the visual wonders of our own world and what about them moves you. If you've spent some time drawing a variety of things from life, you'll have familiarized yourself with how the natural world works. Now try drawing from the memory of things you've seen.

This is a back-and-forth process. Study something, draw it and go back to it to see how well you remembered it. Doing this will train your brain to remember what you see. The human brain tends to make symbols of the various things it experiences rather than to remember the objects themselves. Train your brain to remember what you see the way your eye sees it. When you go to make things up, take all the well-observed bits of the world and combine them in a pleasing fashion. I don't mean to make a mental collage but to use those ideas to generate one idea that works overall.

For example, if you have a very nice idea for an unusual landscape, it'd be nice to populate it with some interesting creatures. Look through your sketchbooks until you find something appropriate and redraw it to fit the scene. If you've drawn a fascinating creature, then invent a landscape to accent its most interesting qualities. Don't be afraid to change the creature's pose or action to make things more interesting.

We humans are great with associations, metaphors, similes and analogies. Allow your brain to free associate. If you simply sit in a quiet empty room, your mind will begin to do it on its own. This will generate numerous ideas for you. Always keep something near you to make notes or to quickly draw an idea.

Your biggest problem with making up everything you draw or paint will be that you'll probably find yourself drawing what you know more than something you're unfamiliar with. So take care to challenge yourself with new subjects.

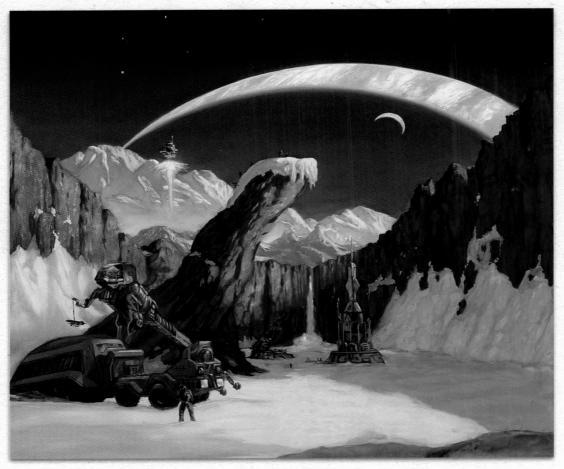

DEPICTING ALIEN LANDSCAPES

This is a book cover I did for Invaders from Earth *by Robert Silverberg. Until we have faster-than-light travel, our exploration of other planets will be only within our solar system. However, you can use what you know about our world to create wholly alien landscapes that exist a million light-years away.*

You'll find that thinking in three dimensions will be a great asset. Then you'll be able to arrange all the elements of your composition to have the greatest effect. It's going to be best to draw this scene from a few different angles and to make a color sketch of your plan. As discussed in earlier chapters, figure out what your direct light and ambient light will be. Your small color version will be a good test for this. I wouldn't spend more than a half hour on the color sketch. It should contain only the basics of what you'll be painting: the mood, the light, the shadow and light/dark masses.

As you apply this practical information, don't lose sight of your feelings. There's nothing wrong with expressing an intellectual idea and wanting to be technically proficient. Live inside the scene you're painting: breathe the air, feel the wind, the heat, the tension of the moment, the dampness in a cave, the cold of a night—all the wonder of it and you can paint it.

DIVERGE FROM EARTHLY ARCHITECTURE

As a fantasy artist your most difficult task will be depicting a non-earth culture. Think about how different architecture has evolved in different periods of our world and how it differs in cities from country to country. Even though we're all human, different influences make for different architecture. You'll need to diverge from earthly architecture to make something unique.

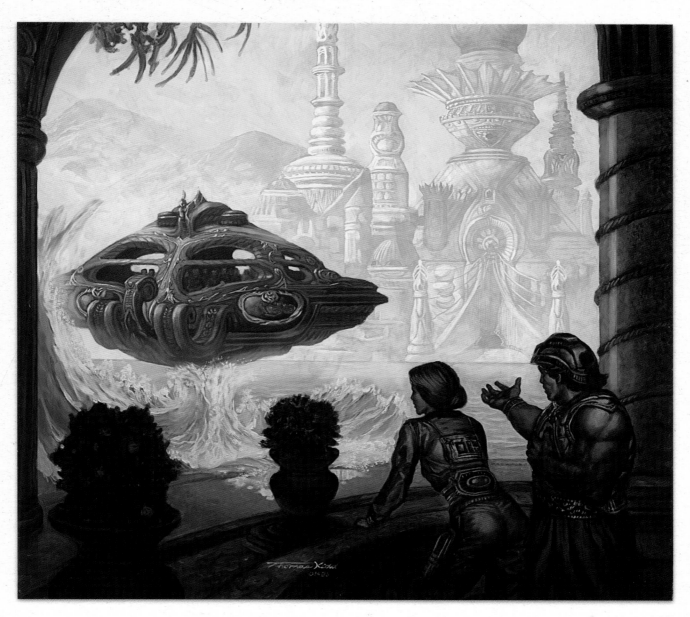

Dulac Manor

Materials

SURFACE
Gessoed Masonite board

ACRYLIC COLOR
Burnt Umber

OIL COLORS
Burnt Sienna
Burnt Umber
Cadmium Orange
Cadmium Red Deep
Cadmium Yellow
Ivory Black
Manganese Violet
Phthalo Blue
Phthalo Green
Purple Madder Alizarin
Raw Sienna
Raw Umber
Sevres Blue
Titanium White
Ultramarine Blue
Veronese Green
Viridian

BRUSHES
nos. 4 and 6 brights
nos. 8–20 bristles
small sable rounds

TOOLS
Cotton swab
Old kneaded eraser
Rag
Turpentine
Linseed oil or Liquin

Inventing new worlds is about the most fun an artist can have. Once the seed for an intriguing world is mentally planted it will grow well beyond what you originally imagined. If you free your mind to daydream and to extrapolate, you can come up with paintings that are truly unique. It's common for people to think of themselves and of their minds as outside of nature. We're not. If you let ideas form naturally and logically, you'll be using the mind nature gave you. Nature determines aesthetics and therefore you'll be exhibiting those aesthetics in your work. This is why machines and architecture built for their practical applications can be so beautiful.

1 Idea is King

If you're going to build a mountaintop mansion, you'll need a way to get there. An airplane requires too long a landing strip and helicopters need a lot of fuel to operate, so the answer is an airship. A lighter-than-air steerable balloon, sometimes called a dirigible (which is French for steerable), can travel to great heights and distances with considerably less fuel than an airplane. Though even an airship needs a landing pad for people to disembark. Because airships are easily blown by the wind, a mast is needed to hold it in place. A circular platform is best to let it turn in the wind along an axis. You now have the idea for a picture based on imagining something practical, albeit fanciful.

2 *Lay in the Ground Colors*

Lay a wash of acrylic Burnt Umber and let thoroughly dry. Throw down some thoughtless strokes of oil colors Manganese Violet and Burnt Umber with a big bristle brush on top of a very thin layer of linseed oil or Liquin. Turn the strokes into soft tonal masses and those masses into more defined shapes.

We humans tend to become involved in details and forget to see the whole of something so starting very loose and messy helps us see aesthetics only.

IMAGINING THE LITTLE THINGS

Don't limit yourself. While you're imagining airships traveling to remote places, go ahead and design a patch or pin for the airship crew to wear.

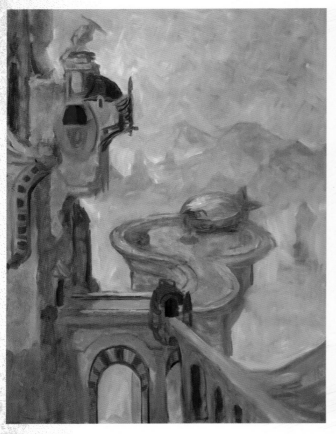

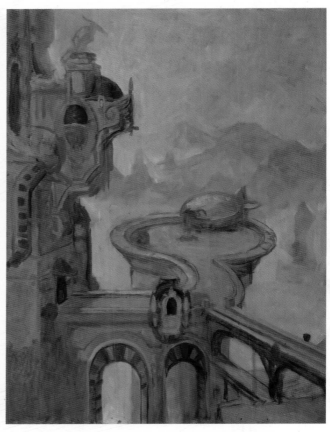

3 Develop the Main Shapes

Continue developing the painting with Titanium White and Burnt Umber using a no. 8 bright. It's a nice brush choice for creating sharp edges and painterly strokes when you're working thin. Introduce Cadmium Red Deep and Purple Madder Alizarin in the architecture on roofs and at design points. This is to repeat a color, something you'll see happen often in nature. Mimicking nature is usually a pleasing way to go. Keep things loose and paint quickly to allow for later changes. If you invest a lot of time in the details this early, you may not want to paint over them.

4 Big Changes

What seemed like a good idea yesterday may not seem so the next day. I decided to change the connection bridge in the lower left of the painting. Don't be afraid to make changes. Oil paint will forgive you almost any transgression. Keep in mind that sometimes it'll take a couple of layers of paint to hide what's underneath though. If you need to do this, you can use alkyds to quickly build up a couple of layers of paint to put your final layer of paint over.

5 Liven the Scene with Complementary Colors

Color sets your mood. This is a somewhat peaceful setting so much of it is harmonically colored. A touch of a green, the complement of red, will make it a bit more playful and less stark, so add small details of Veronese Green and Viridian with a touch of Titanium White with a round no. 1 sable or a no. 4 bright to the smaller elements of your design such as under a roof or to the tops of spirals.

As an afterthought, I added the mountains in the distance to establish the loftiness of the castle/manor and added a rock cliff to the foreground to establish depth. To paint the rocks use a no. 4 and no. 6 bright and add in a thin layer of Burnt Umber to create their basic shapes. Paint the lighted area of the rocks with a mixture of Titanium White and Raw Umber (this is the ambient light from above—the rocks are in shadow, but still get more light on their tops). Finally, paint the darker cracks in the rocks with a mixture of Ultramarine Blue and Burnt Umber.

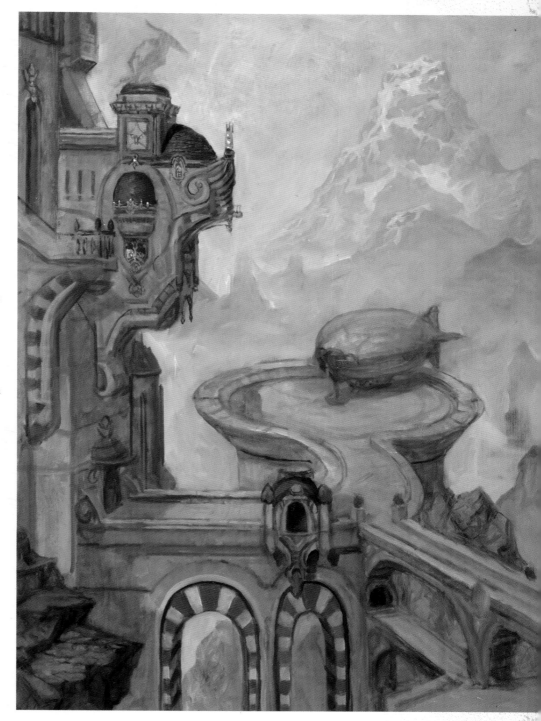

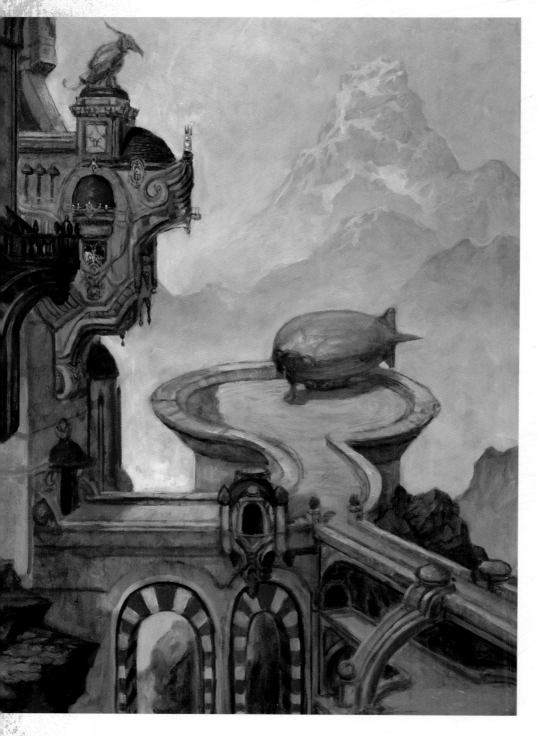

6 *Add Texture to the Stone & Cool Tones to the Sky and Shadows*

Geometric angles can be a bit tricky when painting fantasy architecture; the goal here is to create a solid-looking, man-made structure with a naturally aged surface. Mix up a color to match the main color of the stone and separately mix it in with warmer, cooler, darker and lighter colors creating a variety of mixtures. Lightly drag a no. 4 bright along the surface of the stone area painted to give it a patina. You can also press into it with something rubbery like a cotton swab or an old kneaded eraser to randomize the brushstrokes.

Introduce some blue to cool the shadows and sky. Paint a mixture of Sevres Blue and Ultramarine Blue with Titanium White to the shadows. To explain where the cool colors come from, add an opaque glaze of the mixture to the sky by blending into a thinly applied layer of linseed oil. Use this mixture to sharpen edges and to lighten the mist. To separate the structure in the foreground from the platform in the background, it's thrown into shadow. Shadows are your friends. You can cast them anywhere you want to separate something out or give weight to the composition.

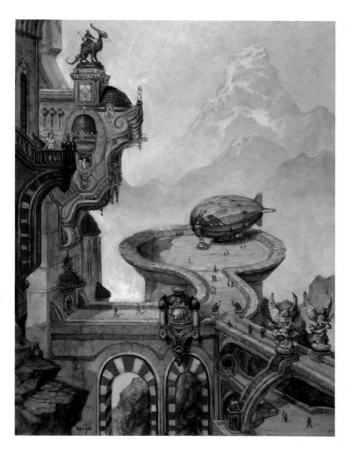

7 Populate your Painting

Where you find buildings you typically find people. They give scale to what you create. Although people are autonomous thinking individuals, they arrange themselves like planets and stars. When placing people, take care to not space them evenly. This is a sparse group and most have recently disembarked the moored airship, but they have already spread out randomly. A nice way to make sure your people follow a truly random form is to go to a reference. Find an aerial view of people and match that arrangement. The easiest way to paint your tiny figures is to pick a neutral color and paint in the basic human forms, then go back and add clothes. Use small sable rounds for the smallest details.

Mix the Phthalo Green with Ivory Black and Titanium White to paint the two bronze statues on the guard walkway.

Work from larger brushes to smaller ones that you can control easier. Proceed using a no. 1 round sable to add details to the smaller details already painted. Your brightest highlights will go on the smoothest objects such as glass or metal. Here, use Titanium White mixed with Cadmium Yellow or Cadmium Orange. For darker details use any umber cooled with any deep blue such as Phthalo Blue or Ultramarine Blue.

8 Experiment Digitally

If you're afraid to proceed with changes, try a few things as thumbnail drawings on your computer to see if you like them. If your painting is dry, you can always gently wipe away things you don't like with a rag moistened lightly with linseed oil. The sculpture at right was drawn and then repainted in this new form.

9 Paint the Airship

Little things can sometimes make a big difference. The larger section of the airship is too close to the color of the stone so apply a thin, semiopaque glaze of Manganese Violet, Ultramarine Blue and Titanium White. This brings the airship back to the center of the attention. Blue is the least dominant color in the composition so your eye will be attracted to it. If the sky were a more common blue, this color wouldn't be as strong.

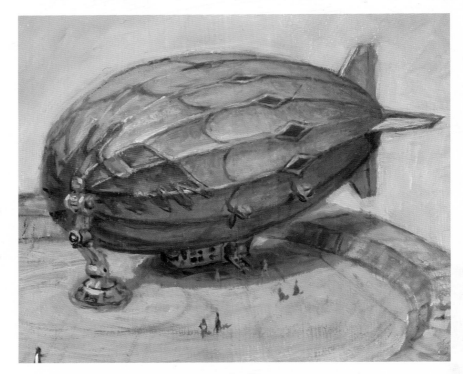

10 Add Details to the Sculpture

What kind of culture would this be without sculptures? If you walk through Paris, you'll notice the city is adorned with every manner of beautiful sculpture. Including them in your architecture gives an insight to the people that live there. Bronzes come in many colors and change color over time with oxidation. Age the two statues with a layer of Burnt Sienna with Raw Sienna thinned with turpentine to blotch the color. Let it seep into the edges of the brushstrokes to create additional details.

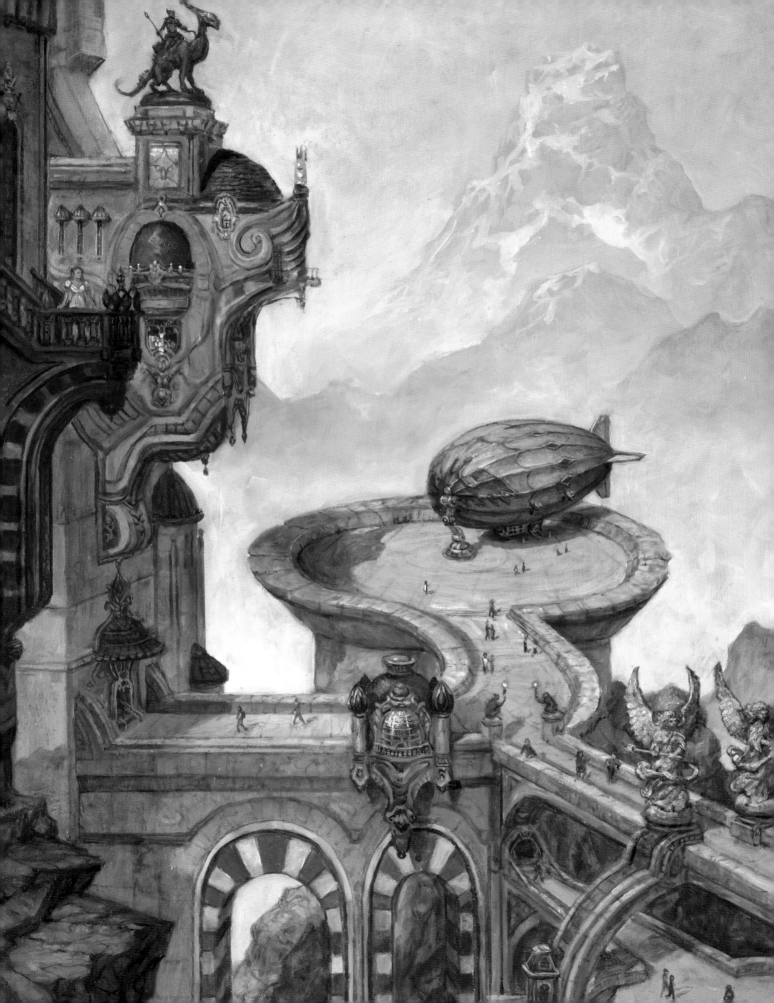

Soldiers of the Future

Materials

SURFACE
Gessoed Masonite board

ACRYLIC COLORS
Burnt Sienna
Phthalo Green

OIL COLORS
Burnt Sienna
Burnt Umber
Cadmium Orange
Cadmium Yellow
Mars Violet
Payne's Gray
Permanent Rose
Phthalo Green
Titanium White
Viridian

BRUSHES
nos. 8 to 24 bristles
nos. 4 to 8 sable brights
no. 1 sable round

TOOLS
HB pencil
Sketch paper
Rag
Linseed oil

This book cover for the anthology Citizens, *edited by John Ringo and Brian M. Thomsen, was needed before the book was completed, so I followed the editor's loose instructions. My cover painting depicts an elite combat force comprised exclusively of soldiers who have lost limbs in combat. They're equipped with strength, speed, endurance and sensory-augmenting battle suits engineered specifically for their bodies. The idea here is that future soldiers will have a wide array of accoutrements to help them fight their battles. Rather than look at what has been done before with this subject, it's best to think about what you think a suit like this would look like and come up with a design that seemingly evolved over time by the forces of need.*

IDEA SKETCHES

Ten-hut! All rejected sketches, step forward and explain why you're receiving your honorable discharges.

- *This anachronistic design wasn't to the point for a beat-up Liberty Bond poster concept. The scene needed to be of a ground battle.*

- *This idea, although right for a battle, was too weird for a war recruitment poster concept. The fallen Lady Liberty passing her torch to the soldier might be seen as disrespectful.*

- *This portrait of a soldier is more to the point, a soldier ruminating after a battle. It's an opportunity to explore how a future soldier will be equipped.*

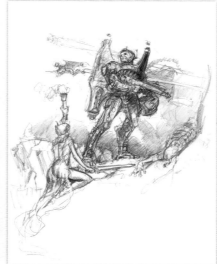

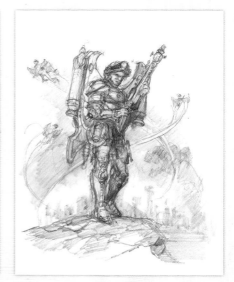

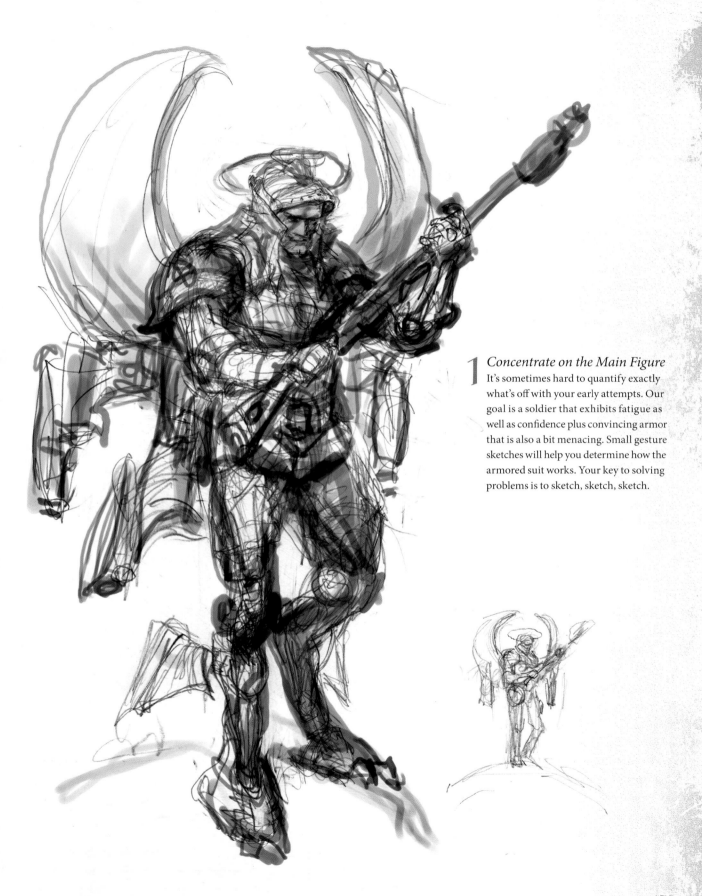

1 *Concentrate on the Main Figure*
It's sometimes hard to quantify exactly what's off with your early attempts. Our goal is a soldier that exhibits fatigue as well as confidence plus convincing armor that is also a bit menacing. Small gesture sketches will help you determine how the armored suit works. Your key to solving problems is to sketch, sketch, sketch.

2 *The First Few Strokes*
Apply an acrylic wash of acrylic Burnt Sienna and let dry for a few minutes, then apply a wash of acrylic Phthalo Green to establish a ground texture and colors. When dry, add the main forms quickly with Burnt Umber and a no. 8 bristle. Compare this beginning step—no more than five minutes of work—to the finished painting. Could this really be how it all began? Let this be a lesson in how friendly paint is. Whatever mess you make in the beginning can still come together later. Your main concern in the beginning of a painting is getting the main blocked form.

3 *Ten Minutes Later*
Further develop the form using smaller brushes—nos. 8 to 12 sables, brights and bristles. Look for ways to improve your design, but try not to follow your drawing too closely. Let the paint show you the way.

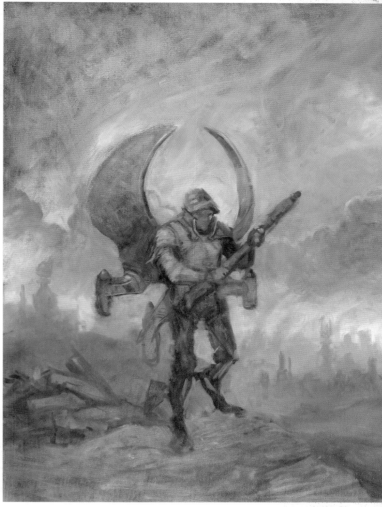

4 Define the Forms

Mixing any color with Titanium White will make that color opaque. Viridian mixed with Titanium White creates an uncommon color—a good choice for the sky color on an alien planet. Lay in strokes in the background of Viridian and Phthalo Green and paint into that with Titanium White. No matter which opaque color you chose for the background, its purpose should be to further define the foreground by, in effect, emphasizing the main forms. Repeat this process as you paint.

5 Unusual Cools & Warms on the Surrounding Colors

In this painting our cool colors are violets, pinks and oranges (Permanent Rose, Cadmium Orange and Mars Violet). If you want a clear separation between the warms and cools, paint them individually. Place the foreground using a no. 8 bristle loaded with Burnt Sienna and Titanium White, push the paint in the foreground with the bristles faced forward. This will create striations in the paint similar to rock. Compare this to the previous step to see how the mind views these colors as units of composition. The blazing cities in the distance certainly are part of the narrative, illustrating that a pitched battle took place, but it's also an important compositional device cutting across the picture and framing the main figure. Note how certain aspects of the underpainting are kept here and there.

6 Spotlight the Figure

For the rocks and the armor use a bristle loaded a mixture of Titanium White, Burnt Sienna, Permanent Rose and Mars Violet. These are the painting's warms ranging from warmest to coolest warm. Up to this point, the subject has been lit with the same ambient light as everything else. To bring it forward, to give it greater significance, put a spotlight on it. Mix together Cadmium Yellow, Burnt Sienna and Titanium White to paint in the lit areas of the soldier. This is a post-battle scene so don't make the armor too smooth and clean. Paint is most interesting used thin or thick. Laying the paint on thick here helps the highlights pop forward and adds character to the battle armor. For both the rocks and the armor use a bristle brush. Don't apply your paint in smooth strokes but push into the paint, even scrape into it, to make it form hills and valleys. Put thick amounts of paint on it and roll the brush on its edge to make random forms. While that's still wet, you can use paint thinly to add shadows and additional form. Roughly and irregularly place shadow forms using Payne's Gray, Burnt Umber and Mars Violet mixed with Titanium White.

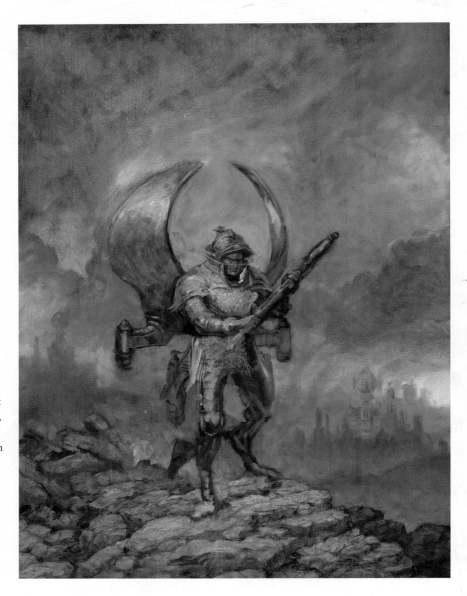

7 Details, Details (opposite page)

The foreground should have the greatest contrast. It will usually be the most important area of interest, as it is here. The eye adjusts to large foreground objects to see them sharper than the background. Adding extra contrast helps give the eyes a bit of a push.

Add the finishing details such as small complex areas, contrast and highlights. The more nongeometric the highlights, the more like nature your painting will be. Note the highlight on the soldier's wing.

The final things you want to place in a painting are distant objects over a large uncomplicated area such as the rocketing soldiers. To effect an ominous mood, darken the stormy sky.

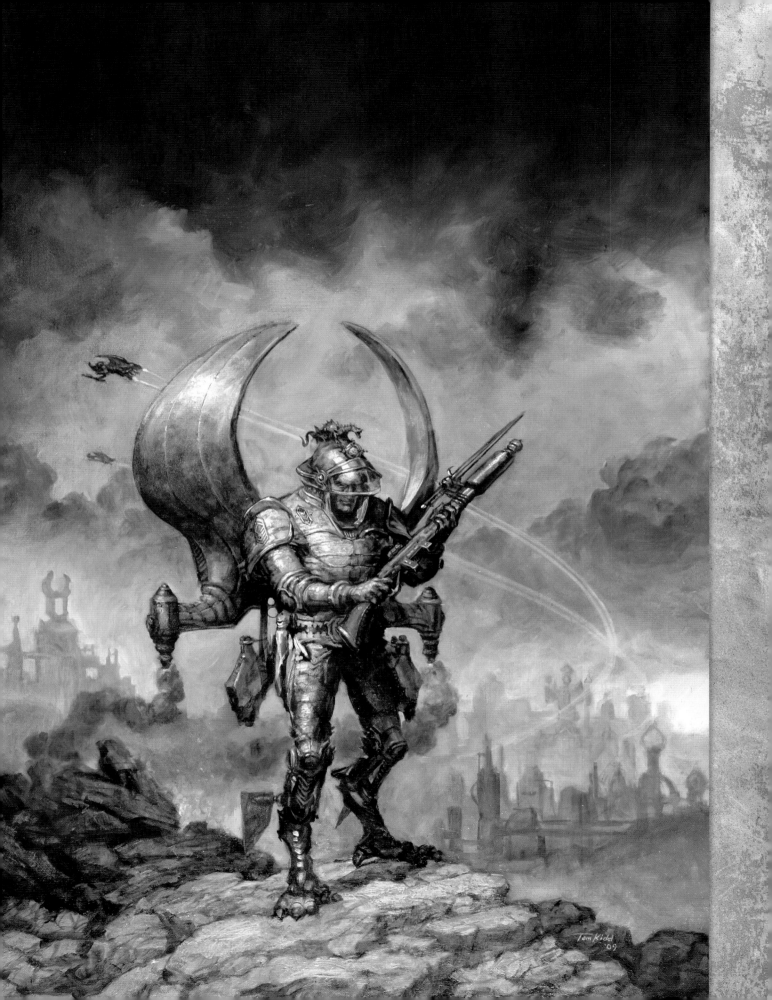

Building a Metropolis

Materials

SURFACE
3' × 8' (91cm × 244cm) gessoed
Masonite board

ACRYLIC COLOR
Burnt Umber

OIL COLORS
Alizarin Crimson
Burnt Sienna
Burnt Umber
Cadmium Red Deep
Cadmium Yellow
Flake White
Ochre
Phthalo Blue
Titanium White
Translucent White
Ultramarine Blue
Viridian
Zinc White

BRUSHES
nos. 4 , 8 sable brights
no. 8 bristle
no. 1 sable round
4-inch (10cm) sponge brush

TOOLS
acrylic matte medium
2B–6B and HB pencils
Sketch paper
Homemade carbon paper
(vellum toned on one side
with a 6B pencil)
T-square to check verticals

I decided to do a really big painting. It was going to be a city, one that was ancient, and built up upon itself over many centuries. For a while I'd been working on another book exploring extrapolations on architecture, so I wanted to combine all the knowledge I'd acquired into one picture. My plan was to create a picture composed of many distinct visual layers using atmospheric perspective. In a large painting, it is important to plan out the visual masses to maintain balance and keep a complicated scene from becoming too busy. This finished piece is titled Piranesi.

1 Idea Sketches
Here are four of the dozen idea sketches I did for the painting. Scribbling helps me pull a great number of ideas from my stray lines, and rarely does anyone see these scribbles. Quite often when I look at older sketches I did for other paintings, I ask myself why I didn't paint something. Sometimes I even find an old idea I'd forgotten about and paint it. So hang on to your scribbles!

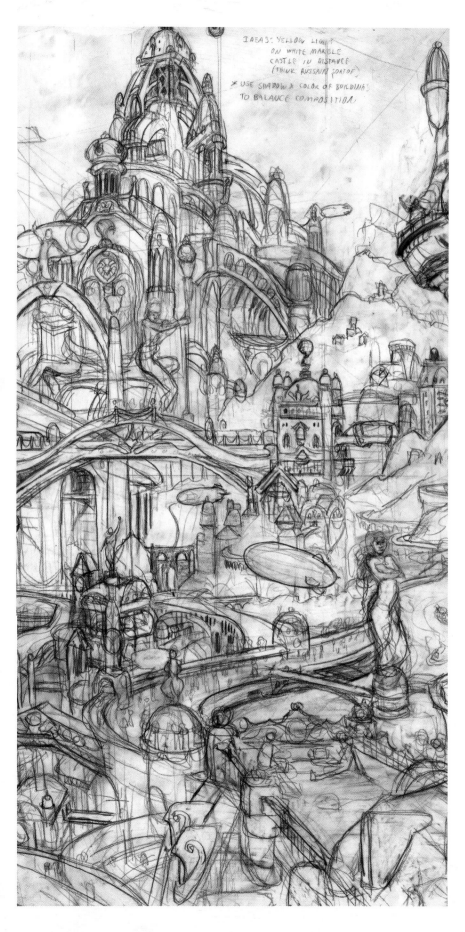

Within the image, handwritten notes:

IDEAS: YELLOW LIGHT
ON WHITE MARBLE
CASTLE IN DISTANCE
(THINK RUSSIAN SORTOF)
✗ USE SHADOW & COLOR OF BUILDINGS
TO BALANCE COMPOSITION.

2 *Transfer the Drawing*

This is a close-up of a section of the drawing. The lines have a heavy quality to them because I traced over them to transfer the drawing to the surface. You can see some of my notes written on this drawing, I jot down my ideas as they occur to me so I don't forget them.

This painting, at 3' × 8' (91cm × 244cm), is larger than the other paintings in this book. If you have a big complicated subject, it's best to work large. I did a full-sized drawing for this painting on vellum taped to the gessoed Masonite panel. Once completed, I placed a sheet of homemade carbon paper in between the drawing and the gessoed surface. Even though the carbon paper is smaller than the drawing, it can be moved around underneath. Trace over the drawing using a hard pencil like an H or HB. This is a bit tedious, and you'll have to check back and forth to see if the tracing went though. Don't worry too much if it's perfect through. You won't be painting within the lines, things will change.

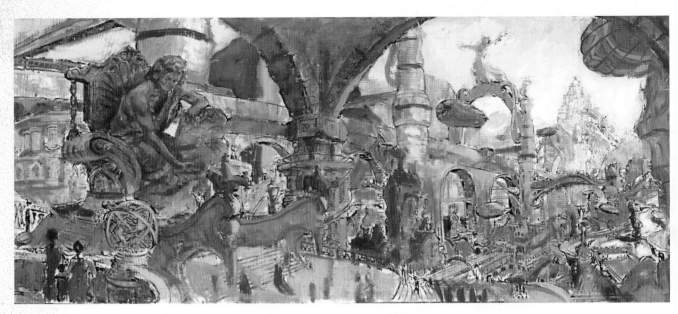

3 A Colored Sketch

I did a couple of color sketches for this painting. It was going to take such an investment of my time, I wanted to make sure I got it right. This is the one I followed closest to the finished painting. As you can see, my color sketches are the barest indication of my intentions. This painting was done before scanners and computers were part of an artist's studio. To make this color sketch I took a Polaroid of the full sketch and then made an enlargement of it on a photocopier. A layer of acrylic matte medium was painted over the photocopy. This is the surface that this oil color sketch was painted.

The design and color sketch took several days. I usually spend a great deal of time pondering what I'll do with one painting while I'm working on another. Expect ideas and solutions to come to you at unexpected times rather than when you're directly trying to solve them.

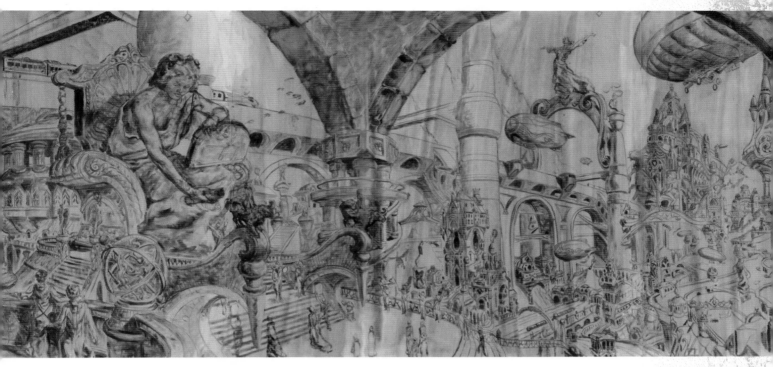

4 Lay in Values with an Underpainting

This is the next step after transferring the drawing. Rather than spraying the drawing with fixative, I put a thin layer of acrylic Burnt Umber over it with a soft 4-inch (10cm) sponge brush. The soft brush won't smear the drawing if you put down your strokes without going back and forth much. This gives you your ground color and fixes the drawing so the oil paint to be placed on top won't smear it. Once the first layer dried, I added darker values with a no. 8 sable bright using acrylic Burnt Umber again. The figures to the left will change completely from what you see here. I don't work this way anymore because establishing my drawing directly with paint is faster and accomplishes the same thing seen here in a more organic way.

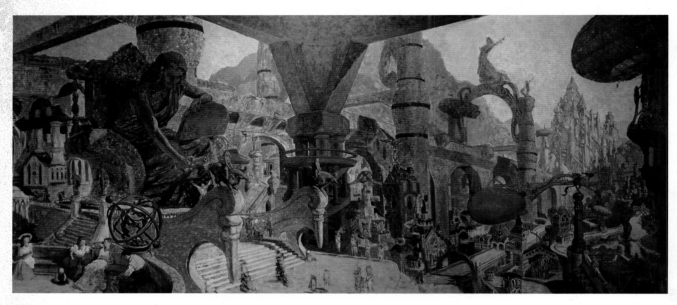

5 Establish a Patina

Here I paint variegated color and value into the underpainting. A great deal of this will show through in the finished work because oil paint is always a little bit translucent. The colors to create the patina are determined by the color sketch. They're a bit over the final color going down and their complementary colors. Also, going a bit lighter and darker here and there helps some of the underpainting texture show through. When you're painting complicated values and forms, sometimes you can lose sight of the textural quality of the surface. This keeps that from happening.

Most of the colors at this point are harmonically placed Cadmium Yellows, Burnt Siennas, Ochres, Flake White, Viridian and a mixture of Cadmium Red Deep and Alizarin Crimson for the red airship. The dark colors are various mixtures of Burnt Umber and Ultramarine Blue.

To test the translucency of various paints, swab different colors across black. For example Flake (lead) White is a warm and translucent compared to Titanium White. Zinc White is a cooler version. It's easy to test a color's opaqueness by running it across black. Many oil colors, like watercolors, are transparent and mix well with translucent colors. You can see that much of this painting at this point is just playing in the paint. That airship on the right is no more than a red glob.

The larger masses, many of the forms and patina are now painted in. Though far from complete, the painting has taken several weeks to get to this point. A painting like this takes me months to complete. I usually have to do some smaller paintings when I do something like this to get some sense of accomplishment.

6 Create Tonal Variation with White

This is an ancient city, and a special case, so it will have many signs of age in the form of erosion and stains built up over time. Even though I've fully developed the form of some things like the red airship, I decided to go back in and add blotchy whites to the stonework with Titanium White to have a greater effect on the texture when painted over. In some cases it will look like granite and in others like marble.

Now cooler colors in the form of Phthalo Blue and Ultramarine Blue are introduced into the shadows of the painting with thin layers of paint. This emphasizes the ambient light of the sky. Painting thinly allows a lot of the patina underneath to show through. Working from darker to lighter colors in layers is a nice way to control how the patina is lost in some areas while maintained in others. Also, working from dark to light builds form.

By varying the thickness of the paint as it comes off your brush, you can show more or less of what's beneath it. You can see how I've built up form in this step.

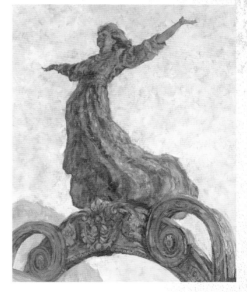

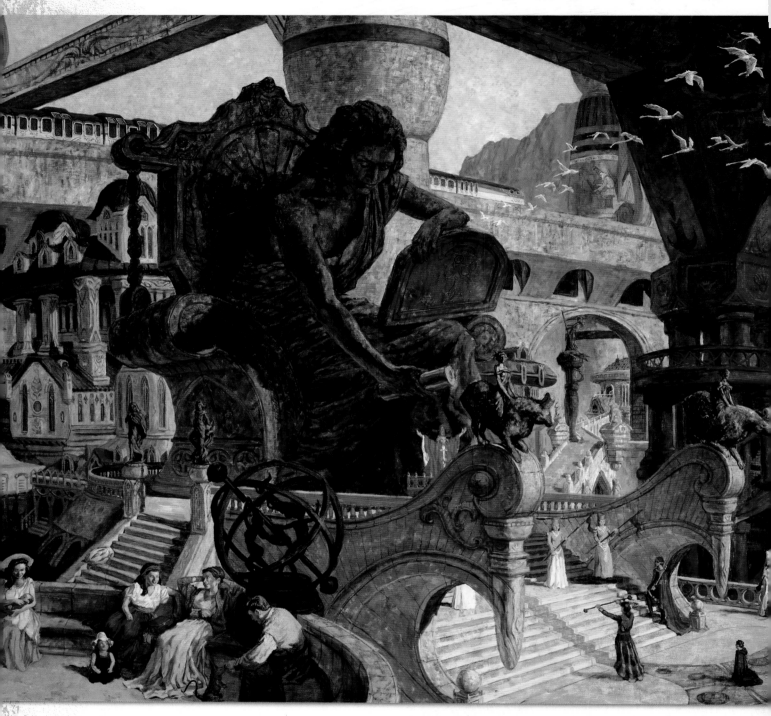

7 Thoughts on Finishing a Large Painting

I used a no. 4 sable bright and no. 1 sable round to complete the painting. These smaller brushes are good for detail work. As you add detail make sure to leave large areas with little detail. This is a busy city with a lot going on, but there should be quiet places, too, like the couple having a picnic in the lower right. A general rule to follow with areas of interest is to put light objects against dark and dark objects against light.

As much as you plan out your composition, it will change in the process of painting. If you apply the principles discussed throughout this book, they will save you considerable time. Otherwise much time will be spent correcting mistakes. Errors will always happen, but you can keep them to a minimum.

Inventing and painting a complicated cityscape like this will take months to do, and you will find it very hard to know when it's finished, unlike when you're painting a real scene before you. There's not a painting I've done that I wouldn't want to go back and improve, but at some point you'll need to stop. Your guess is as good as mine as to when.

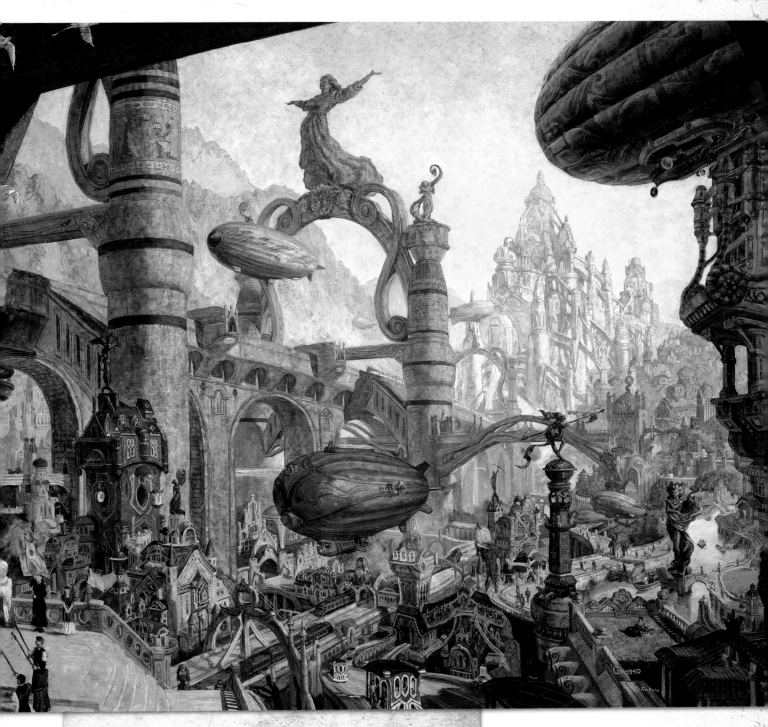

PAINT A PATTERN OVER AGED STONE VERANDA

The aged stone veranda to the left of the painting is best done with the thinnest
of paint to show through the rough sense of stone. To depict the irregular
surface of stone as seen in the stone pillars, roll your brush on its side, spinning
it between your fingers, to vary how the paint is applied. It's best to paint the
tiniest objects in a painting last. This way you won't have to carefully paint around
them when you paint larger objects.

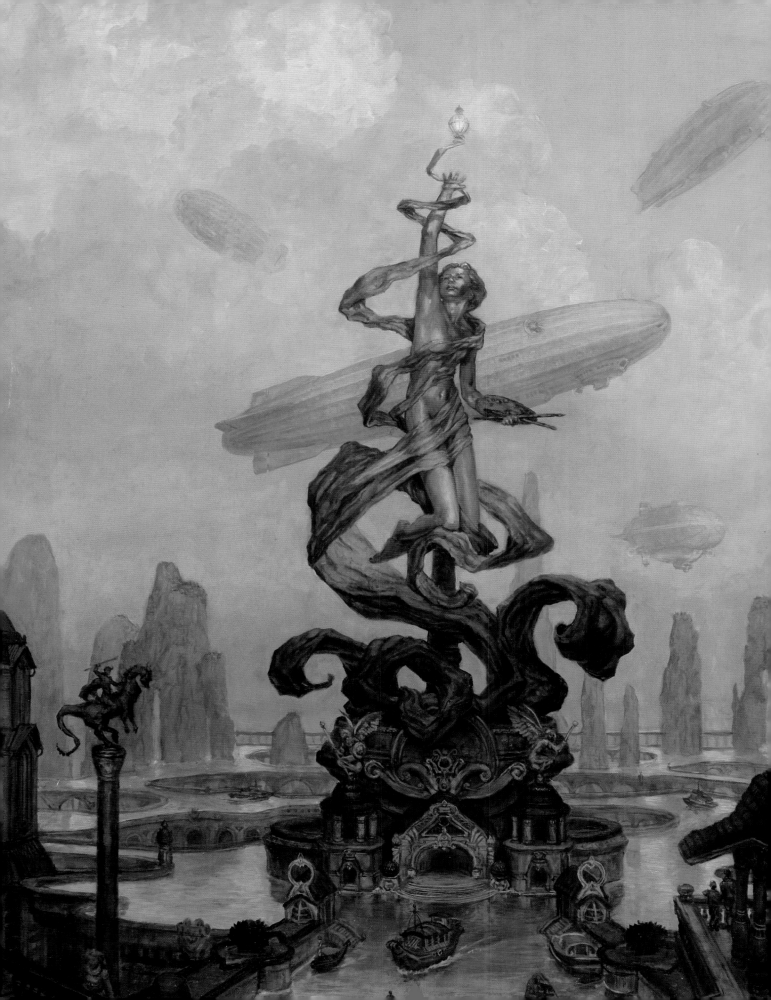

BON VOYAGE

Understanding principles is the better way to make art than to follow a particular formula for creating art. My hope is that the examples in this book aren't followed like a recipe book. You can't make art that way. It has to be made from your own observations and a structure that is based on nature. The painting at left is titled *Artistic Liberty*. It represents the liberating qualities of art. With the knowledge in this book I hope to have shown you the freedom you have in reinterpreting the world around you. Use it to release yourself from the shackles of the ordinary and build your own new worlds. I wish you an extraordinary journey.

"Art is not a transcript or a copy. Art is the expression of those beauties and emotions that stir the human soul."

—*Howard Pyle*

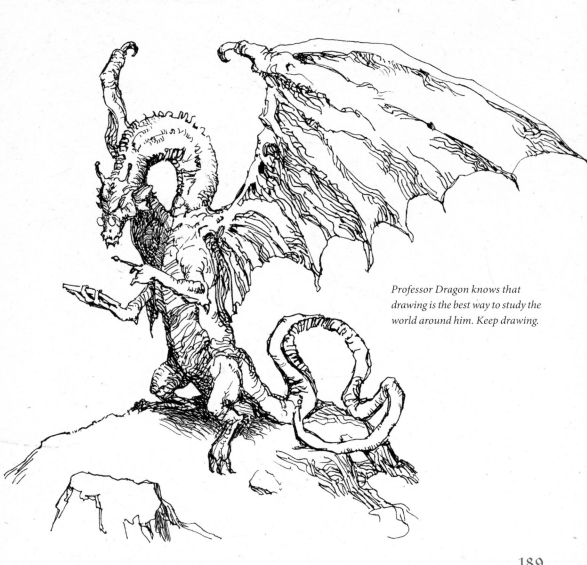

Professor Dragon knows that drawing is the best way to study the world around him. Keep drawing.

INDEX